Wisdom With
Understanding
is Better
Than Rubies

Lurine Karon Greenberg
Fine Arts Collection

Wolfgang Tillmans
Burg

Wolfgang Tillmans
Burg

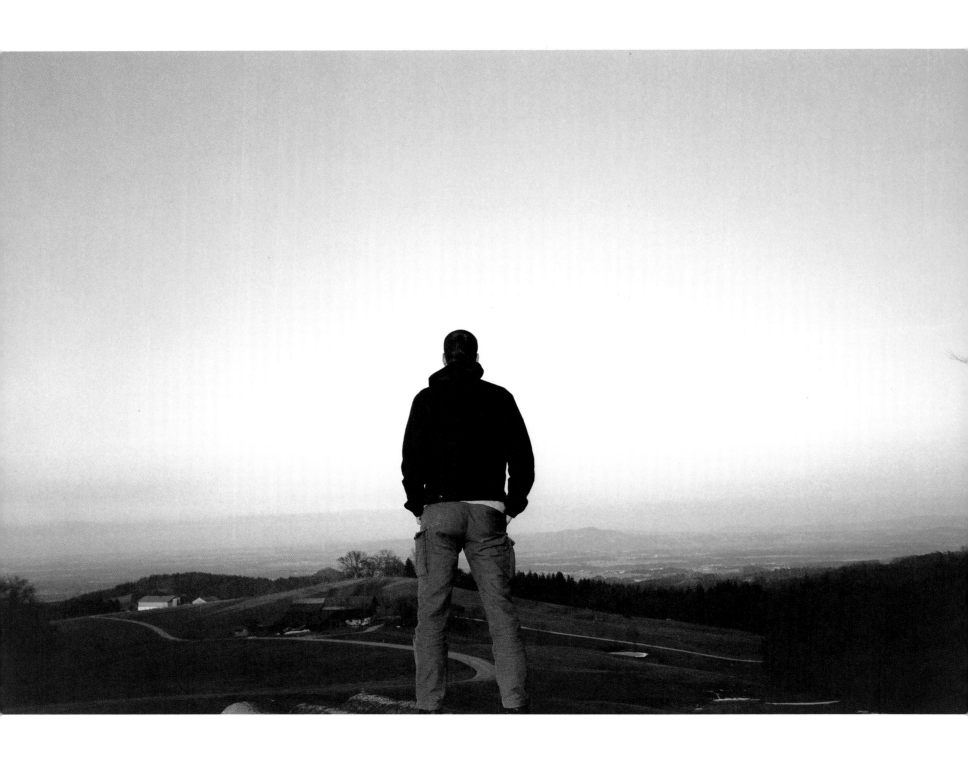

Valentine, 1998

WOLFGANG TILLMANS
BURG

edited and designed by Wolfgang Tillmans with an essay by David Deitcher

TASCHEN

KÖLN LISBOA LONDON NEW YORK PARIS TOKYO

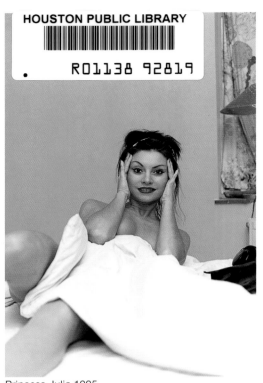

Princess Julia 1995

Kultur Report 1995

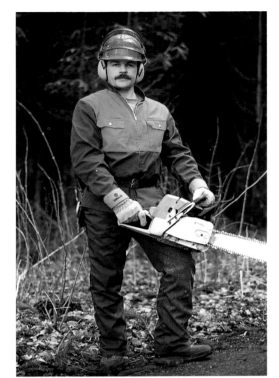

Förster 1994

Alison Folland Inde

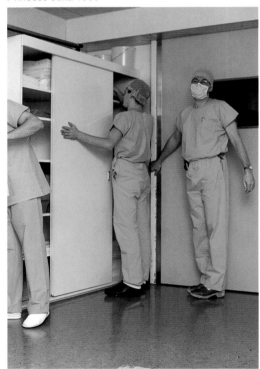

OP Schleuse 1994

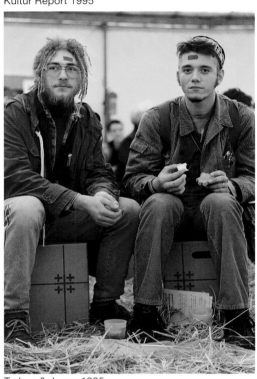

Torben & Jonas 1995

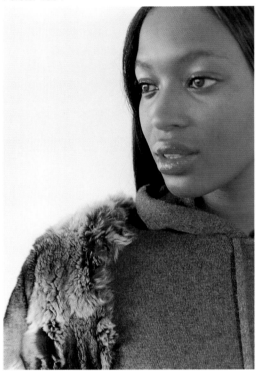

Naomi 1997

Richie Hawtin, hon

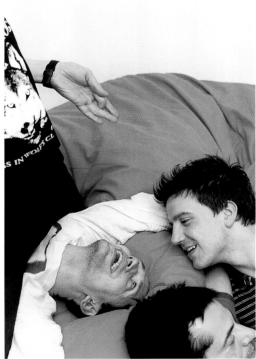

Cerith, Michael, Stefan & Gregorio 1998

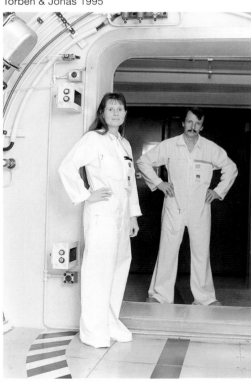

Frau & Mann in KKW Schleuse 1994

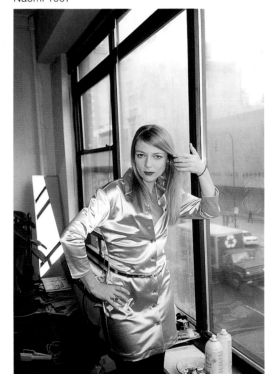

Morwenna Banks, 14th Street 1995

Harmony & Chloe

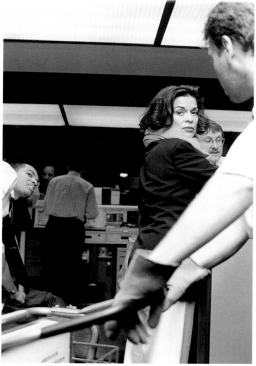

5

Bianca Jagger Index Cover 1998

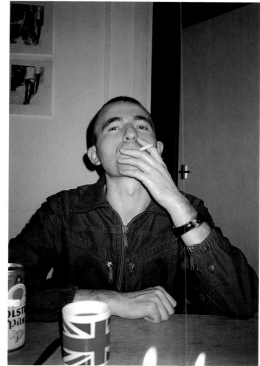

Kenny 1997

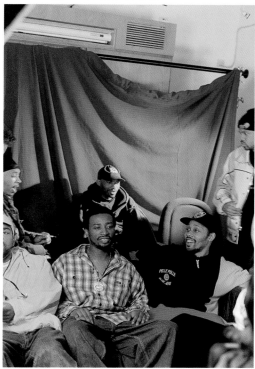

4

Wu Tang Clan 1997

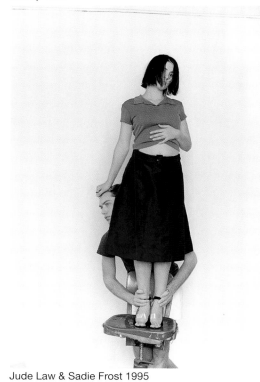

Jude Law & Sadie Frost 1995

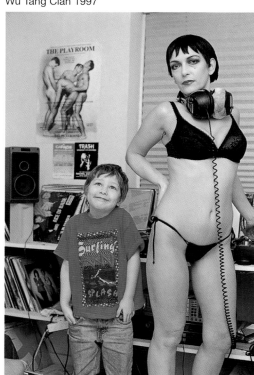

Rachel Auburn & son 1995

Todd Haynes 1998

Not too long ago I was speaking with a friend about the photographs of Wolfgang Tillmans. Late in our conversation, my friend – himself a photographer – summarized his feelings by declaring with more than a trace of annoyance, "I don't get it. Why does Tillmans show the same pictures over and over again?" I too had noticed Tillmans' propensity for showing old pictures in combination with new ones, especially in the extensive installations he creates for his gallery and museum shows. Nor had it escaped my attention that Tillmans has documented these installations in photographs that he publishes not just in the relevant exhibition catalogue but in other catalogues and in books like this one together with photographs of other installations. Unlike my friend, however, I am not annoyed by these aspects of Tillmans' practice, which strikes me as more significant than bothersome. In fact, the meanings I associate with this method inform much of what I value most about Tillmans' work.

Confronted by a wall of his photographs, or by the sequences of images he has published in magazines and books, I want to find the common denominator, to make sense of the whole. In short, I am possessed by a powerful desire to know things. In a situation like this, I work like an amateur detective, combing through the evidence in an effort to uncover meaning. I look for patterns in the formal correlations between pictures that otherwise appear to have nothing in common. I consider hierarchies of scale and other ways of granting priority to some pictures over others. Given a profusion of images, I look for the links between them: are there, I wonder, individuals who appear in more than one picture? And if so under what circumstances? What geographical locales do the pictures represent? And what social milieus? Even while attending to the beauty and plainness of the everyday objects that Tillmans has singled out for posterity, I look for the significant detail, as if it might provide me with access to domestic spaces and private rituals. Finally, I wonder, does the whole somehow add up to something greater than the sum of its parts?

Such a desire to know is analogous to the structure of narrative. Writing about the works of Henry James, literary theorist Tzvetan Todorov once observed that narrative is based on the quest for an "absent cause"; the absence of that cause is what sets the machinery of the story in motion and keeps it grinding along. Once the cause is identified or otherwise made present, narrative ceases. The desire for narrative ceases. The desire for narrative induced by Tillmans' photographic practice results in part from a structural idiosyncrasy of photographs: they are, as Susan Sontag once observed, powerless to explain anything.[1] But the ensuing flood of speculation about the meaning of the photographs is sustained and intensified by Tillmans' various ways of rearranging his work, which keep meaning in a state of flux. "As an artist," he once said, "I am interested not in singular readings, but in constructing networks of images and meanings capable of reflecting the complexity of the subject."[2]

If Tillmans' photographs suggest any kind of narrative it would be the chronicle. But for a number of reasons, the kind of chronicle his practice suggests is perhaps the memoir more than a journal, and certainly more than photojournalism and documentary. Eager to classify the work of this young photographer, early observers quickly noticed the prevalence of young people in his seemingly spontaneous photographs and labeled Tillmans a documentarian of his generation. The truth was more complex, and not just because of the extent to which Tillmans was actually collaborating with his friends to ensure that they properly "impersonated" the idea of themselves that they and Tillmans were interested in seeing.[3] In fact, Tillmans was adjusting the sober code of documentary in order to register in his photographs a measure of emotional engagement with his youthful subjects who often displayed self-conscious, awkward and exhibitionistic modes of self-presentation with which he identified. Tillmans specifically resents the wholesale dismissal of this aspect of youth as only a "phase". In this regard it is interesting that he has noted the use of the same form of patronizing devaluation in relation to his experience of growing up gay.

The process of youthful self-constitution through manipulation of one's public image provided Tillmans with his own self-defining motif from the beginning of the '90s. This process, and its ritualization in subcultural formations, are not just theatrically riveting but can be politically resistant as well as they occur in the context of a predatory commodity culture that is perpetually pursuing the next trend, fad and fashion, and the next label through which these fads and fashions can be neutralized and marketed to the lucrative mass market of youth. As Neville Wakefield has perceptively observed, Tillmans was investigating the tension between "desire as it has been commercialized within the image and the sanctity of the self as something apart from its myriad representations."[4]

What Tillmans found, and photographed, in the space created by that tension was beauty and grace. His photographs of young lives being shaped through resistant engagement with the prescriptive codes of mainstream representation reflected his effort to expand on what he has referred to as the "climate of possibility." And while it was above all Tillmans' individual pictures of young people that made visible the extent to which the self is always a work in progress, his thoughtful (re-)arrangements of those pictures in magazine spreads, books and installations provided him with a means of coming to grips with his own mutable state of selfhood, as he has said, at any given moment in time.

Since the mid-1990s, Tillmans has moved on somewhat from his former tendency to focus on the formation of the youthful self in the city square, the dance club, and the crash pad. Intimacy and reflectiveness which were always implicit in his work have become explicit as he has shifted his focus to describe what might in every sense be termed "interiority." To be sure, Tillmans has by no means constructed a vision of a literally sedate or securely settled existence. There has always been visual evidence of travel in his photographs, and these traces have lately become even more apparent. But only now have they clearly coalesced to form a visual trope, a metaphor in which the photographer's restlessness takes on the significance of a search – whether for intimate contact and meaning, or for rare experiences of transport, by which I refer to transcendence.

Transport of both kinds is the subject of *Haselmaus* (1995), a photograph of the pale young man who warranted this affectionate, and slightly antiquated, sobriquet (roughly: honeymouse). Wearing only blue bathing trunks and a beatific expression, he stands on a rock before a tropical waterfall, arms raised and head tilted back in delight. Inasmuch as the work's title declares Tillmans' love for this man, the word "transport" applies on both sides of the camera.

Travel also promises a sense of unfettered possibility – of ungroundedness – that crystallizes in the idea of flight. Transport of

this kind is the subject of *JAL* (1997), an improbably beautiful view from the window of a jet at cruising altitude, showing the gleaming, streamlined engines and wing sandwiched comfortably between a bed of clouds and an azure sky. But on the ground as well, Tillmans' nomadism has afforded him occasions to contemplate and record beautiful vistas that recall and happily secularize the romantic tradition of the sublime (*Louisiana* (1996), *Moonrise, Puerto Rico* (1995), *Port La Galère* (1996)).

Tillmans manages to maintain a certain reflectiveness in the midst of a life that now more than ever could be consumed by distraction. Among his many portraits, the appearance of unmistakably familiar faces from the worlds of fashion, art, and popular music attests to the photographer's success. Tillmans' portrait style does little to diminish the high voltage of celebrity, but it does manage to instill some doubt in the viewer's mind about whose "aura" is a product of fame and whose is not. This effect is partly the result of his collaboration with sitters who seem to know innately how to deliver what the camera and the man behind it want. But it is also due to the fact that his photographs of the famous people are inevitably seen in the company of other images. In his installations and photospreads Tillmans creates such a mix of ordinary people and living legends that within this realm of the symbolic he manages a partial leveling of the social field.

Tillmans' unconventional sense of beauty, combined with his work's increased focus on the practice of everyday life, has produced an extensive body of still lifes. "I want to reflect the way I look at the world," Tillmans has said. "That I am aware of the fact that I'm now looking at the sky, but now I'm looking at my feet.... I'm interested in various aspects of life, and I want to give them space and representation."[5] At first glance, the still lifes have a primarily abstract visual appeal partly because they are so frequently photographed from overhead. *Naoya Tulips* (1997), for example, is an aerial shot of radiant flowers encircled by the debris of a busy life. But the flowers are also bracketed by bare feet – the photographer's own – and part of his right leg, and this makes explicit a quality that is present in most of his still lifes and that sets them apart: they convey a strong sense of the photographer's physical and emotional relationship with the inanimate objects he pictures.

Although Tillmans' views from above emphasize the abstract qualities of his "motifs", the same vantage point also promotes an awareness of these objects' integration within the patterns of everyday life. The wealth of vernacular debris (price stickers, plastic containers, skimpy paper napkins, plastic spoons, elastic bands, disposable lighters...) that accompanies his fruits, flowers and vegetables anchors these arrangements securely in the everyday. Combining with the sense of seeing the objects in *Last Still Life* (1995) through Tillmans' eyes, the presence of the small dish containing four spent cigarettes deepens this otherwise merely elegant composition by ensuring that it is grasped on an emotional level as the residue of an experience that has passed and with which the viewer can identify through the agency of his or her own private associations.

Tillmans' still lifes are also enlivened by his playful, sometimes eccentric way of interacting with the objects that inhabit the world around him. This is evident in his placement of a used make-up pad, hiding in plain sight among the otherwise banal flesh tones and bone-dry textures of *Shells* (1995); or in the two-dimensional raspberries

LOST AND FOUND

BY DAVID DEITCHER

that adorn the top of a yogurt container and that now – seen from overhead – blend right in among the (originally) three-dimensional cherries, roses and half-eaten grapefruit of *Stilleben Marktstrasse* (1997). Tillmans also played with the expectations and challenged the perceptions of the viewer in the photographs he shot for American *Vogue* in 1996: only an attentive viewer will finds the cluster of homely new potatoes nestling among the strawberries that provide a properly colorful counterpoint to a beaming Kate Moss. Only a formalist and a prankster would think to situate the supermodel behind a "still life" of shrinkwrapped artichokes and a head of broccoli. This *Arte povera* art direction provides the required spot of texture and color while also functioning as a rudimentary eye test to see if any fashion enthusiast either notices this impropriety or cares.

The life that Tillmans describes in his photographs reveals other, more serious signs of being at odds with middle-class convention. Which, thankfully, is not to say that he has in any way turned this into a pretext for solemnity. Consider, for example, two photographs of a youth who sports a trim Mohawk. The interior is recognizable from other photographs of Kate Moss and Michael Stipe: both sat for Tillmans in a "modern" armchair with a cantilevered green upholstered seat and back and that chair figures significantly in one of the pictures of this self-styled punk. Was it, I wonder, before or after Tillmans photographed those luminaries that this multiply pierced, shirtless young man dropped his trousers and aimed to make sure that not a drop of his piss would miss that seat? A second photograph shows the same rebellious young man masturbating on his knees in front of a storage unit. To intensify his pleasure, he has fastened a chain and tit clamps to his pierced nipples. To intensify ours, Tillmans has photographed him so as to show the blue jeans bunched between his alabaster thighs, and red suspenders that echo in reverse the angle and color of his cock.

A potentially hazardous incident of queer attraction provides the occasion for *Soldaten I* and *II* (1997): while riding on a train somewhere in Germany, Tillmans seems to have positioned his camera only inches from the beefy, camouflage-clad thighs of a soldier. Both photographs emit an incendiary sexual charge, which is not entirely due to the fetishized appeal of this big man in uniform; it also derives from the pleasure Tillmans evidently took in stealing a sideways glance at this man who, though put together to elicit admiration, might not have welcomed it from a fag.

Soldaten I and *II* are extremely rare images for Tillmans in one respect: they convey an enthrallment to a kind of hypermasculinity that for once is completely consistent with the construction of the contemporary gay male ideal in gay market culture and pornography. Tillmans' photographs more often describe a queer sexuality that within the context of this discussion can be seen as being doubly transgressive, for not only does it violate the coercive code of compulsory heterosexuality, it also resists the blandishments of a gay sexual culture that Tillmans, along with many other young and insightful same-sexers, rightly find oppressive.

As I survey Tillmans' photographs of young men, none of them – not even the punk who pissed on Tillmans' chair and jerked off beside his closet – adheres to the gay sexual ideal as embodied in the pages of your average glossy gay skin magazine. One has only to look at the studies of the young man identified as "Paul" to conclude that Tillmans' photographs of the male nude are not erotic, or certainly

not in any conventional sense. When Tillmans wants to project sexual longing, he focuses on the fetish instead of the man. In *Jeremy* (1993), for example, he directs the viewer's gaze to the thick black leather belt, with an eagle-emblazoned buckle that encircles the man's waist; to the tattoos that coil up an arm; and only then to the smoothly muscled torso of this faceless young man.

The erotic charge of the fetish also informs the many photographs that Tillmans has taken of clothing. (He has said that sexuality for him is located "on the surface of the clothes."[6]) In *Gray Jeans over Stair Post* (1991) the post supports the jeans like a blunt armature, and in so doing suggests the legendary phallus whose absence, according to Freud, brings the fetish to life. But the photographs of fallen garments are not always so illustratively fetishistic: as often as they may elicit sexual longings in the viewer, they can also inspire more tender longings and associations about the circumstances that led to their being cast off in the first place. Whether hung over a radiator to dry or tossed casually to the floor, the button-fly jeans, shorts and T-shirts Tillmans photographs give him a concise and evocative way of demonstrating the permeation of everyday life by the erotic. *Sportflecken* (1996), a monumentalizing close-up of a plain white T-shirt, focuses on the soft folds of the collar, the fabric below that puckers in places, and the ivory spots that hint at the presence of sex. In its evocation of purity and comfort, *Sportflecken* is emblematic of the increasingly visible importance of romantic love in Tillmans' work, as is plainly evident in photographs in which the body of the loved one is immersed within the fullness and complexity of a shared life. Thus, *Sleep* (1995), *Haselmaus, Jochen Taking a Bath* (1997), and *New Inn Broadway* (1997).

To look at *Sportflecken* is to imagine the body of the person who once filled that T-shirt. In this sense, the work recalls another well-known picture, the photograph that the artist Felix Gonzalez-Torres took of an unmade bed in 1991. There, two dented pillows conjure up the heads of now absent occupants. Enlarged to billboard scale and exhibited that way in streets throughout New York, this work has been interpreted primarily, though not exclusively, in relation to disappearances brought on by AIDS.

Throughout the decade of Tillmans' photographic activity, AIDS has been a prominent fact of life, though not one that he has made a point of chronicling directly. Nevertheless, the photographs of discarded clothing are so redolent of desire and loss that I cannot help but relate them to AIDS. This association is only intensified by the fact that the articles of clothing that Tillmans photographs and transforms into fetishes are for some observers especially encoded as queer. In this context it is helpful to recall Freud's analysis of the fetish once again: he observed of these inanimate objects that they stand in for absences that are felt by the subject to be intolerable. Looking at Tillmans' photographs of cast-off clothing, one can be reminded of the fact that now it is death, rather than the threat of castration, that the fetish simultaneously acknowledges and disavows.

Tillmans has been extremely careful to facilitate identification with his work even among viewers who do not share in the particularities of his life. This is even true of the single photograph that is almost literally cast in shadow by the presence of AIDS, an image of a robust hand reaching across a bed to make contact with the hand of another. The thumb of this second hand is connected to an electronic

device that emits a red glow against the institutional blue of the bedding, signaling that this transitory connection between two human beings is occurring within the antiseptic chill of a hospital room. Personally, I would find it impossible not to identify this photograph with the prevalence of AIDS in my life. That said, I would find it presumptuous and wrong to use that historical context to foreclose on the capacity of this photograph to generate other meanings. For one thing, such a foreclosure would contradict Tillmans' statement about being interested "not in singular readings, but in constructing networks of images and meanings capable of reflecting the complexity of the subject."

Tillmans' installations, with their elaborate recombination of old and new photographs, demonstrate his belief in the capacity of such networks of images and of meanings to suggest the multivalent complexity of a life. But another effect of these installations is to deflect the viewer's attention away from the individual photograph and onto the ensemble of which it is a part. Combined with the fact that their photographs are unframed, and merely fastened by adhesive to the wall, the installations tend to undermine the authority of the individual work, underscoring the extent to which its meaning is dependent on both context and the experiences of the viewer. In these situations Tillmans has found, not just a new and challenging way to work with photographs in the spaces of galleries and museums, but to underscore the depth of his engagement with contingency. By "contingency" I mean the way in which meaning, but also subjectivity, sexuality, gender and identity, are all the unstable and temporary results of dynamic processes at the heart of which is difference.

Tillmans' apparent willingness to embrace contingency rubs against the grain of such quintessentially Western values as permanence, stability, commitment, and rootedness, just as it also contradicts such articles of faith within the dominant ideology of capitalist democracies as the belief in self-sufficiency, autonomy, and freedom – this last considered to have been already accomplished. To embrace contingency can be exhilarating, as is evident in the photographs that describe flirtation and sexual adventure, travel and sublime transport; in a word, liberation. To judge from the photographs it can be both beautiful and sad to surrender to the cadences of everyday life. But to embrace contingency is also frightening, inasmuch as it implies transitoriness and death. The great modern invention of photography can be identified with just such an attempt, if not to stop time, then at least to preserve that which was. Yet even as the camera records the object, the resulting photograph can only be the mark of its passage. "To take a photograph," Sontag has written, "is to participate in another person's (or thing's) mortality, vulnerability, mutability. Precisely by slicing out this moment and freezing it, all photographs testify to time's relentless melt."[7]

Tillmans has evolved a practice that requires constant returns to the past and equally constant reconsiderations of how the events of the past, and one's thoughts and feelings about them, relate to those of the present. What results is therefore something more than a photocollage of a life; something other than a cumulative portrait of the artist as a complexly constituted young man. Tillmans' recombinatory practice extends the dialectic of desire and loss that informs the practice of photography. As such, it constitutes not just a way of maintaining in consciousness cherished aspects of the past but a way of managing the trauma of their perpetual loss. It is ultimately essential to the serious beauty of Tillmans' project that even as the individual photographs record sensual pleasure and intimate connection they simultaneously represent the fear of their imminent loss, a fear that should be familiar to all people who have been fortunate enough to have found what they are looking for in life.

1 "Photographs, which cannot themselves explain anything, are inexhaustible invitations to deduction, speculation and fantasy." See: Susan Sontag, *On Photography* (New York, Farrar Straus and Giroux, 1977), p. 23
2 "Neville Wakefield in conversation with Wolfgang Tillmans," in: Brigitte Kölle (ed.), *Wolfgang Tillmans* (Frankfurt/M., Portikus, 1995), n. p.
3 "I don't photograph them as friends. They are impersonators of their own and my ideas." Ibid.
4 Ibid.
5 "Wolfgang Tillmans with Peter Halley and Bob Nickas," *Index*, March 1997, p. 42.
6 Wakefield and Tillmans, op. cit.
7 Sontag, op. cit., p. 15.

The Day Family 1995

Pulp 1998

Karl, Georg, Rosa & Ut

Scott in Madrid 1994

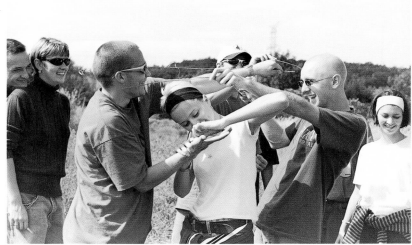
Plus 8 friends + family 1994

Jake, George, Damien,

Lutz, Alex & David 1997

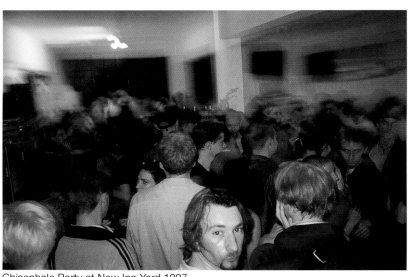
Chisenhale Party at New Inn Yard 1997

Johnnie, Michael & Ce

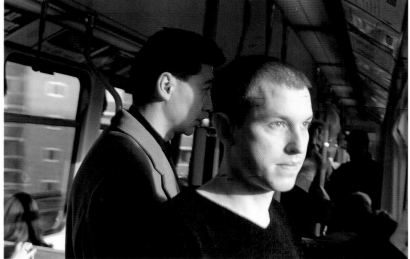
John & Matthew in DLR train 1997

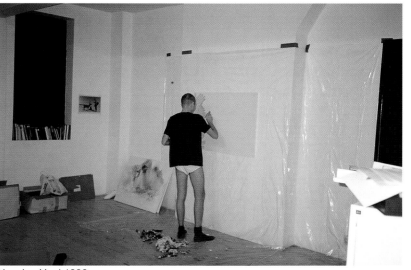
New Inn Yard 1996

Mayrose 1996

...e 1996

Bernadette Corporation 1995

...rt at Päff 1993

Tanya, Rachel, Andrea, Michelle & Yvonne at Lot 61 1998

...hns 1998

Krsna Display, Venice Beach 1990

Naomi 1997

Neulich sprach ich mit einem Freund über Wolfgang Tillmans' Fotografien. Gegen Ende des Gesprächs erklärte mein Freund, selbst ebenfalls Fotograf, mit mehr als einer Spur von Verärgerung in seiner Stimme: »Ich verstehe das nicht. Warum zeigt er immer wieder dieselben Bilder?« Tillmans' Neigung, ältere Bilder mit neuen zu kombinieren, vor allem in den umfangreichen Installationen, die er für seine Galerie- und Museumsausstellungen zusammenstellt, war auch mir aufgefallen. Und es war mir auch nicht entgangen, daß Tillmans diese Installationen wiederum fotografiert und diese Fotos nicht nur im Katalog der jeweiligen Ausstellung, sondern auch in anderen Katalogen und in Büchern wie diesem hier zusammen mit anderen Fotografien aus anderen Installationen abdrucken läßt. Doch im Gegensatz zu meinem Freund irritiert es mich nicht. Ich halte es für einen weniger störenden als vielmehr bedeutungsvollen Aspekt von Tillmans' Praxis, und die Bedeutungen, die ich in dieser Methode sehe, stehen für vieles, was ich in seinem Werk besonders schätze.

Wenn ich vor einer Wand mit seinen Fotografien stehe oder eine seiner Fotostrecken in einem Buch oder einer Zeitschrift betrachte, möchte ich den gemeinsamen Nenner finden, den Sinn des Ganzen. Kurz gesagt, mich treibt ein machtvoller Wunsch, zu wissen. Wie ein Amateurdetektiv durchkämme ich das Material, um eine Bedeutung zu entdecken. Ich suche nach gleichbleibenden Mustern in der formalen Wechselbeziehung zwischen Bildern, die augenscheinlich nichts miteinander zu tun haben. Ich studiere Größenordnungen und andere Möglichkeiten, einigen Bildern einen Vorrang vor anderen einzuräumen. Ich suche nach Verbindungen zwischen einer Fülle von Bildern; ich frage: Gibt es Menschen, die auf mehr als einem Bild zu sehen sind? Wenn ja, unter welchen Umständen? Welche geographischen Orte zeigen die Bilder? Und welche sozialen Milieus? Ich erblicke die schlichte Schönheit der alltäglichen Dinge, die Tillmans ausgewählt hat, um sie der Nachwelt zu überliefern, aber zugleich suche ich nach dem entscheidenden Detail, als könnte es mir den Zugang zu persönlichen Räumen und privaten Ritualen eröffnen. Und ich frage mich: Ist das Ganze mehr als die Summe seiner Teile?

Mit dem Wunsch zu wissen, verhält es sich so wie mit der Struktur des Erzählens. Der Literaturtheoretiker Tzvetan Todorov schrieb in einem Essay über die Werke von Henry James, daß jede Erzählung auf der Suche nach einem »abwesenden Grund« aufbaut; diese Abwesenheit des Grundes ist der Motor, der die Geschichte in Gang setzt und sie vorwärts treibt. Wenn der Grund gefunden und erkannt oder anderweitig beigebracht wird, ist die Erzählung am Ende. Der Wunsch nach einer Erzählung, den Tillmans' fotografische Praxis auslöst, ergibt sich einerseits aus einer strukturellen Eigenheit der Fotografie: Fotografien können, wie Susan Sontag einmal bemerkte, nichts erklären.[1] Doch die Flut der Spekulationen über die Bedeutung der Bilder wird auch dadurch genährt und weiter angeregt, daß Tillmans seine Fotografien immer wieder neu arrangiert, so daß ihre Bedeutung ständig in Bewegung bleibt. »Als Künstler«, sagt Tillmans, »bin ich nicht an singulären Interpretationen interessiert, sondern ich möchte Vernetzungen von Bildern und Bedeutungen herstellen, um die Komplexität der Subjekte wiederzugeben.«[2]

Wenn sich in Tillmans' Fotografien eine bestimmte Art von Erzählung andeutet, dann die Chronik. Doch die Chronik hat in diesem Fall aus einer Reihe von Gründen mehr von einer Schilderung als von einem Tagebuch und unterscheidet sich deutlich von Fotojournalis-

mus und Dokumentarfotografie. Die ersten Kommentatoren, die eine Schublade suchten, um das Werk des jungen Fotografen einzuordnen, bemerkten die Vielzahl junger Menschen in seinen scheinbar spontan aufgenommenen Bildern und nannten ihn daher einen Dokumentaristen seiner Generation. Tatsächlich verhielt es sich nicht so einfach, und das nicht nur, weil Tillmans seine Freunde in den Arbeitsprozeß einbezog, damit sie die Vorstellung von ihnen selbst, die sie und er sichtbar machen wollten, in passender Weise »verkörpern«.[3] Er wich auch von dem nüchternen Code des Dokumentarischen ab, um in seinen Bildern eine emotionale Verbundenheit mit seinen jugendlichen Modellen festzuhalten, mit deren zumeist bewußt gewählten, auffälligen, exhibitionistischen Formen der Selbstdarstellung Tillmans sich identifizierte. Es verärgerte ihn, in welcher Weise dieser Aspekt der Jugend von anderen als eine bloße »Phase« abgetan wird – mit derselben Herablassung, der er als Heranwachsender in bezug auf seine Homosexualität ausgesetzt war.

Der Prozeß der jugendlichen Selbsterfindung durch die Stilisierung eines öffentlichen Image diente Tillmans seit Anfang der neunziger Jahre als Motiv für die Bestimmung seiner eigenen Position. Dieser Prozeß und seine Ritualisierung in subkulturellen Milieus sind nicht nur theatralisch faszinierend, sie können auch eine Form des politischen Widerstands bilden, denn sie vollziehen sich inmitten einer begierigen Konsumkultur, die ständig auf der Suche nach dem nächsten Trend ist und nach einem Schlagwort, das es erlaubt, den Trend zu neutralisieren und auf dem lukrativen Massenmarkt der Jugend zu vermarkten. Wie Neville Wakefield hellsichtig bemerkte, ging es Tillmans um »die Spannung zwischen der Wunschvorstellung, so wie sie im Image kommerzialisiert wird, und der Unverletztheit des Ichs, das unabhängig von seinen unzähligen Repräsentationsformen existiert«.[4]

Was Tillmans in dem hierdurch aufgespannten Raum fand und fotografierte, war Schönheit und Eleganz. Seine Fotografien von jungen Menschen, deren Leben von ihrem resistenten Verhältnis zu den konventionellen Regeln der Repräsentation geformt ist, zeugten von seinem Bestreben, eine, wie er sagte, »Atmosphäre der Offenheit« darzustellen. Während die einzelnen Bilder verdeutlichten, inwieweit das Ich stets ein »work in progress« ist, boten die durchdachten Arrangements dieser Bilder in Zeitschriften, Büchern und Installationen Tillmans eine Möglichkeit, wie er sagte, jederzeit mit den Schwankungen seines eigenen Selbstgefühls zurechtzukommen.

Seit Mitte der neunziger Jahre hat Tillmans sich ein Stück weit von dieser Fokussierung auf die Entwicklung jugendlichen Selbstverständnisses und ihren Schauplätzen Straße, Dance Club und Schlafgelegenheit entfernt. Intimität und Reflexivität, die schon immer implizit vorhanden waren, sind nun explizit, seit er dazu übergegangen ist, in seinen Fotografien etwas zu beschreiben, das man mit Fug und Recht als »Innerlichkeit« bezeichnen kann. Doch es ist keineswegs das Bild einer geruhsamen, seßhaften Lebensweise. Seine Fotos zeigten schon immer Spuren des Reisens, Spuren, die sich in den vergangenen Jahren eher verdichtet haben. Erst jetzt aber fügen sie sich zu einer deutlich lesbaren visuellen Figur zusammen, zu einer Metapher, in der die rastlose Bewegung des Fotografen sich als eine Suche darstellt – nach persönlichem Kontakt und Bedeutung, oder nach außergewöhnlichen Momenten der Leidenschaft, das heißt nach Transzendenz.

Reise und Leidenschaft sind das Thema von *Haselmaus* (1995), ein

Foto des blassen jungen Mannes, der diesen zärtlichen, etwas altmodischen Spitznamen trug. Nur mit einer blauen Badehose bekleidet und mit einem verzückten Lächeln steht er auf einem Stein vor einem tropischen Wasserfall, die Arme erhoben, den Kopf beglückt in den Nacken gelegt. Wenn man zudem weiß, daß der Titel von Tillmans' Liebe zu diesem Mann spricht, dann gilt das Wort »Leidenschaft« auf beiden Seiten der Kamera.

Das Reisen lockt mit einer Vorstellung von grenzenlosen Möglichkeiten, von Ungebundenheit, die Gestalt erhält in der Idee des Fliegens. Dieses ist das Thema von *JAL* (1997), einer unwahrscheinlich schönen Aufnahme aus dem Fenster eines Flugzeugs, dessen Tragfläche und stromlinienförmigen Triebwerke zwischen einem Wolkenband und dem azurnen Himmel aufglänzen. Auch am Boden bot Tillmans' nomadische Lebensart Gelegenheiten, Ansichten zu betrachten und zu fotografieren, die in ihrer Schönheit an die romantische Tradition des Erhabenen erinnern und sie fröhlich aktualisieren, wie in *Louisiana* (1996), *Moonrise, Puerto Rico* (1995) oder *Port La Galère* (1996).

Tillmans' Bilder bewahren eine gewisse Nachdenklichkeit inmitten eines Lebens, das heute mehr denn je in der Zerstreuung aufgehen kann. Die unverkennbar bekannten Gesichter aus der Welt der Mode, der Kunst und der Popmusik, die immer wieder in seinen Porträts erscheinen, zeugen von seinem Erfolg. Tillmans' Porträtstil nimmt ihnen kaum etwas von der Ausstrahlung der Berühmtheit, doch er wirft im Betrachter die Frage auf, wessen »Aura« ein Produkt seines Ruhms ist und wessen nicht. Dies liegt zum Teil an Tillmans' Zusammenarbeit mit Modellen, die instinktiv zu wissen scheinen, wie sie genau das vorstellen, was die Kamera und der Mann hinter der Kamera wollen. Andererseits kommt diese Frage auch deswegen auf, weil seine Fotos von Berühmtheiten stets zusammen mit anderen Bildern gesehen werden. In seinen Installationen und in den Fotostrecken seiner Publikationen mischt Tillmans gewöhnliche Menschen und lebende Legenden in solcher Weise, daß er damit in diesem symbolischen Bereich einen gewissen Ausgleich der sozialen Differenzen bewirkt.

Tillmans' ungewöhnlicher Sinn für das Schöne hat, in Verbindung mit einer häufigeren Thematisierung des Alltagslebens, eine Vielzahl von Stilleben hervorgebracht. »Ich möchte wiedergeben, wie ich die Welt sehe«, sagte Tillmans. »Daß ich mir bewußt bin, daß ich jetzt in den Himmel schaue und jetzt auf meine Füße ... Ich interessiere mich für sehr verschiedene Aspekte des Lebens, denen ich Raum und Repräsentation geben möchte.«[5] Auf den ersten Blick haben die Stilleben eine vor allem abstrakte visuelle Qualität, unter anderem weil sie sehr häufig von oben fotografiert sind. So zum Beispiel *Naoya Tulips* (1997), eine Aufnahme von leuchtendbunten Blumen, umgeben von Anzeichen eines geschäftigen Lebens. Die Blumen sind zudem eingerahmt von zwei nackten Füßen – den Füßen des Fotografen – und einem Teil seines rechten Beins; damit wird hier etwas explizit, das in den meisten seiner Stilleben angelegt ist und sie von anderen unterscheidet: Sie vermitteln einen nachhaltigen Eindruck von der physischen und emotionalen Beziehung des Fotografen zu den Gegenständen, die er ablichtet.

Die Perspektive von oben betont einerseits die abstrakten Eigenschaften der »Motive«, andererseits läßt sie aber auch erkennen, wie diese Gegenstände in die Gewohnheiten des Alltags einbezogen sind. Eine Fülle herumliegender Kleinigkeiten (Preisschildchen, Film-

dosen, kleine Papiertücher, Plastiklöffel, Gummibänder, Einwegfeuerzeuge, …) neben seinen Früchten, Blumen und Gemüsen verankert diese Arrangements unhinterfragbar im Alltag. Wenn nun noch der Eindruck hinzukommt, daß man die Gegenstände in *Last Still Life* (1995) mit Tillmans' Augen sieht, dann verleiht der kleine Ascher mit den vier Zigarettenkippen dieser ansonsten einfach nur eleganten Komposition eine Tiefe, denn er bewirkt, daß dies auf einer emotionalen Ebene als die sichtbaren Spuren eines vergangenen Erlebnisses begriffen wird, mit dem man sich als Betrachter durch seine eigenen persönlichen Assoziationen identifizieren kann.

Tillmans' Stilleben erhalten manchmal einen gewissen »Dreh« durch seinen spielerischen, bisweilen auch exzentrischen Umgang mit den Dingen in seiner Umgebung: zum Beispiel das gebrauchte Make-up-Pad, das sich vor aller Augen zwischen den banalen Fleischfarben und knochentrockenen Texturen von *Shells* (1995) verbirgt, oder die zweidimensionalen Brombeeren auf dem Deckel eines Joghurtbechers, die sich in *Stilleben Marktstraße* (1997) nahtlos zwischen den (im Original) dreidimensionalen Kirschen, Rosen und der angegessenen Grapefruit einfügen. Auch in den Fotos, die er 1996 für die amerikanische *Vogue* machte, spielte Tillmans mit Erwartungen und stellte den Blick der Betrachter auf eine Probe: Nur wer genau hinsieht, wird die unscheinbaren jungen Kartoffeln zwischen den Erdbeeren entdecken, die einen passend farbenfrohen Gegenpol zu einer strahlenden Kate Moss bilden; und nur ein Formalist und Ironiker kann auf die Idee kommen, das Supermodel hinter ein »Stilleben« aus vakuumverpackten Artischocken und einem Brokkolikopf zu setzen. Dieses Arte-povera-Arrangement bietet die notwendige Textur und Farbe, und zugleich dient es als ein rudimentärer Sehtest, um herauszufinden, ob die Modefans diesen Lapsus bemerken und ob sie sich daran stören.

Das Leben, das Tillmans in seinen Fotografien beschreibt, zeigt auch andere, deutlichere Zeichen seiner Mißachtung bürgerlicher Konventionen. Glücklicherweise macht er es nicht zum Vorwand für einen gravitätischen Ernst. Zum Beispiel in zwei Fotos eines jungen Mannes mit einem kurzgeschorenen Irokesenschnitt: Das Interieur ist von Porträts von Kate Moss und Michael Stipe bekannt, die beide für Tillmans auf einem »modernen«, grün bezogenen Freischwingerstuhl posierten, der auch in einem der beiden Fotos dieses selbststilisierten Punks einen bedeutenden Platz einnimmt. War es bevor oder nachdem Tillmans die beiden Stars fotografierte, fragt man sich, daß der mehrfach gepiercete Mann mit dem nackten Oberkörper die Hosen herunterließ und genau zielte, um sicherzugehen, daß kein Tropfen seines Urins den Sessel verfehlt? Ein zweites Foto zeigt denselben jungen Rebell, vor einem Schrank kniend, beim Masturbieren. Um seine Lust zu steigern, hat er sich eine Stahlkette an seine gepiercten Brustwarzen geklammert. Und Tillmans hat, um unseren Genuß zu steigern, ihn so fotografiert, daß das Bild die heruntergezogene blaue Jeans zwischen seinen alabasterweißen Schenkeln zeigt und ein Paar rote Hosenträger den Winkel und die Farbe seines Penis spiegelbildlich wiederholen.

In einem möglicherweise riskanten Moment homoerotischer Anziehung entstand *Soldaten I* und *II* (1997). Offenbar hat Tillmans während einer Zugfahrt irgendwo in Deutschland seine Kamera nur wenige Zentimeter vor dem muskulösen Oberschenkel eines Soldaten im Tarnanzug postiert. Beide Bilder strahlen eine brisante erotische Dynamik aus, nicht nur wegen des fetischistischen Appeals des kräf-

tigen Mannes in der Uniform, sondern auch, weil Tillmans offensichtlich Genuß in dem verstohlenen Seitenblick auf einen Mann fand, der zwar Bewunderung zu erregen strebt, es aber vielleicht nicht gern gesehen hätte, wenn diese Bewunderung ihm von einem Schwulen entgegengebracht wird.

Soldaten I und *II* sind in einer Hinsicht eher ungewöhnlich für Tillmans: Sie zeigen eine Empfänglichkeit für eine Art von Hypermaskulinität, die hier nahtlos übereinstimmt mit der derzeitigen Konstruktion des idealtypischen homoerotischen Mannes in der schwulen Marktkultur und Bildwelt. Häufiger beschreiben Tillmans' Fotos eine abweichende Sexualität, die in diesem Zusammenhang doppelt transgressiv genannt werden kann, denn sie verstößt nicht nur gegen die Verpflichtung auf einen heterosexuellen Code, sondern sie widersetzt sich auch den Verlockungen einer Schwulenkultur, die Tillmans, wie viele andere junge Homosexuelle auch, zu Recht als repressiv empfindet.

Wenn ich Tillmans' Fotos von jungen Männern betrachte, entspricht keines von ihnen – nicht einmal der Punk, der auf Tillmans' Sessel uriniert und neben seinem Schrank masturbiert – dem schwulen Idealbild, wie man es auf den Hochglanzseiten der üblichen Homo-Magazine findet. Man braucht nur die Studien des jungen Mannes namens »Paul« zu betrachten, um zu erkennen, daß Tillmans' männliche Aktfotografien nicht erotisch sind, jedenfalls nicht in einem konventionellen Sinn. Wo er erotisches Verlangen projizieren möchte, bringt Tillmans nicht den Mann, sondern den Fetisch in den Fokus. So beispielsweise in *Jeremy* (1993), wo er den Blick des Betrachters auf den breiten schwarzen Ledergürtel mit der Adlerschnalle lenkt, der die Hüfte des Mannes umfaßt, auf die Tätowierungen, die sich seinen Arm hinauf winden, und erst dann auf den glatten, muskulösen Körper des gesichtslosen jungen Mannes.

Die Erotik des Fetischs markiert auch einen Großteil von Tillmans' Fotos von Kleidungsstücken. (Sexualität, sagt er, sei für ihn vor allem »an der Oberfläche der Kleider« lokalisiert.[6]) In *Gray Jeans over Stair Post* (1991) wirkt der Pfosten, über dem die Jeans hängt, wie ein gewölbtes Gestell und bildet so eine Andeutung des legendären Phallus, dessen Abwesenheit, wie Freud erklärte, den Fetisch ins Leben ruft. Doch die Fotos von gefallenen Kleidungsstücken sind nicht alle dermaßen illustrativ fetischistisch; statt sexueller Lust rufen sie ebensooft eher zarte Gefühle und Vermutungen über die Situation hervor, in der jemand sie ausgezogen hat. Ob zum Trocknen über die Heizung gehängt oder achtlos auf den Boden geworfen, die Jeans, Shorts und T-Shirts, die Tillmans fotografiert, geben ihm Gelegenheit, die erotische Durchdringung des Alltagslebens prägnant und anspielungsreich vor Augen zu führen. *Sportflecken* (1996), eine monumentalhafte Nahaufnahme eines einfachen weißen T-Shirts, zeigt die weichen Falten des Kragenbunds, den (teilweise verknitterten) Stoff darunter und dunkelweiße Flecken, die auf Sex deuten. Der Eindruck von Reinheit und Behaglichkeit, den *Sportflecken* hervorruft, ist emblematisch für die immer deutlicher sichtbar werdende Bedeutung der romantischen Liebe in Tillmans' Werk, die vor allem in den Fotos offen zutage tritt, in denen der Körper des Geliebten inmitten der Fülle und Komplexität eines gemeinsamen Lebens erscheint – z. B. *Sleep* (1995), *Haselmaus, Jochen Taking a Bath* (1997) oder *New Inn Broadway* (1997).

Sportflecken zu sehen heißt, sich den Körper des Menschen vorzustellen, der dieses T-Shirt einmal ausfüllte. In dieser Hinsicht erin-

nert es an ein anderes bekanntes Bild: das Foto eines ungemachten Bettes, das Felix Gonzalez-Torres 1991 aufnahm. In diesem Bild deuteten zwei zerwühlte Kissen die Köpfe der abwesenden Schläfer an. Auf Plakatwandformat vergrößert und auf Reklametafeln in ganz New York präsentiert, wurde dieses Bild vor allem, wenn auch nicht ausschließlich, in bezug auf die Leerstellen interpretiert, die die an AIDS Gestorbenen hinterlassen haben.

In den zehn Jahren von Tillmans' fotografischem Schaffen ist AIDS ein bedeutender Aspekt des Lebens gewesen, auch wenn er darauf verzichtet hat, es direkt darzustellen. Doch die Bilder von hingeworfenen Kleidungsstücken scheinen so voller Verlangen und Verlust, daß ich sie fast unvermeidlich mit AIDS in Verbindung bringe. Diese Assoziation findet einen weiteren Rückhalt darin, daß die Kleidungsstücke, die Tillmans fotografiert und zu Fetischen verwandelt, für manche Betrachter eine besondere Bedeutung innerhalb eines homoerotischen Codes besitzen. In diesem Zusammenhang ist nochmals auf Freuds Analyse des Fetischs zu verweisen: Freud bemerkte, daß die Fetisch-Gegenstände als Ersatz für etwas anderes stehen, dessen Abwesenheit jemandem unerträglich ist. Tillmans' Fotografien von abgelegten Kleidungsstücken können vielleicht daran erinnern, daß das, was der Fetisch zugleich eingesteht und verleugnet, heute nicht mehr die Kastrationsangst ist, sondern der Tod.

Tillmans achtet darauf, auch Betrachtern, die nicht an seiner Lebensweise teilhaben, die Identifikation mit seinem Werk zu ermöglichen. Dies gilt selbst für das eine Bild, das am unmittelbarsten von AIDS überschattet ist, ein Bild einer kräftigen Hand, die über ein Bett reicht, um die Hand eines anderen Menschen zu berühren. Der Daumen der zweiten Hand ist an ein elektronisches Gerät angeschlossen, das vor dem Anstaltsblau der Bettbezüge rot aufleuchtet; so wird signalisiert, daß dieser flüchtige Kontakt zwischen zwei Menschen in der antiseptischen Kühle eines Krankenhauszimmers stattfindet. Ich persönlich kann nicht anders als dieses Foto mit der übermächtigen Präsenz von AIDS in meinem Leben zu identifizieren. Dennoch fände ich es anmaßend und falsch, dem Foto aufgrund dieses historischen Zusammenhangs die Möglichkeit abzusprechen, auch andere Bedeutungen hervorzubringen – nicht zuletzt, weil eine solche Haltung im Widerspruch zu Tillmans' eigener Position stände, daß er »nicht an singulären Interpretationen interessiert« ist, »sondern Vernetzungen von Bildern und Bedeutungen herstellen möchte, um die Komplexität der Subjekte wiederzugeben«.

Tillmans' Installationen, seine sorgsam durchdachten Kombinationen von alten und neuen Fotografien zeigen seinen Glauben an die Möglichkeit, daß solche Vernetzungen von Bildern und Bedeutungen die vieldeutigen Komplexitäten eines Lebens anzeigen können. Ein weiterer Effekt dieser Installationen ist, daß sie die Aufmerksamkeit des Betrachters nicht auf das einzelne Bild lenken, sondern auf die Gesamtheit, von der es ein Teil ist. Nimmt man hinzu, daß die Fotos nicht gerahmt sind, sondern nur mit Klebeband an der Wand befestigt, dann untergraben die Installationen vielleicht die Autorität des einzelnen Bildes, unterstreichen sie, inwieweit dessen Bedeutung einerseits vom Kontext und andererseits von den Erfahrungen des Betrachters abhängig ist. Tillmans hat damit nicht nur eine neue und faszinierende Art gefunden, in Galerie- oder Museumsräumen mit Fotografien zu arbeiten, sondern auch ein Mittel, um das Ausmaß seines Sicheinlassens auf Kontingenz geltend zu machen. »Kontingenz« meint in diesem Sinne, daß Bedeutung, aber auch Subjektivität,

Sexualität, Geschlechtszugehörigkeit und Identität die instabilen, zeitweiligen Resultate von dynamischen Prozessen sind, in deren Kern die Differenz steht.

Tillmans' Bereitschaft, die Kontingenz zu bejahen, steht im Widerspruch zu essentiellen abendländischen Werten wie Dauerhaftigkeit, Stabilität, Verläßlichkeit und Verwurzelung und Glaubensartikeln innerhalb der dominanten Ideologie der kapitalistischen Demokratien wie dem Glauben an Unabhängigkeit, Autonomie und Freiheit – wobei letztere allgemein als bereits verwirklicht angesehen wird. Die Kontingenz zu bejahen kann ein erhebendes Gefühl sein, wie die Fotografien zeigen, die Flirt und sexuelles Abenteuer, Reisen und sublime Leidenschaft beschreiben, in einem Wort: Befreiung. Nach den Fotografien zu urteilen kann es schön und traurig sein, sich den Rhythmen des Alltagslebens zu überlassen. Doch die Kontingenz zu bejahen hat auch etwas Erschreckendes, denn sie impliziert Vergänglichkeit und Tod. Die Fotografie, die große Erfindung der Moderne, ist vielleicht ein Versuch, wenn nicht die Zeit anzuhalten, dann zumindest das zu bewahren, was gewesen ist. Doch schon in dem Moment, da die Kamera etwas aufzeichnet, kann das aufgenommene Foto nur ein Anzeichen von dessen Vergänglichkeit sein. »Fotografieren«, schrieb Susan Sontag, »bedeutet teilnehmen an der Sterblichkeit, Verletzlichkeit und Wandelbarkeit anderer Menschen (oder Dinge). Eben dadurch, daß diese einen Moment herausgreifen und erstarren lassen, bezeugen alle Fotografien das unerbittliche Verfließen der Zeit.«[7]

Tillmans hat eine Praxis entwickelt, die unausgesetzt die Rückkehr zur Vergangenheit verlangt und ebenso unausgesetzt das Wiederaufwerfen der Frage, wie vergangene Ereignisse und unsere diesbezüglichen Gedanken und Gefühle sich zu den Ereignissen, Gedanken und Gefühlen der Gegenwart verhalten. Das Resultat dieser Praxis ist daher mehr als eine Fotocollage des Lebens und etwas anderes als ein zusammenaddiertes Porträt des Künstlers als komplex strukturierter junger Mann. Tillmans' Methode der wechselnden Kombinationen führt die Dialektik von Verlangen und Verlust fort, die alle Fotografie durchdringt. Als solche ist sie nicht nur ein Mittel, um liebgewonnene Momente der Vergangenheit im Bewußtsein zu bewahren, sondern auch eine Art des Umgangs mit dem Trauma ihres immerwährenden Verlusts. Für die ernste Schönheit von Tillmans' Projekt ist es schließlich von essentieller Bedeutung, daß

die einzelnen Bilder nicht nur sinnlichen Genuß und persönliche Berührung festhalten, sondern zugleich auch die Furcht vor dem drohenden Verlust darstellen, eine Furcht, die allen Menschen bekannt sein wird, die sich glücklich schätzen können, daß sie gefunden haben, was sie in ihrem Leben suchten.

1 »Fotos, die von sich aus nichts erklären können, fordern unwiderstehlich zu Deduktion, Spekulation und Phantastereien auf.« Susan Sontag, *Über Fotografie* (München: Hanser, 1978), S. 28.

2 »Neville Wakefield im Gespräch mit Wolfgang Tillmans«, in: Katalog *Wolfgang Tillmans* (Frankfurt am Main: Portikus, 1995), o. Pag.

3 »Ich fotografiere sie nicht als Freunde. Sie verkörpern ihre eigenen und meine Vorstellungen.« Ebd.

4 Ebd.

5 »Wolfgang Tillmans with Peter Halley and Bob Nickas«, *Index* 3/1997, S. 42.

6 »Neville Wakefield im Gespräch mit Wolfgang Tillmans«, a. a. O.

7 Susan Sontag, *Über Fotografie*, S. 21.

Barnaby 1991

Richie Hawtin praying mantis 1994

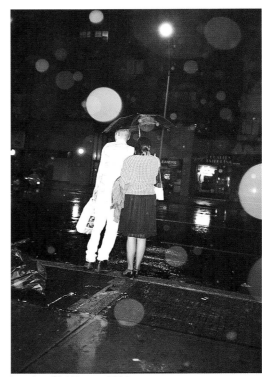

Leaving Ciel Rouge 1996

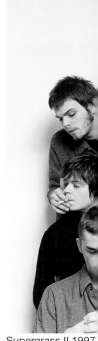

Supergrass II 1997

Jochen 14th Street 1995

Amber Valetta 1998

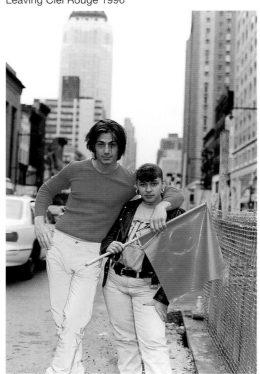

Michael Bergin & Fan 1995

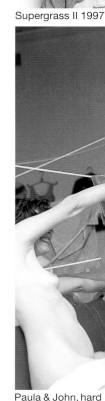

Paula & John, hard

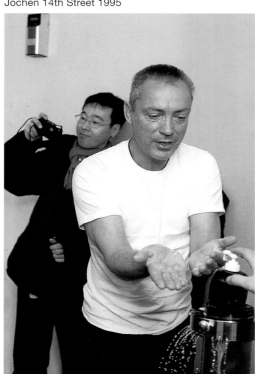

Udo Kier index cover 1996

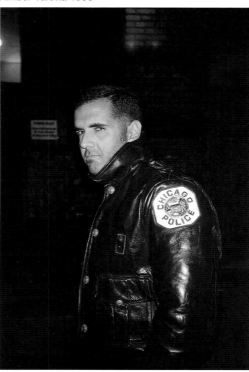

Felix outside Pork / The Lure 1995

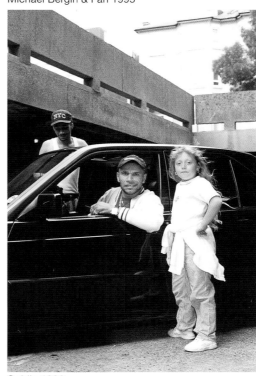

Goldie 1996

Gillian on dune 199

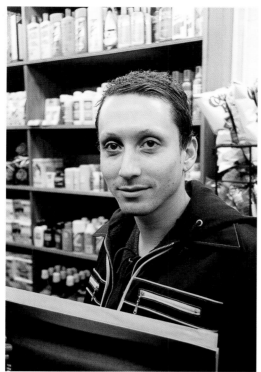

Michael / Mistress Formica 1995

Seventh Ave/ Ninth St 1996

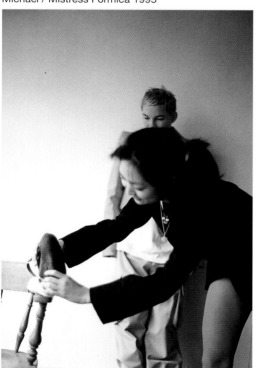

Elisabeth & Gillian with thing 1995

John Waters 1996

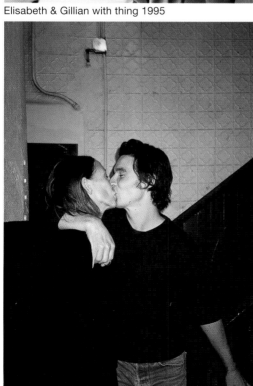

Camilla & Neville 1995

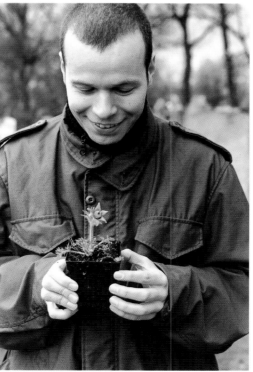

Küchenschelle, 1998

Il y a peu, je discutais avec un ami des photographies de Wolfgang Tillmans. A un moment, mon ami, qui est lui-même photographe, résuma ses sentiments avec une exaspération certaine : « Je ne comprends pas. Pourquoi Tillmans nous montre-t-il encore et toujours les mêmes images ? » Moi aussi j'avais remarqué la propension de Tillmans à combiner d'anciennes photographies avec des nouvelles, surtout dans les vastes installations qu'il crée pour ses shows dans les galeries et les musées. Il ne m'avait pas non plus échappé qu'il documentait ces installations par des photos publiées non seulement dans le catalogue de l'exposition, mais aussi dans d'autres catalogues et dans des livres comme celui-ci, mêlées aux images d'autres installations. Pourtant, contrairement à mon ami, cet aspect du travail de Tillmans, loin de m'exaspérer me paraît plutôt signifiant qu'ennuyeux. A vrai dire, le sens que j'accorde à cette pratique influe énormément sur l'estime que je porte au travail de Tillmans.

Face à un mur tapissé de ses photos ou devant les séquences d'images publiées dans des magazines ou des livres, je cherche à trouver le dénominateur commun, le sens de l'ensemble. Bref, je suis obsédé par le désir impérieux de comprendre les choses. Je deviens alors comme un détective amateur qui passerait au peigne fin le moindre indice susceptible de dévoiler le sens caché des choses. J'essaie de déceler des patterns dans les corrélations formelles reliant des images qui par ailleurs ne semblent avoir rien en commun. Je m'efforce de découvrir des hiérarchies de degrés et d'autres moyens d'attribuer une priorité à certaines images sur d'autres. Devant une telle profusion d'images, je suis en quête de correspondances : certaines personnes se retrouvent-elles sur plus d'une photographie ? Si oui, dans quelles circonstances ? Quels endroits sont représentés ? Quels milieux sociaux ? Même devant la beauté et la simplicité des objets quotidiens choisis par Tillmans pour être transmis à la postérité, je cherche le détail significatif, comme s'il pouvait me donner accès à des espaces domestiques et des rituels privés. Et finalement, je me demande si l'ensemble pourrait former plus que la somme de ses éléments.

Ce désir de savoir ressemble à la structure du récit. Comme l'a remarqué Tzetvan Todorov à propos des œuvres de Henry James, le récit est basé sur la recherche d'une « cause absente »; c'est cette absence même qui enclenche la machine narrative et qui la fait avancer. La cause une fois identifiée ou représentée, le récit cesse. Le désir d'histoires et de narrations suscité par la technique de Tillmans découle partiellement d'une particularité inhérente à la photographie : de l'impuissance de celle-ci, selon les termes de Susan Sontag, à expliquer quoi que ce soit.[1] Cependant, le flux de spéculations qui s'ensuit sur le sens des photographies est alimenté et même augmenté par les différentes façons de Tillmans de réarranger son œuvre; réarrangements faits pour maintenir le sens dans un état de flottement. « En tant qu'artiste, déclare-t-il, je ne suis pas intéressé par une seule façon de voir, mais par la constitution de réseaux d'images et de significations capables de refléter la complexité du sujet.[2] »

Si les photographies de Tillmans devaient suggérer un certain genre narratif, ce serait probablement celui de la chronique. Mais pour une kyrielle de raisons, son travail relève plutôt du mémoire que du journal, du reportage photo ou du documentaire. Certains observateurs, avides de classifier l'œuvre de ce jeune photographe, remarquèrent très tôt la prédominance de jeunes gens sur les photos apparemment spontanées de Tillmans et qualifièrent son travail de documentation de sa génération. Pourtant, la vérité était plus complexe, non seulement parce que Tillmans collaborait de manière très poussée avec ses amis, afin de s'assurer qu'ils incarneraient bien l'idée ou la conception d'eux-mêmes que Tillmans et eux voulaient montrer.[3] En fait, Tillmans adaptait le sobre code documentaire afin de fixer sur sa pellicule le degré de son engagement envers ses jeunes sujets — se présentant souvent de façon embarrassée, gauche et exhibitionniste — et son identification avec eux. Il refuse de considérer cet aspect de la jeunesse comme une simple « phase ». Il est intéressant de noter à cet égard qu'il a remarqué la même condescendance envers son expérience de se découvrir gay.

Pendant la jeunesse, la personnalité se construit par la manipulation de l'image qu'on donne de soi aux autres. Un développement qui fournit à Tillmans son sujet, la définition du propre moi, dès le début des années 90. Ce processus et sa ritualisation par les membres de la subculture n'attirent pas seulement l'attention de manière théâtrale, mais peuvent véhiculer une force politique revendicatrice, surtout dans le contexte d'une société de consommation toujours avide de nouvelles modes, de tendances inédites et de la prochaine marque qui permettra de neutraliser ces modes et ces tendances mêmes en les commercialisant sur le marché immense et lucratif de la jeunesse. Comme Neville Wakefield l'a très justement observé, Tillmans explorait la tension qui règne entre « le désir tel qu'il est commercialisé par l'image, et la pureté du moi en tant qu'entité indépendante de ses myriades de représentations.[4] »

Ce que Tillmans trouva dans ce champ de tension, c'est la beauté et la grâce. Les photographies de jeunes vies en train de se façonner en se heurtant aux normes de la représentation conventionnelle reflètent son effort pour préciser ce qu'il appelle le « climat de possibilité ». Certes, ses images de jeunes gens rendaient visible à quel point le moi reste toujours un processus en cours, pourtant les arrangements habiles de ces photographies dans les pages centrales des magazines, les livres et les installations lui donnaient, selon ses propres termes, les moyens de mieux comprendre l'état changeant de son moi à chaque instant donné du temps.

Depuis le milieu des années 90, Tillmans s'est quelque peu éloigné de sa tendance antérieure à ce concentrer sur la formation du moi juvénile sur les places, dans les clubs et les appartements. Le caractère intime et réfléchi toujours implicitement présent dans son œuvre devint explicite lorsqu'il déplaça la focale de son appareil pour décrire ce qu'on pourrait appeler « l'intériorité ». Evidemment, Tillmans ne construisit pas une vision d'une vie littéralement tranquille, ordinaire et rangée. Ses photographies ont toujours comporté des indices de voyages, qui sont même devenus plus apparents ces derniers temps. Mais c'est aujourd'hui seulement que ces signes ont fusionné en un véritable trope, métaphore où l'agitation perpétuelle du photographe prend le sens d'une recherche — que ce soit de contact intime, de sens, ou de rares instants de transport, terme par lequel je désigne la transcendance.

Le transport dans les deux sens du terme est le sujet de *Haselmaus* (1995), photographie d'un jeune homme pâle justifiant pleinement son sobriquet affectueux – « muscardin » ou « petit loir » et quelque peu démodé. Habillé seulement d'un caleçon de bain bleu et l'expression béate, il est debout sur un rocher devant une cascade tropicale, les bras levés et la tête rejetée en arrière dans un élan de bonheur. Vu le titre de l'œuvre, qui déclare l'amour de Tillmans pour cet homme, le mot « transport » vaut pour les deux côtés de l'obturateur.

Le voyage est aussi une promesse de liberté sans frontières, d'indépendance qui se cristallise dans l'idée du vol. Un tel transport est le sujet de *JAL* (1997), une vue d'une beauté irréelle prise de la fenêtre d'un avion à très haute altitude. On y voit les moteurs luisants et lisses ainsi qu'une aile confortablement calée entre des nuages douillets et un ciel d'azur. Mais sur la terre ferme aussi, Tillmans le nomade a rencontré des occasions de contempler et de fixer sur la pellicule des vues splendides qui rappellent, tout en la démystifiant de manière joyeuse, la tradition romantique du sublime (*Louisiana* [1996], *Moonrise, Puerto Rico* [1995], *Port La Galère* [1996]).

Tillmans parvient à préserver la réflexion au cœur d'une vie qui aujourd'hui plus que jamais risque d'être consumée par les distractions. Parmi tous ses portraits, les visages immanquablement familiers des gens de la mode, de l'art ou de la musique attestent bien le succès du photographe. Le style des portraits de Tillmans ne fait rien pour rompre le charme de la célébrité, pourtant il arrive à semer le doute dans l'esprit du spectateur. L'aura d'une personne est-elle liée ou pas à sa renommée ? D'une part, cet effet résulte de la collaboration de Tillmans avec ses modèles, qui semblent livrer de façon innée ce que l'appareil photo et le photographe qui se tient derrière attendent. D'autre part, cela vient du fait que ses images de personnes célèbres sont toujours exhibées avec d'autres photographies. Dans ses installations comme sur les pages des magazines, Tillmans crée un tel mélange de gens ordinaires et de légendes vivantes que dans ce royaume du symbolique, il parvient presque à lever les barrières sociales.

Grâce à son sens insolite de la beauté combiné à son intérêt grandissant pour la pratique du quotidien, Tillmans a produit un grand nombre de natures mortes. « Je veux refléter la manière dont je vois le monde. Que je suis conscient du fait qu'à cet instant, je regarde le ciel, mais qu'à cet autre, je regarde mes pieds … Ce qui m'intéresse, ce sont les différents aspects de la vie, je veux leur offrir un espace et une représentation[5] », explique-t-il. A première vue, les natures mortes semblent abstraites, peut-être parce qu'elles sont souvent prises d'en-haut. *Naoya Tulips* (1997) par exemple est une vue aérienne de fleurs lumineuses entourées des déchets d'une vie bien remplie. Mais les fleurs sont également mises entre parenthèses par deux pieds nus — ceux du photographe et une partie de sa jambe droite. Ceci met en évidence une qualité présente dans la plupart des natures mortes de l'artiste et qui fait leur différence : elles véhiculent le sens profond de la relation physique et émotionnelle du photographe avec les objets inanimés qu'il prend.

Certes, la vue d'en-haut accentue les qualités abstraites des « motifs », mais elle exacerbe aussi la conscience de l'intégration de ces objets dans la vie de tous les jours. La profusion de débris vernaculaires (étiquettes de prix, gobelets en plastique, nappes en papier, cuillères en plastique, élastiques, briquets jetables …) qui encadrent les fruits, les fleurs et les légumes positionne ces arrangements dans un contexte résolument quotidien. Associée à l'impression de voir les choses avec les yeux de Tillmans, la présence du petit bol contenant quatre mégots de cigarettes donne une dimension supplémentaire à la composition *Last Still Life* (1995), qui ne serait autrement qu'élégante : elle assure un ancrage émotionnel, résidu d'une expérience passée à laquelle le spectateur peut s'identifier grâce à ses propres associations.

Tillmans anime ses natures mortes en combinant de manière ludi-

PERDU ET TROUVÉ

PAR DAVID DEITCHER

que et parfois excentrique les objets qui l'entourent. cela apparaît de manière évidente dans *Shells* (1995), où une houppette à maquillage usagée côtoie les tons chair ordinaires et les textures sèches. Ou encore dans *Stilleben Marktstrasse* (1997), où les framboises qui ornent le couvercle d'un yaourt se mélangent à présent, vues d'en haut, aux cerises, aux roses et au pamplemousse à moitié mangé (initialement) tridimensionnels. Parfois Tillmans joue avec les attentes et lance un défi à la perception du regardeur, comme dans les photographies prises pour le magazine *Vogue* américain en 1996 : seul un observateur attentif découvrira le tas vulgaire de pommes de terre nouvelles nichées entre les fraises, qui offrent un contraste véritablement coloré à une Kate Moss radieuse. Seul quelqu'un de formaliste et de méprisant aurait l'idée de placer un top model derrière une nature morte composée d'artichauts sous cellophane et de brocolis. Cette mise en scène façon art pauvre fournit la touche de couleur et de texture nécessaires tout en servant de test rudimentaire : un fanatique de mode remarquera-t-il cette incongruité ?

La vie décrite par Tillmans dans ses photographies révèle d'autres signes plus sérieux de désaccord avec les conventions de la classe moyenne. Ce qui, dieu merci, ne signifie nullement qu'il en ait fait un prétexte à solennité. Prenez par exemple deux images d'un jeune homme exhibant une coupe « iroquois ». L'intérieur est reconnaissable : on l'a vu sur des photographies de Kate Moss et de Michael Stipe. Tous deux ont posé pour Tillmans sur un fauteuil « moderne » à siège et dossier verts rembourrés. De manière significative, on retrouve cette chaise sur une des images du jeune punk. Je me demande si c'est avant ou après que Tillmans eut photographié ces vedettes que le jeune homme aux multiples piercings et au torse nu baissa son pantalon et urina sur le siège en prenant soin qu'aucune goutte ne tombe à côté. Sur une autre photo, le même jeune homme rebelle se masturbe à genoux devant un placard. Pour rendre son plaisir plus intense, il a fixé une chaîne et des pinces à ses mamelons percés. Et afin d'augmenter le nôtre, Tillmans l'a montré son jean froissé entre les cuisses d'albâtre et les bretelles rouges faisant écho à l'angle et à la couleur de sa verge.

Soldaten I et *II* (1997) offrent un exemple d'attirance gay qui aurait pu mal tourner : lors d'un voyage en train à travers l'Allemagne, Tillmans semble avoir positionné sa caméra à quelques centimètres seulement des cuisses puissantes d'un militaire en treillis. Les deux images véhiculent une charge sexuelle incendiaire, pas uniquement due au charme fétichiste qui se dégage de cet homme massif en uniforme. Elle provient tout autant du plaisir évident pris par Tillmans à regarder à la dérobée cet homme certainement désireux de susciter l'admiration, mais qui ne l'aurait probablement guère appréciée venant d'un homosexuel.

Soldaten I et *II* sont des photographies rarissimes dans l'œuvre de Tillmans sous un rapport précis : elles traduisent une fascination pour une forme de virilité excessive, pour une fois en accord total avec l'idéal homosexuel mâle tel que le conçoivent la culture de masse et la pornographie gay. En général, les œuvres de Tillmans décrivent plutôt une homosexualité pouvant être considérée comme doublement transgressive : non seulement elle viole les conventions contraignantes d'une hétérosexualité de rigueur, mais en plus elle résiste à la tentation d'une culture sexuelle gay que Tillmans, comme nombre d'autres jeunes homosexuels clairvoyants, estime à juste titre opprimante.

Passant en revue les photographies de jeunes hommes prises par Tillmans, je m'aperçois qu'aucun d'entre eux, pas même le punk « urineur » et « masturbeur », n'adhère à l'image de l'idéal sexuel gay tel que le renvoient les pages glacées des magazines spécialisés. Un seul coup d'œil sur les études du jeune homme nommé « Paul » suffit pour conclure que les nus masculins de Tillmans ne sont pas érotiques, ou alors certainement pas dans le sens conventionnel du terme. Lorsque Tillmans veut montrer le désir, son attention se fixe sur le fétiche plutôt que sur l'homme. Dans *Jeremy* (1993) par exemple, le regard du spectateur est d'abord dirigé sur un large ceinturon de cuir noir à boucle ornée d'un aigle, entourant la taille de l'homme; puis sur les tatouages qui s'enroulent sur son bras et tout à la fin seulement sur le torse nu, lisse et musclé du jeune homme sans visage.

La charge érotique du fétiche pèse également sur les nombreuses photos de vêtements prises par Tillmans. (Il prétend d'ailleurs que pour lui, la sexualité se situe « à fleur de vêtement.[6] ») Dans *Gray Jeans over Stair Post* (1991), le poteau soutient le jean comme une armature contondante suggérant par là-même le phallus légendaire dont l'absence, selon Freud, éveille le fétiche à la vie. Mais les photographies de vêtements éparpillés n'ont pas toujours ce côté clairement fétichiste. Si elles peuvent bien souvent provoquer des désirs sexuels, elles sont aussi à même d'inspirer des sentiments et des associations plus tendres sur les circonstances qui ont conduit à laisser choir tel ou tel vêtement. Qu'ils sèchent sur un radiateur ou gisent négligemment sur le sol, les jeans, caleçons et autres maillots permettent à Tillmans de montrer de façon concise et évocatrice l'imprégnation de la vie quotidienne par l'érotisme. *Sportflecken* (1996), le détail agrandi d'un T-shirt blanc, dévoile les plis doux du col, le tissu en dessous, froissé par endroits, et des taches ivoire évoquant le sexe. En suggérant la pureté et le confort, *Sportflecken* est emblématique de l'importance croissante que Tillmans attache de toute évidence à l'amour romantique. C'est particulièrement clair sur les images où le corps du bien-aimé se trouve dans la plénitude et la complexité d'une vie partagée, dans *Sleep* (1995), *Haselmaus, Jochen Taking a Bath* (1997) et *New Inn Broadway* (1997).

Regarder *Sportflecken*, c'est imaginer le corps de la personne qui jadis occupait ce T-shirt. De ce point de vue, l'œuvre rappelle une autre image bien connue : la photographie d'un lit défait prise par l'artiste Felix Gonzalez-Torres en 1991. Là, l'empreinte laissée sur les deux oreillers évoque la tête des occupants désormais absents. En grand format et affichée dans les rues de New York, cette œuvre fut surtout interprétée, quoique pas exclusivement, comme un symbole des disparitions liées au sida.

Pendant toute la décennie d'activité photographique de Tillmans, le sida a tenu un rôle de premier plan, même s'il n'en fit pas directement un sujet de chronique. Néanmoins, les images de vêtements éparpillés évoquent tellement le désir et la perte que je ne peux m'empêcher de songer au sida. Cette association est même renforcée par le fait que les vêtements photographiés et transformés en fétiches par Tillmans relèvent, selon certains observateurs, du code gay. Il est utile de rappeler à ce propos l'analyse freudienne du fétiche : ces objets inanimés compensent une absence ressentie comme intolérable par le sujet. Le spectacle de ces vêtements enlevés nous rappelle aujourd'hui que c'est la mort et non plus le complexe de castration que le fétiche reconnaît et nie tout à la fois.

Tillmans a pris grand soin de permettre même à des spectateurs

étrangers aux particularités de sa vie de s'identifier à son travail. Ceci vaut également pour la photographie qui parle le plus explicitement du sida. On y voit une main robuste cherchant sur un lit la main d'un autre. Le pouce de cette seconde main est relié à un dispositif électronique émettant une lumière rouge qui tranche avec le bleu institutionnel du lit et nous signale que ce contact éphémère entre deux êtres a lieu dans le froid aseptisé d'une chambre d'hôpital. Personnellement, il me serait impossible de ne pas associer cette image au rôle que le sida joue dans ma vie. Mais il serait prétentieux et erroné d'utiliser ce contexte historique pour ne concéder aucune autre signification possible à cette photographie. D'ailleurs, cette réduction irait à l'encontre de l'affirmation de Tillmans : « Je ne suis pas intéressé par une seule façon de voir, mais par la constitution de réseaux d'images et de significations capables de refléter la complexité du sujet. »

Les installations de Tillmans, avec leurs recombinaisons élaborées de photographies anciennes et nouvelles, attestent qu'il croit ces réseaux d'images et de significations capables de suggérer la complexité et les multiples facettes d'une vie. Mais ces installations ont pour autre effet de détourner l'attention du spectateur d'une seule image sur l'ensemble dont elle fait partie. Les photos étant par ailleurs dépourvues de cadres et pour la plupart fixées au mur avec du scotch, tendent à miner l'autorité de l'œuvre individuelle, tout en soulignant à quel point l'interprétation dépend autant du contexte que des expériences du regardeur. Tillmans a trouvé par ce biais non seulement une manière inédite et provocante de jouer de ses images dans les galeries et les musées, mais également une façon de souligner la profondeur de son implication dans la contingence. Par contingence, j'entends la manière dont la signification, mais aussi la subjectivité, la sexualité, l'identité et l'identité sexuelle ne sont que les résultats éphémères de processus dynamiques (au centre desquels se trouve la différence).

La volonté apparente de Tillmans d'embrasser la contingence se heurte aux valeurs chères à l'Occident, telles que la permanence, la stabilité, l'engagement et le besoin de racines et entre en contradiction avec certains articles de foi de l'idéologie dominante des démocraties capitalistes, à savoir la croyance en l'autosuffisance, l'autonomie et la liberté — cette dernière étant considérée comme ayant déjà été atteinte. Se soumettre à la contingence peut être joyeux, comme on le voit sur les photos décrivant le flirt et l'aventure sexuelle, le voyage et le transport sublime, en un mot : la libération. A en juger par les images, il peut être beau et triste de s'abandonner au rythme de la vie quotidienne. Mais embrasser la contingence est aussi effrayant, car impliquant le transitoire et la mort. La grande invention moderne qu'est la photographie peut être identifiée comme une tentative sinon d'arrêter le temps du moins de préserver ce qu'il fut. Mais même lorsque l'appareil fixe un objet, la photographie qui en résulte ne peut être que la trace de son passage. « Prendre une photographie », a écrit Sontag, « c'est participer à la mortalité, la vulnérabilité, l'inconstance d'une autre personne (ou d'une autre chose). C'est précisément en découpant cet instant et en le figeant que toutes les photos témoignent de la fuite inexorable du temps.[7] »

Tillmans a développé une méthode exigeant de constants retours en arrière et une réflexion constante sur la relation qui existe entre les événements du passé, les pensées et les sentiments que nous y attachons, et les événements du présent. Ce qui en résulte est donc plus que le « photo-collage » d'une vie; autre chose qu'un portrait cumulatif de l'artiste en tant que jeune homme complexe. Les recombinaisons de Tillmans étendent la dialectique du désir et de la perte qui influe sur la pratique photographique. En tant que telle, cette pratique n'est pas seulement un moyen de retenir des aspects aimés du passé, mais une façon d'assumer le traumatisme de leur perte perpétuelle. Finalement, l'essentiel dans la beauté grave du projet de Tillmans, c'est que tout en montrant le plaisir sensuel et l'intimité, chaque photographie représente simultanément la crainte de leur perte imminente, une crainte qui devrait être familière à tous ceux qui ont eu la chance de trouver ce qu'ils cherchaient dans la vie.

1 *Les photographies, qui n'expliquent rien par elles-mêmes, sont une invitation perpétuelle à la déduction, la spéculation et l'imagination.* Susan Sontag. *Photography*, Farrar Straus and Giroux, New York, 1977, p. 23.
2 *Neville Wakefield discute avec Wolfgang Tillmans*. Brigitte Kölle (éd.). *Wolfgang Tillmans*, Portikus, Francfort, 1995, s. p.
3 *Je ne les photographie pas en tant qu'amis. Ils sont l'incarnation de leurs propres idées et des miennes.* Ibid.
4 Ibid.
5 *Wolfgang Tillmans avec Peter Halley et Bob Nickas. Index*, mars 1997, p. 42.
6 Wakefield et Tillmans, op. cit.
7 Sontag, op. cit., p. 15.

Lacanau (self), 1986

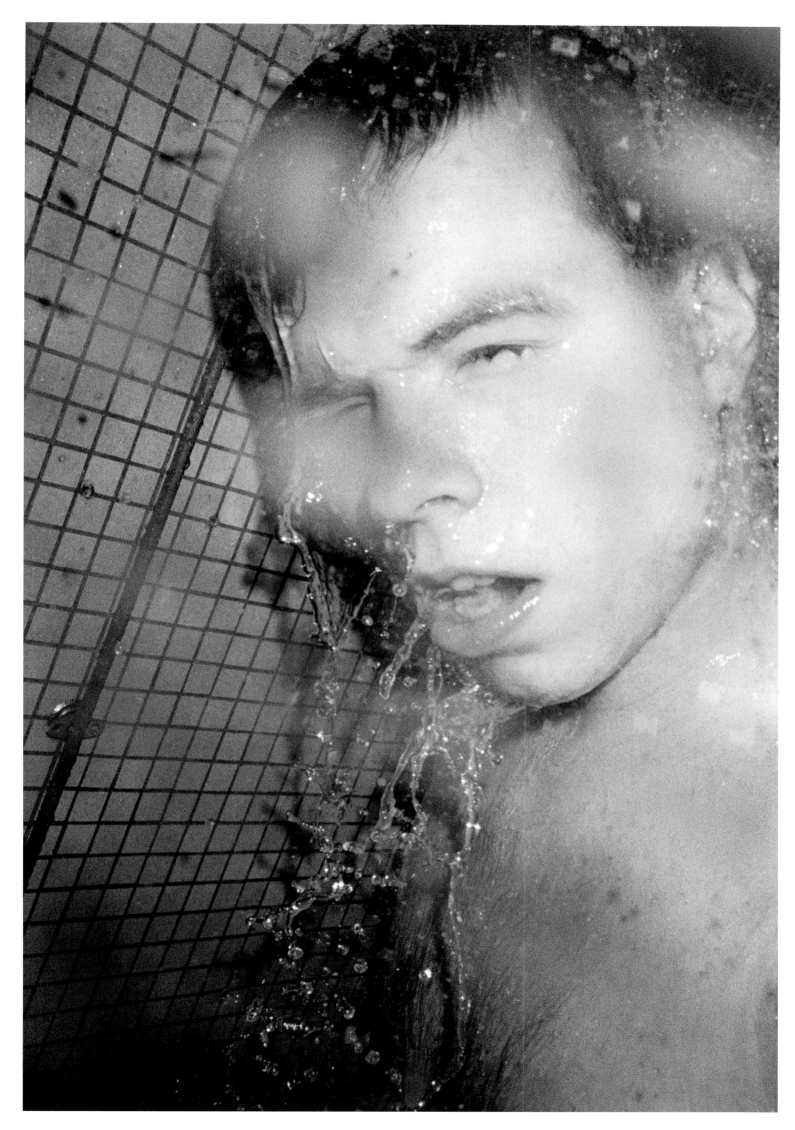

ne in the shower, 1990

gray jeans over stair post, 1991

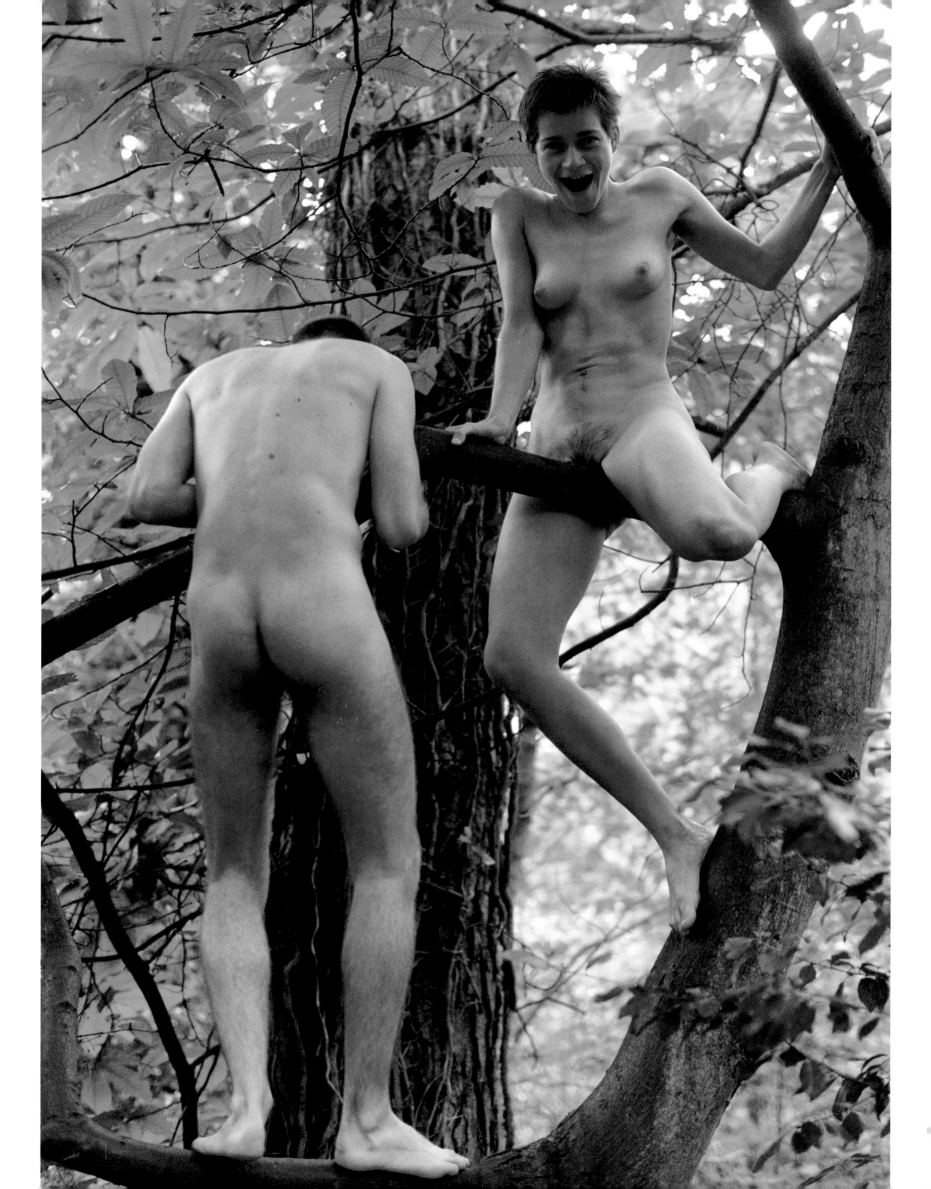

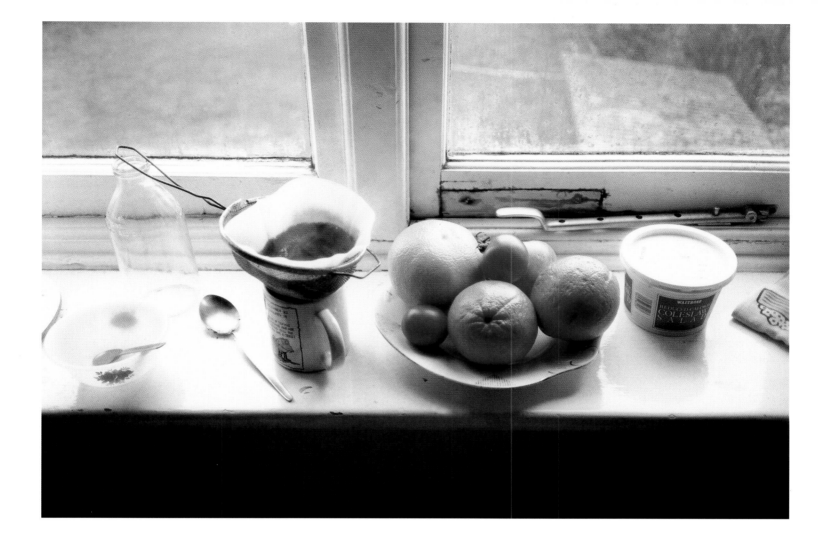

Lutz & Alex climbing tree, 1992

still life Talbot Road, 1991

Turnhose (Sandalen), 199

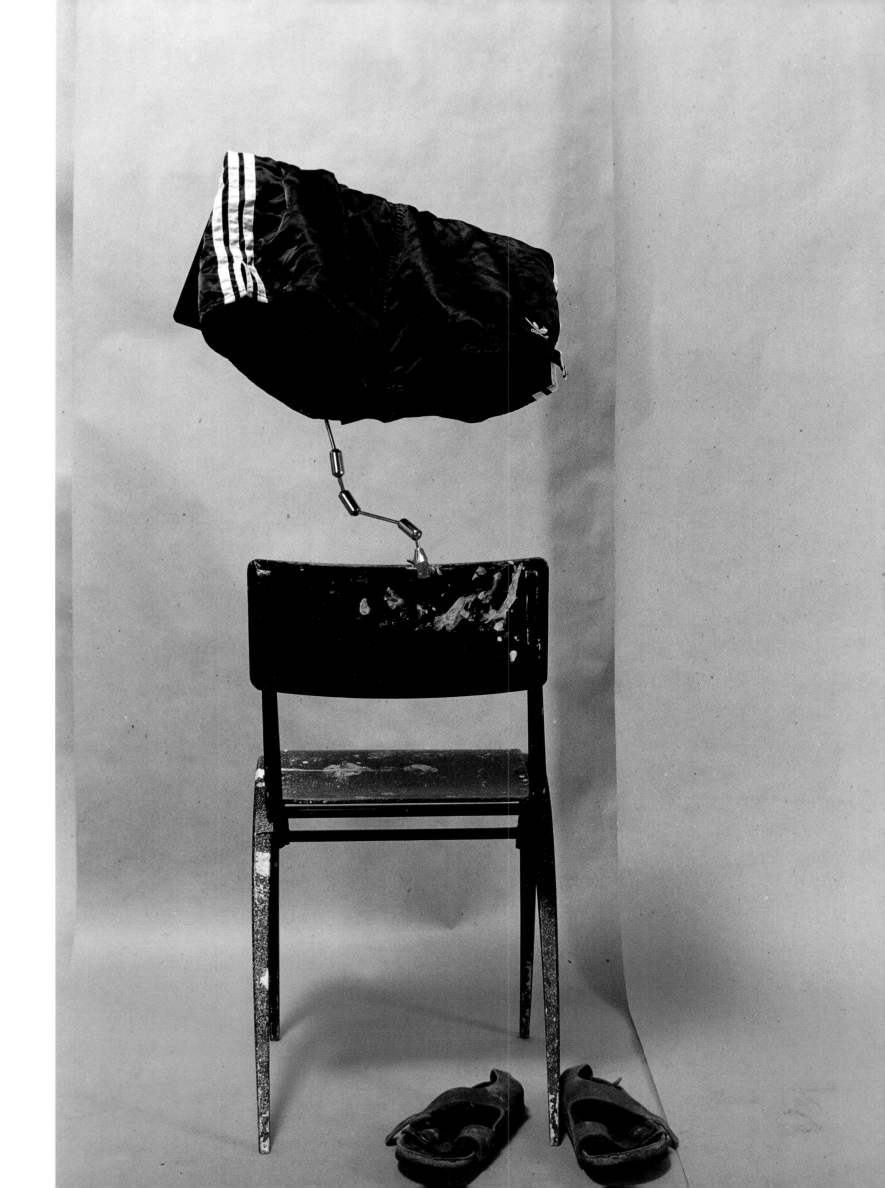

Piloten, 1993
Jeremy, 1993

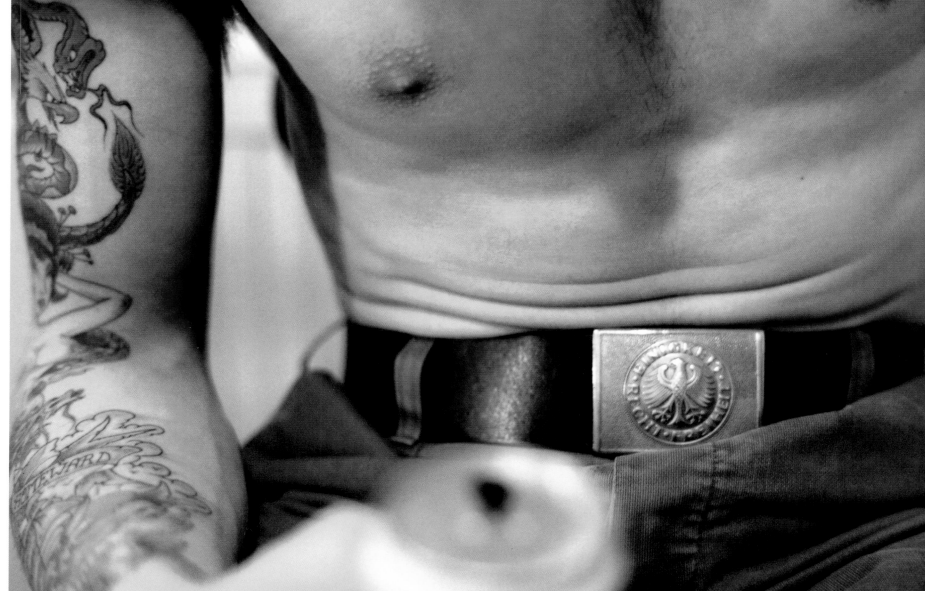

Jason in skatepipe, 1993

Macau Bridge, 1993

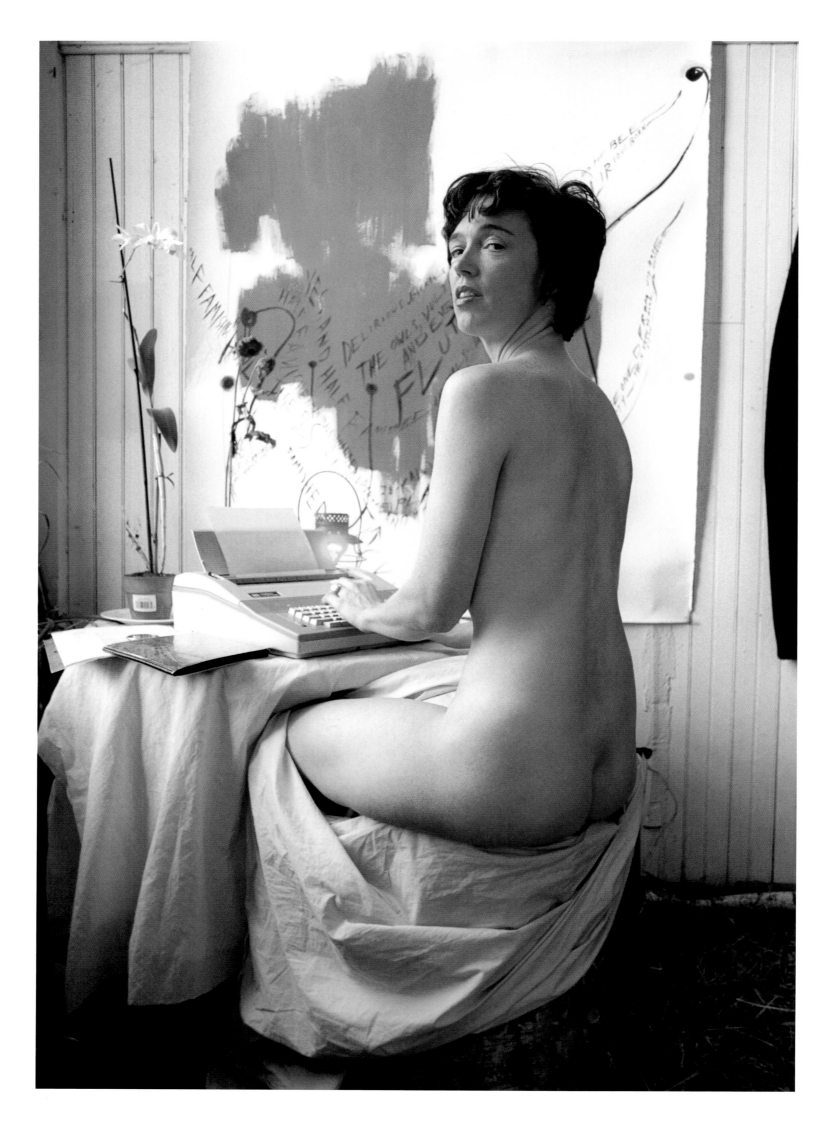

Paula with typewriter, 1994

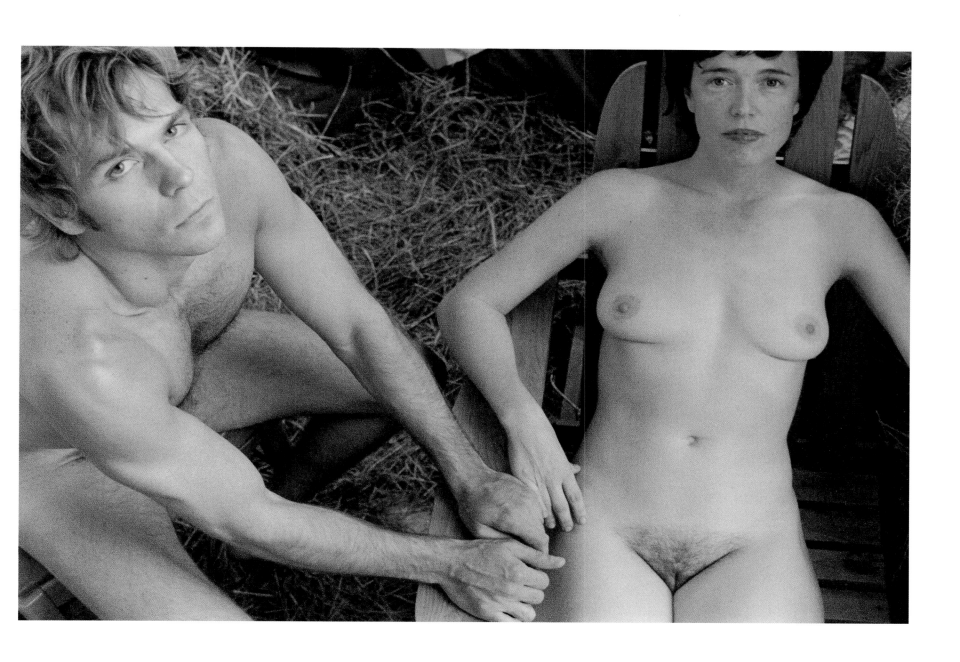

John & Paula, hay, CX 1000, 1994

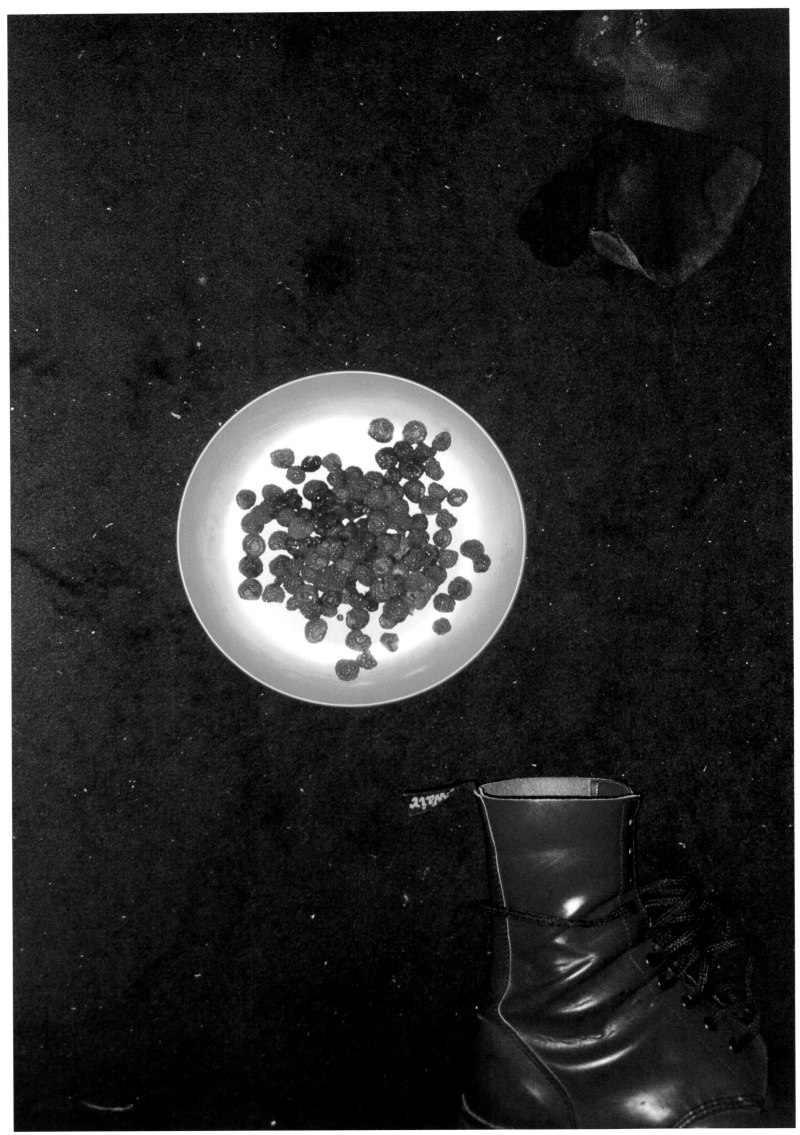

raspberries & boot, 1994

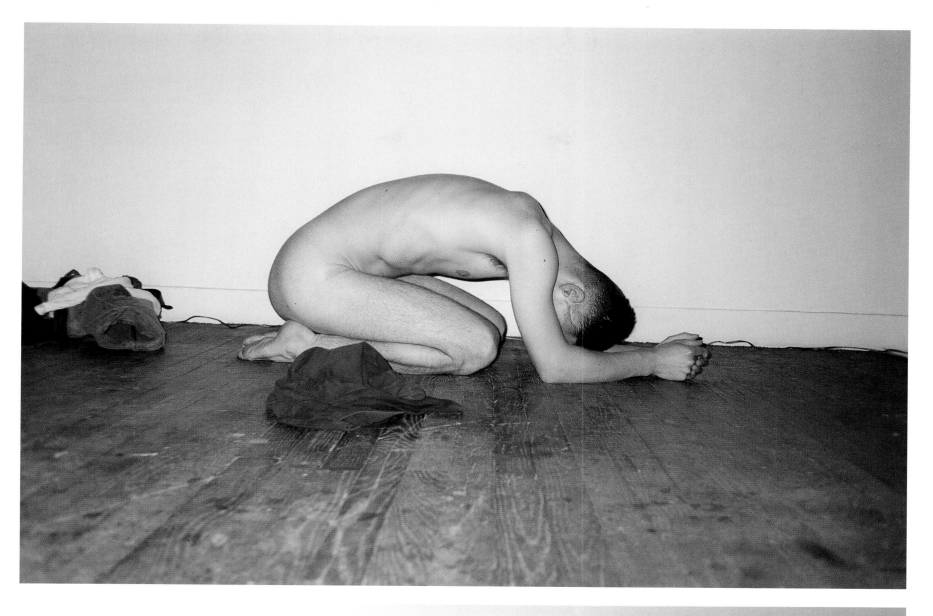

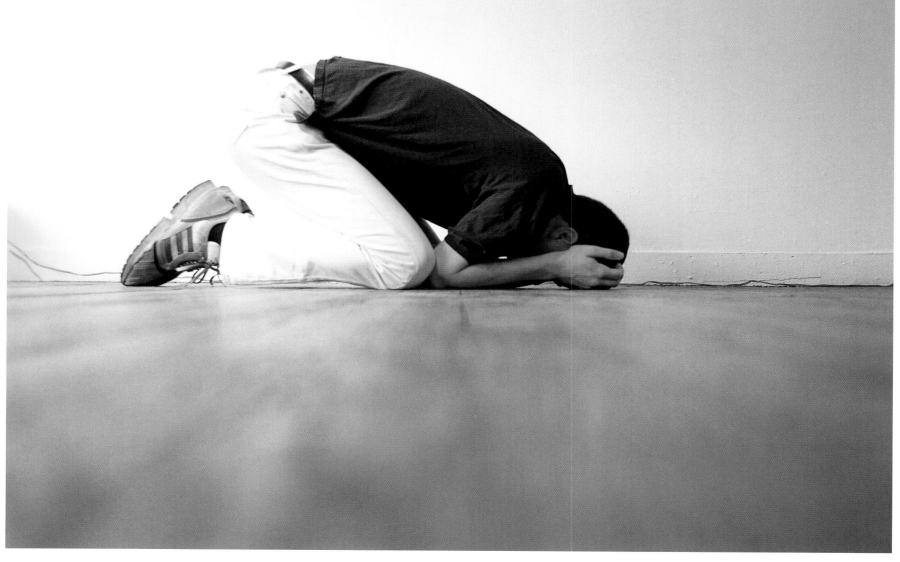

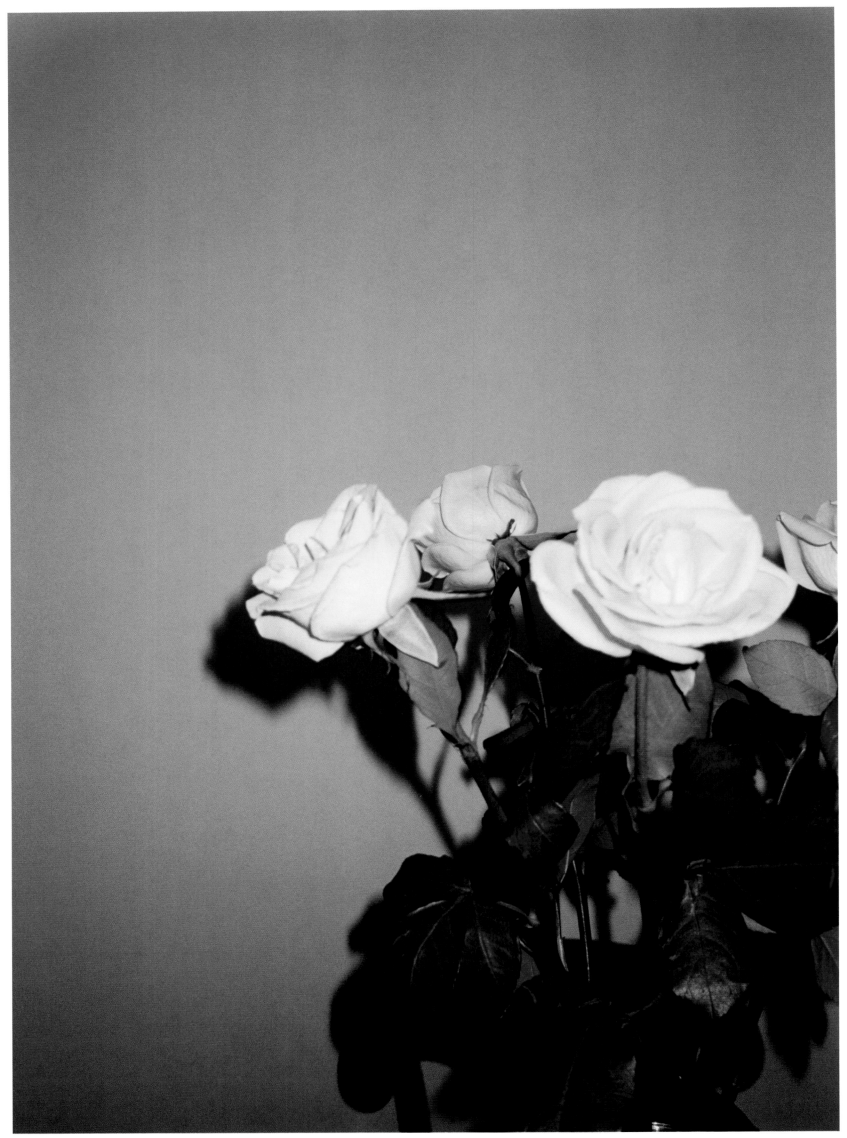

Rosen, 1994

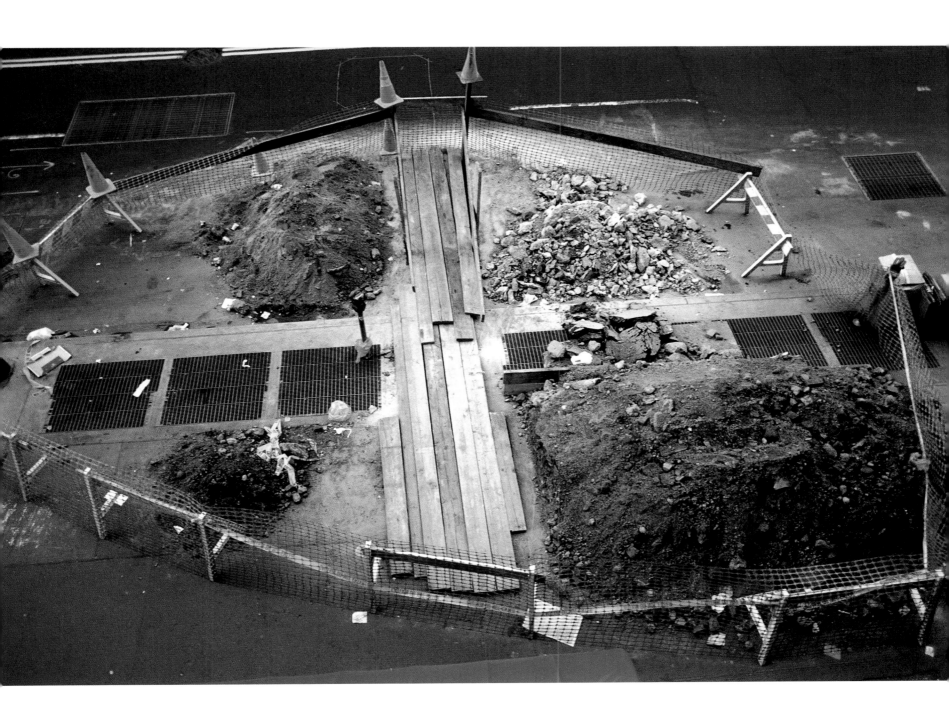

adworks, 1995

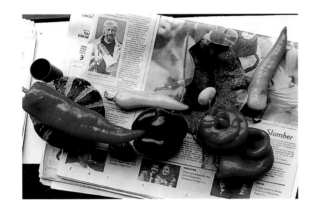

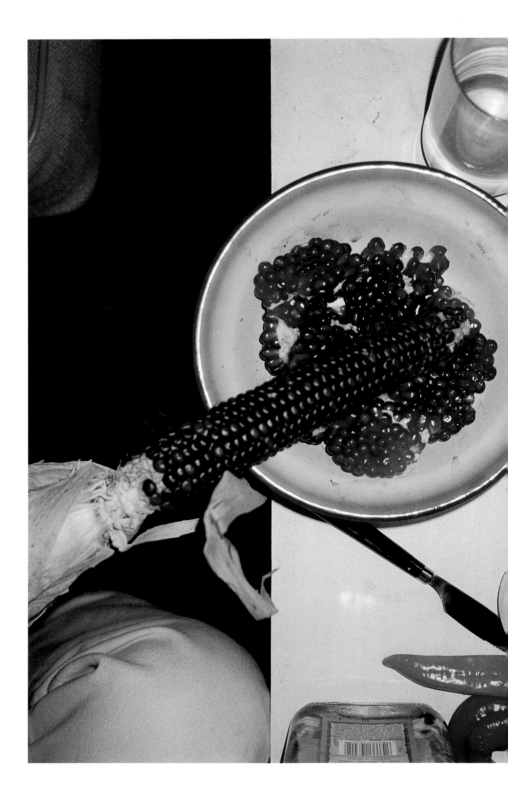

Peppers, 1994 indian corn & pomme granate, 1994

Police helicopter, 1995

Isa dancing, 1995

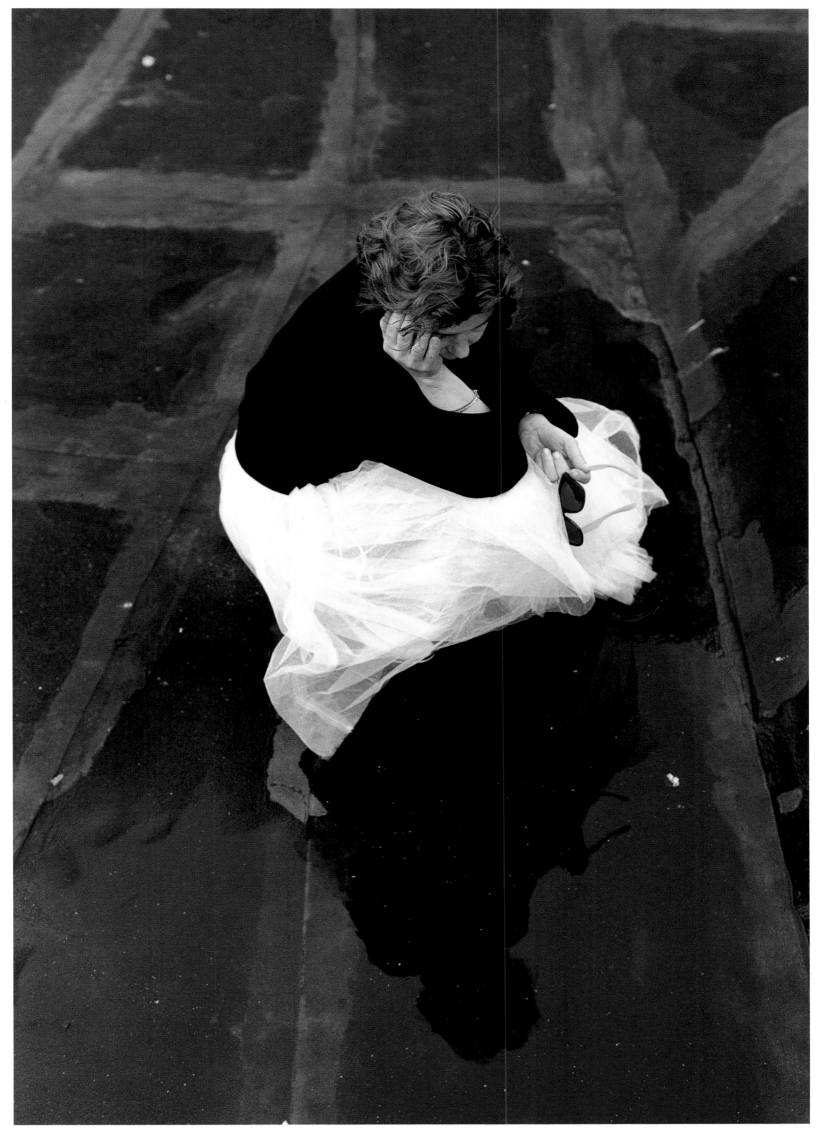

sa with pool of water, 1995

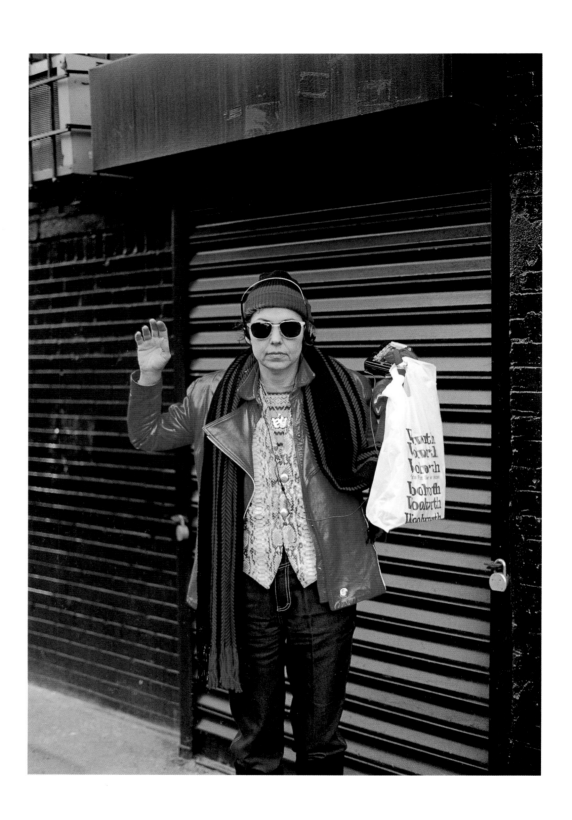

Isa vor Sound Factory, 1995

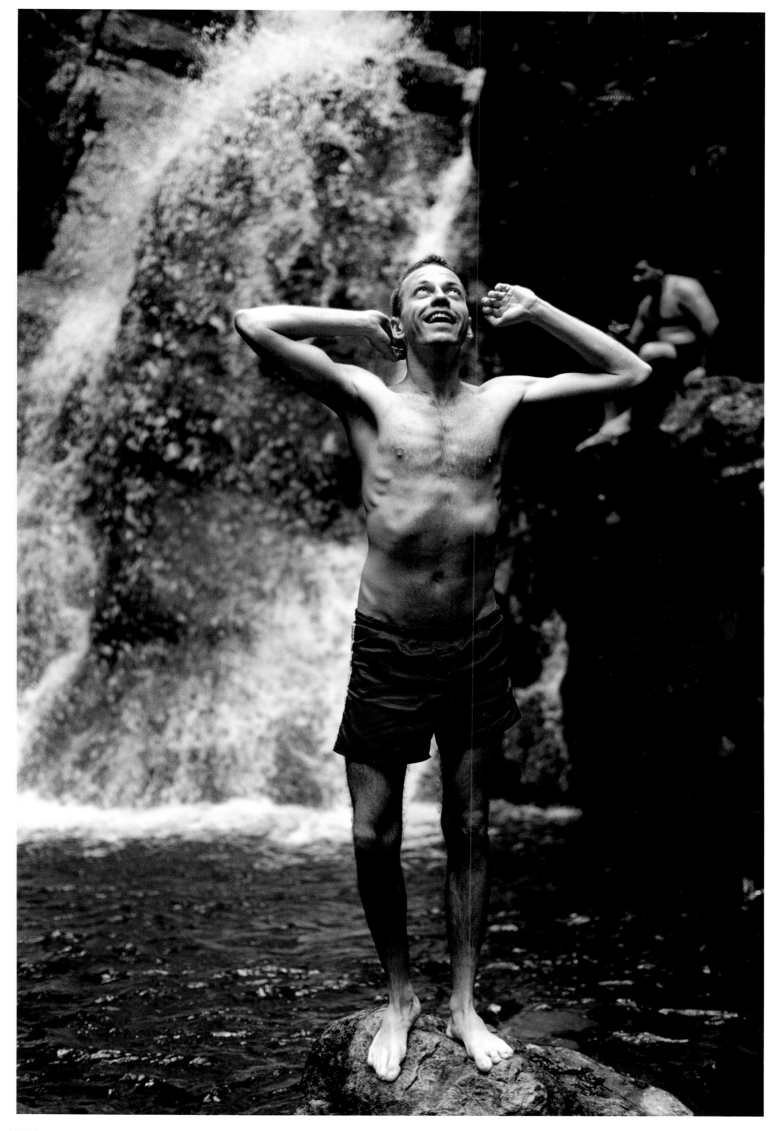

Haselmaus, 1995

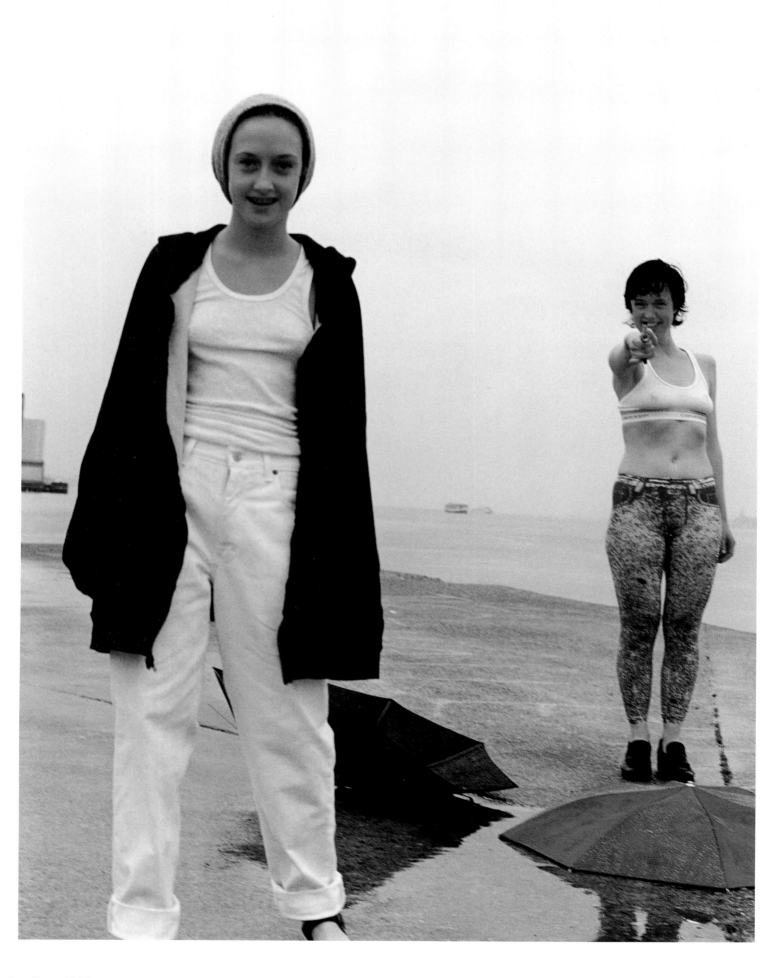

Rylan & Paula shooting, 1995

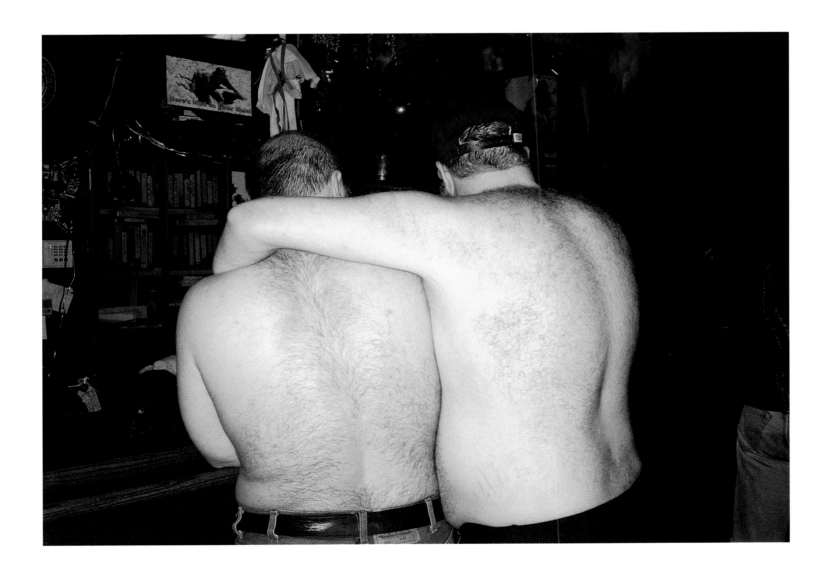

Hole In The Wall, 1995

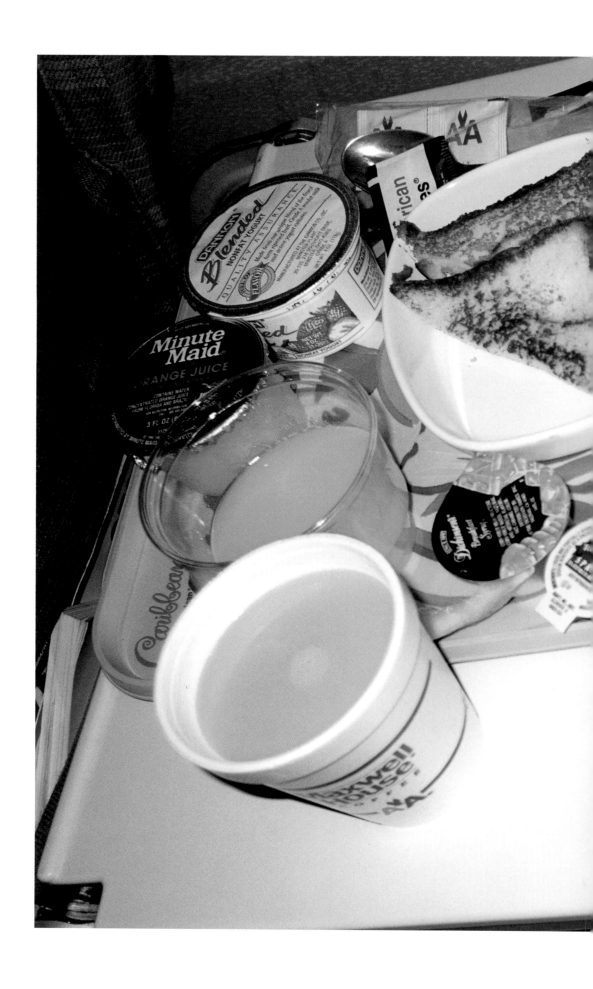

AA Breakfast, 1995

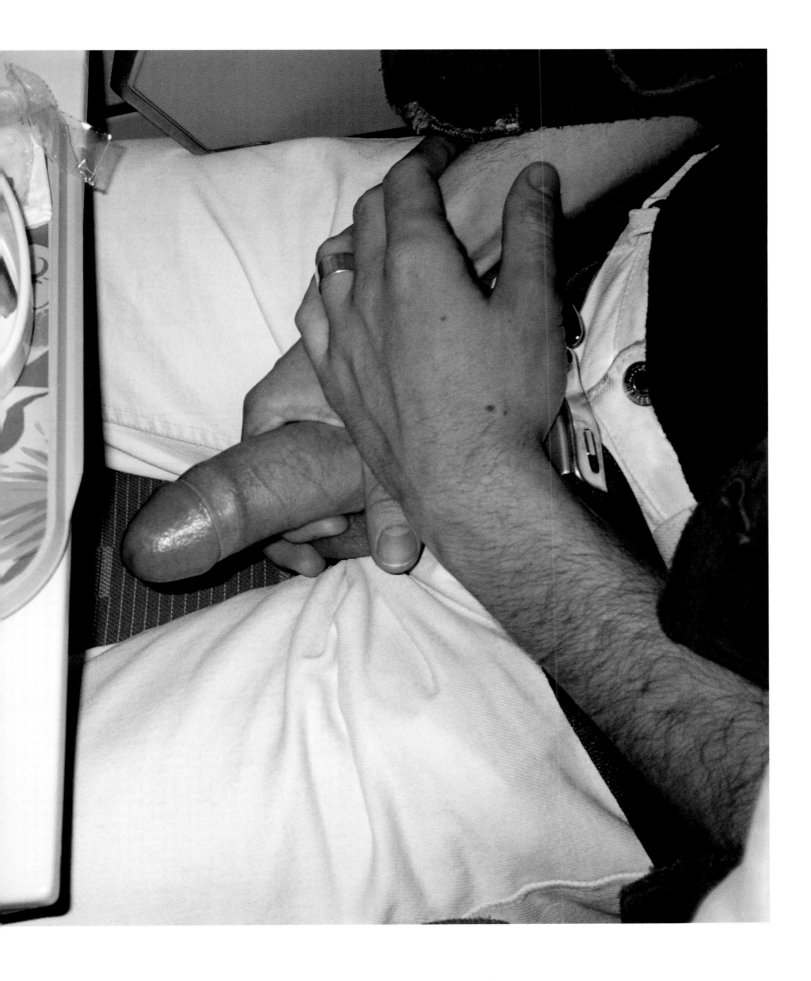

Leaf, 1995

moonrise, Puerto Rico, 1995 →

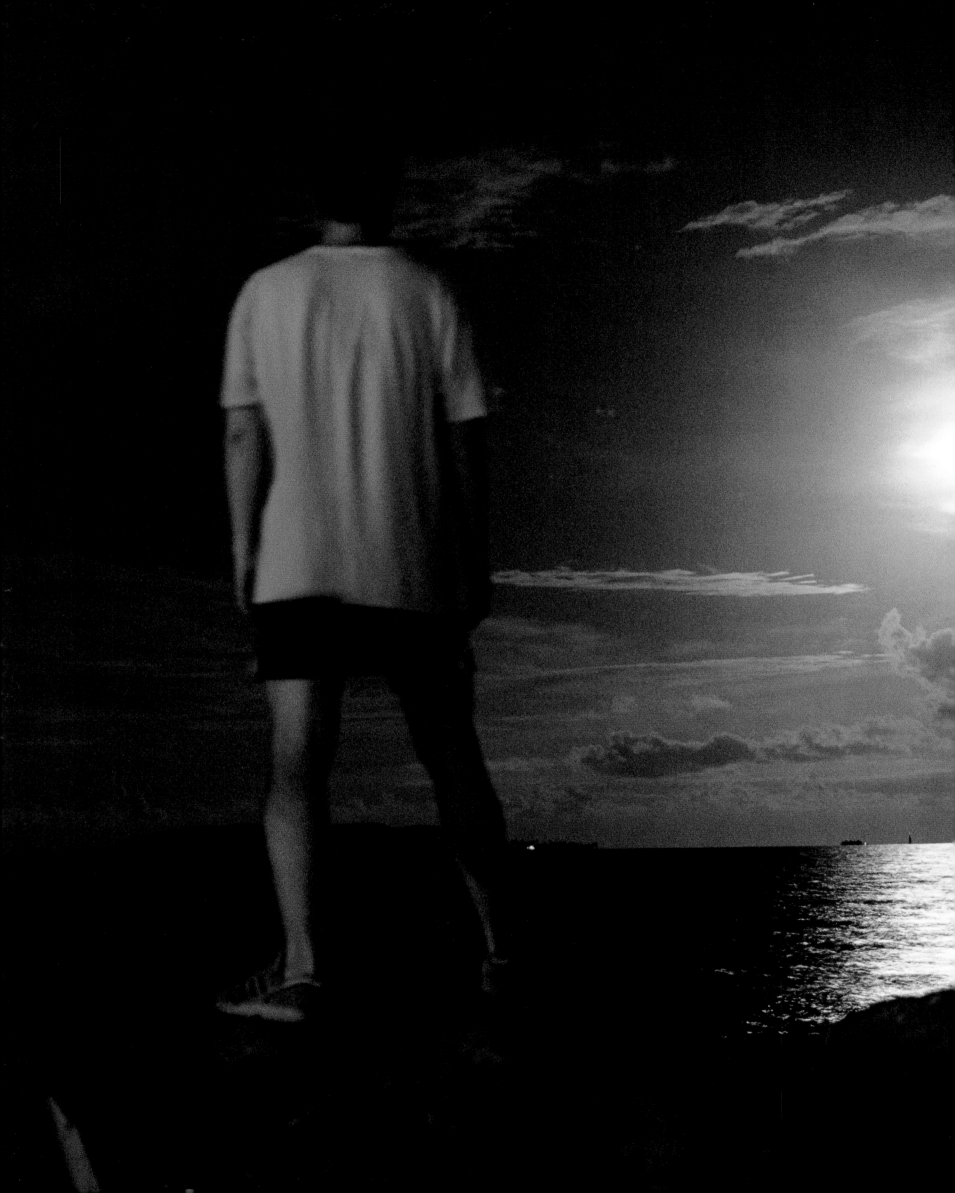

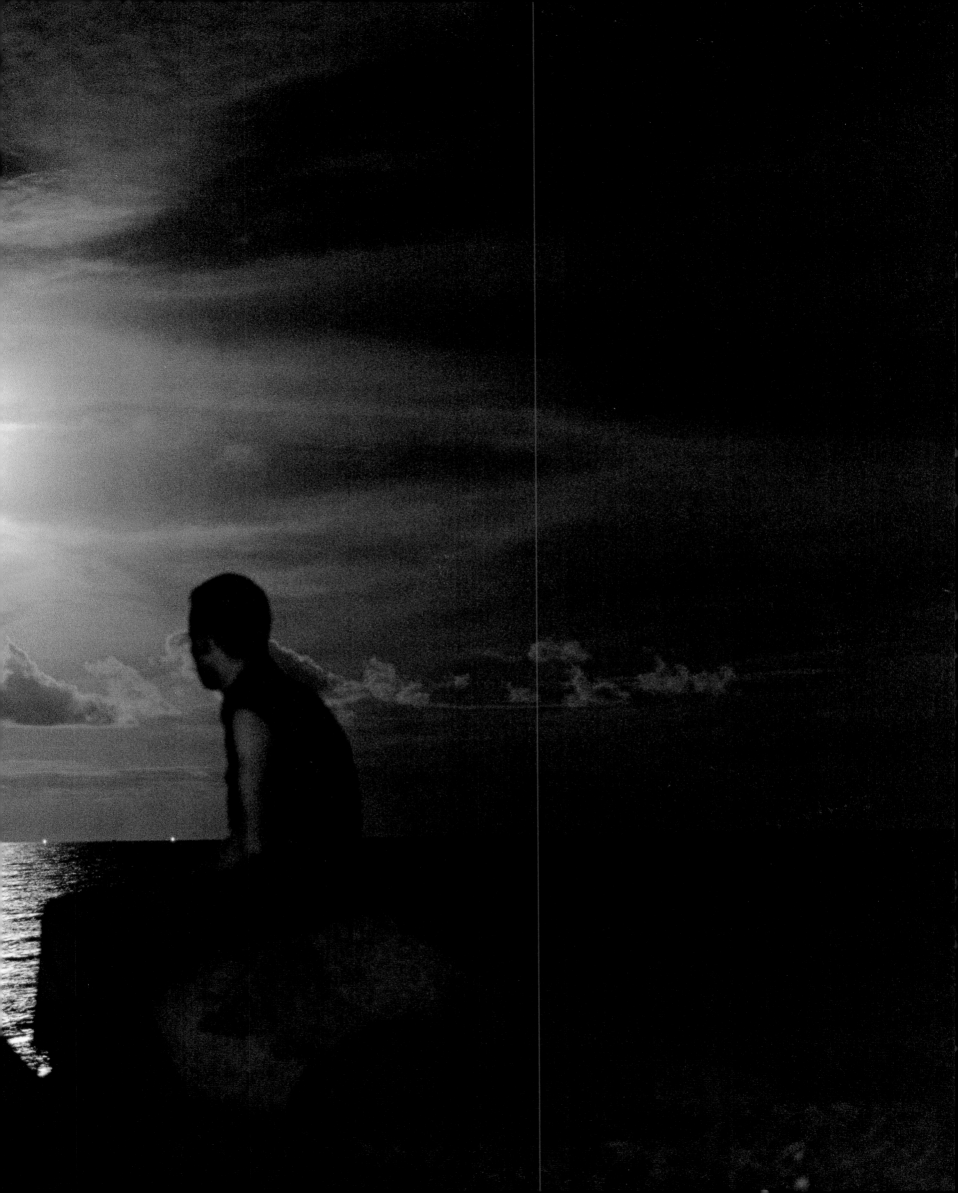

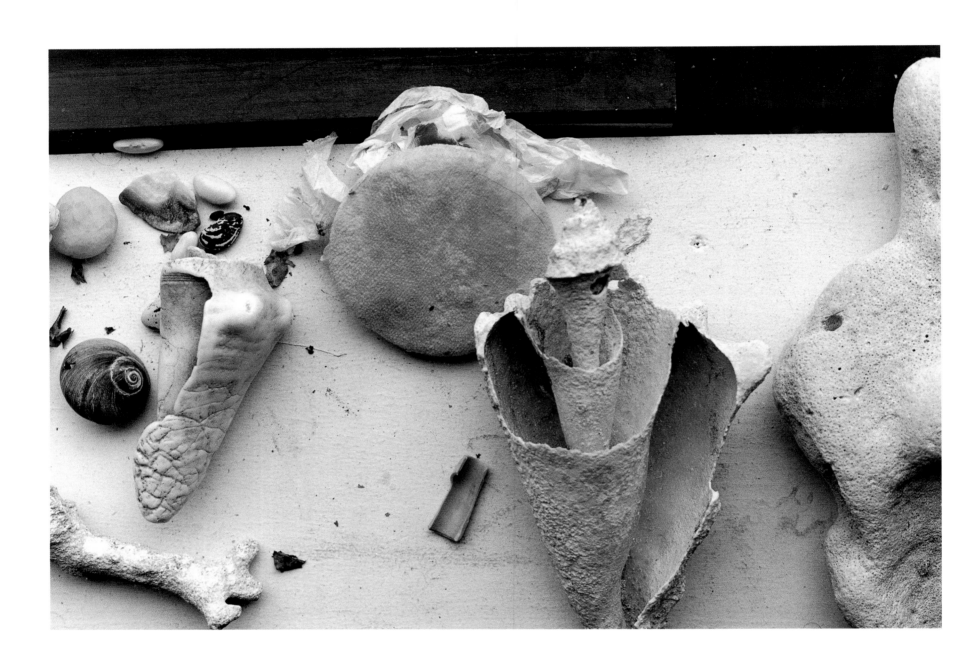

Shells, 1995

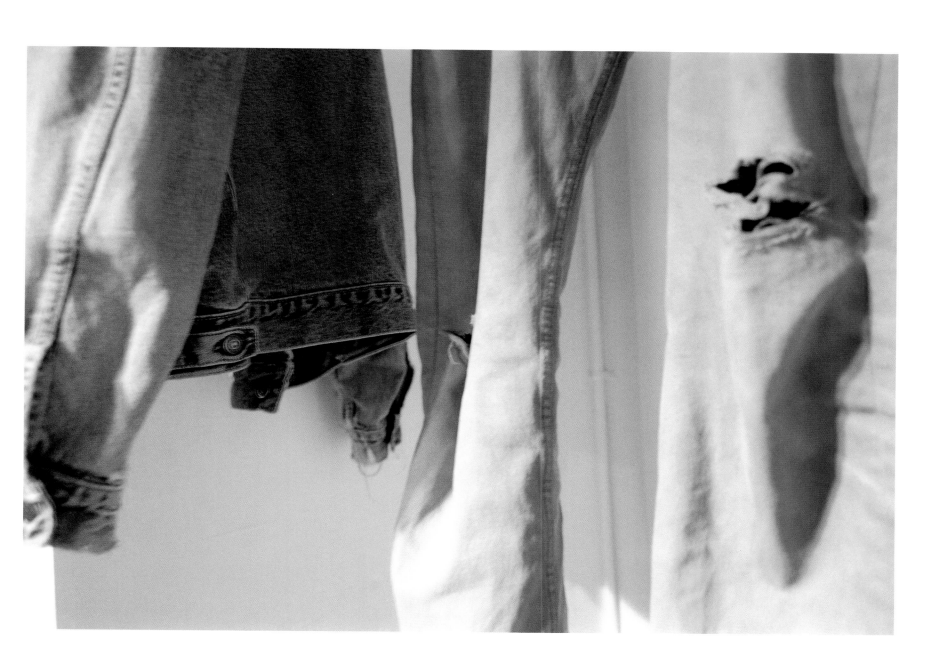

blue jacket, grey jeans, 1995

Liv Tyler, 199

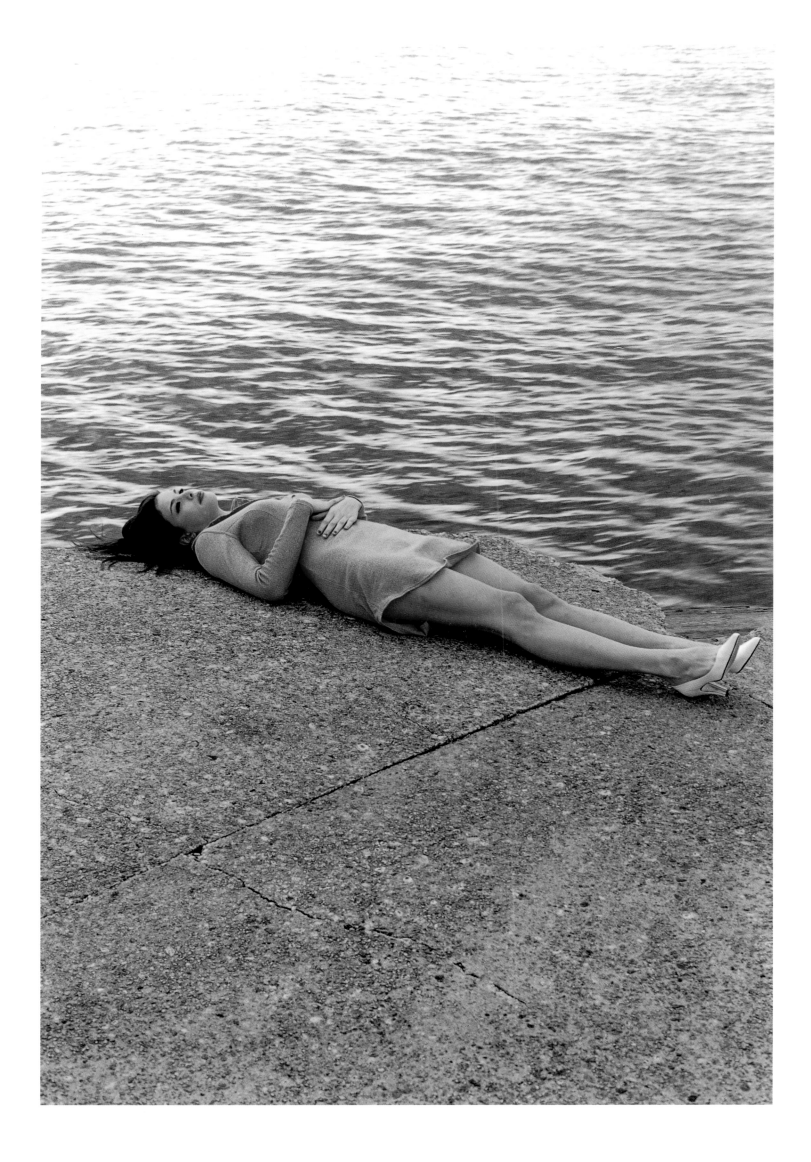

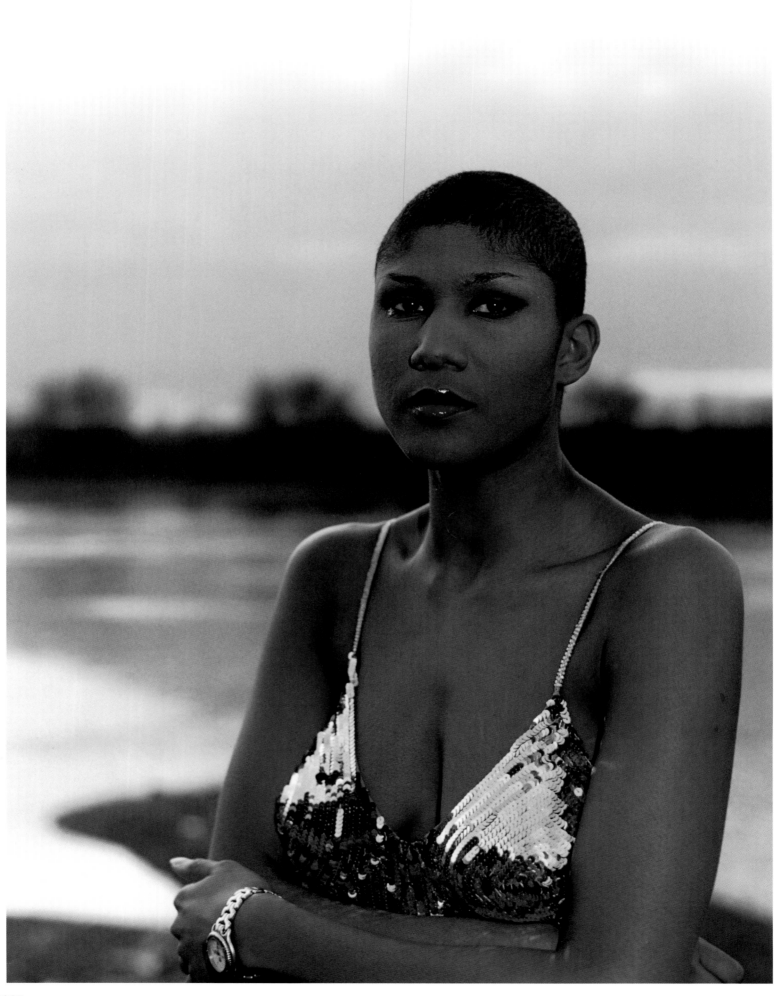

Smokin' Jo, 1995

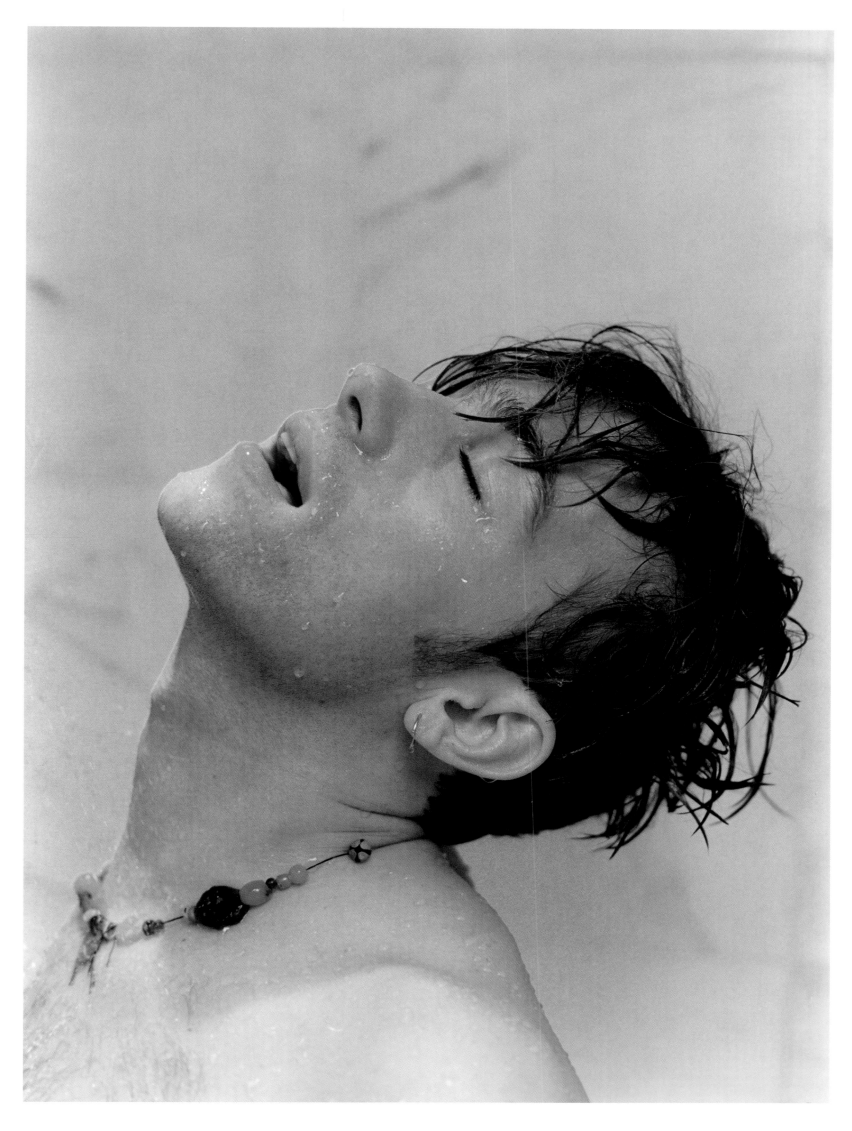

Damon, shower, head up, 1995

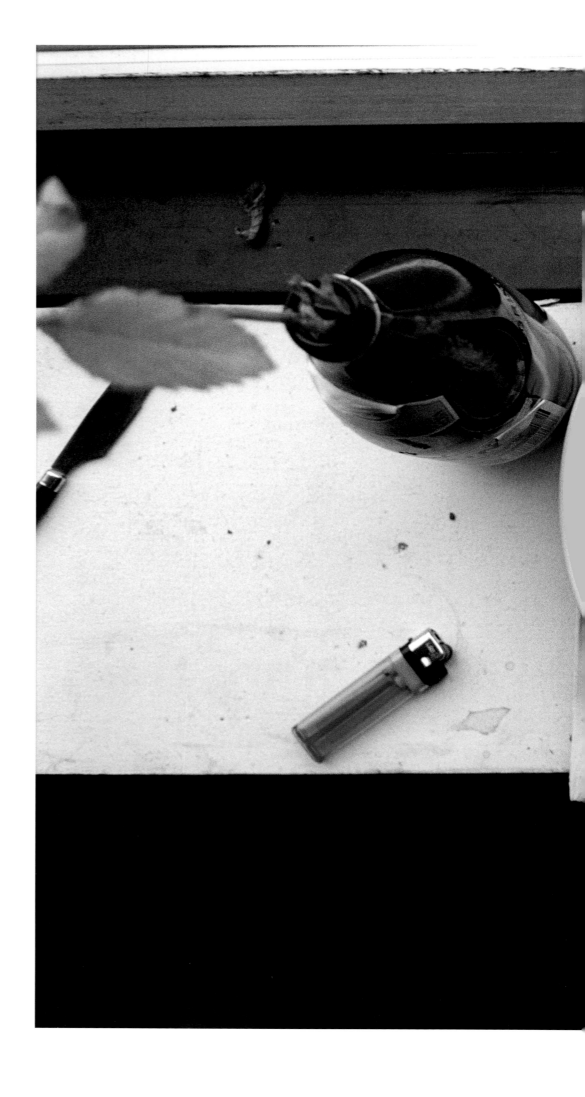

summer still life, 1995

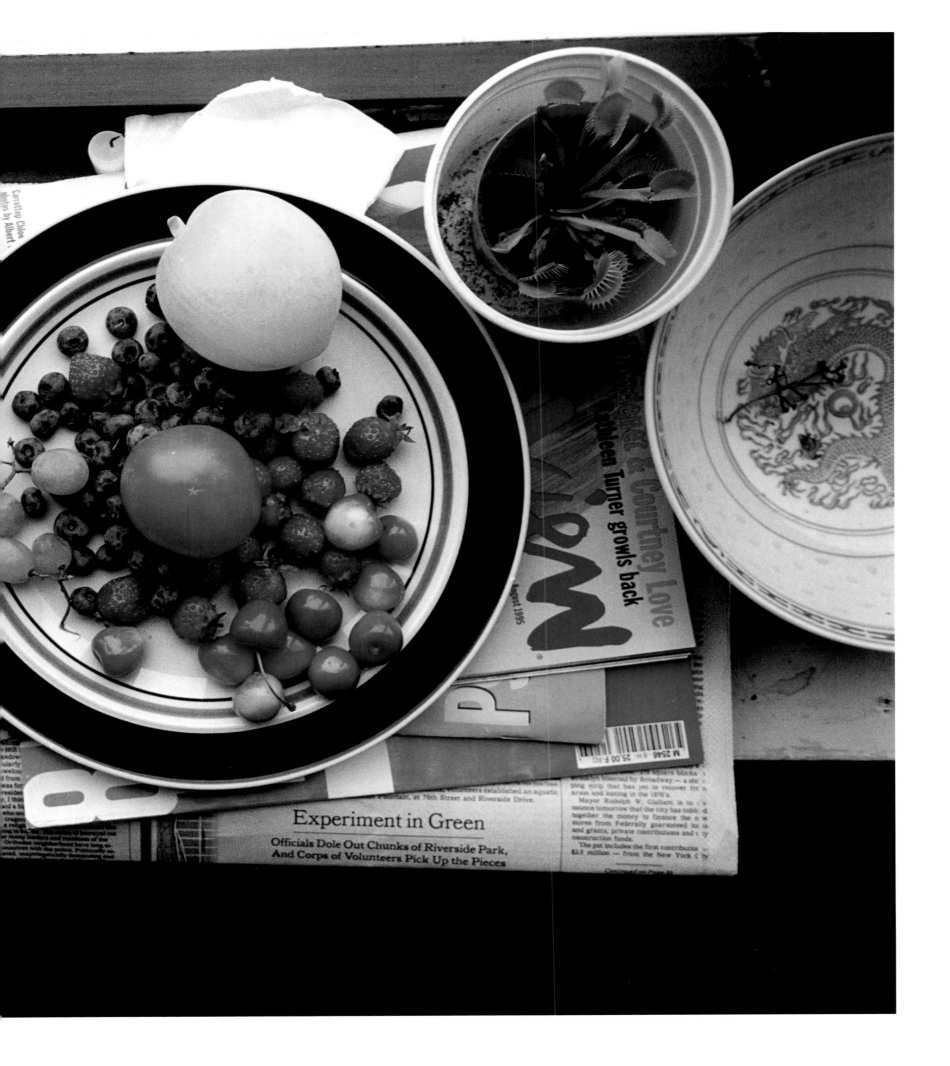

Deer Hirsch, 1995

Hallenbad Detail, 1995

Pumpkin, tomato & pomme granate, 1995

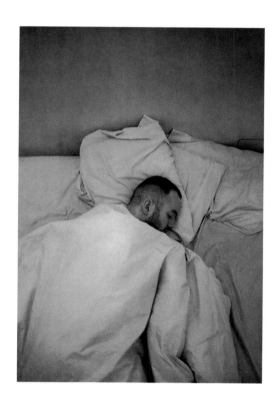

leep, 1995 Dachshund, 1995 Maus, 1997

still life, yellow tomatoes, 1995

boy with ball, 1995

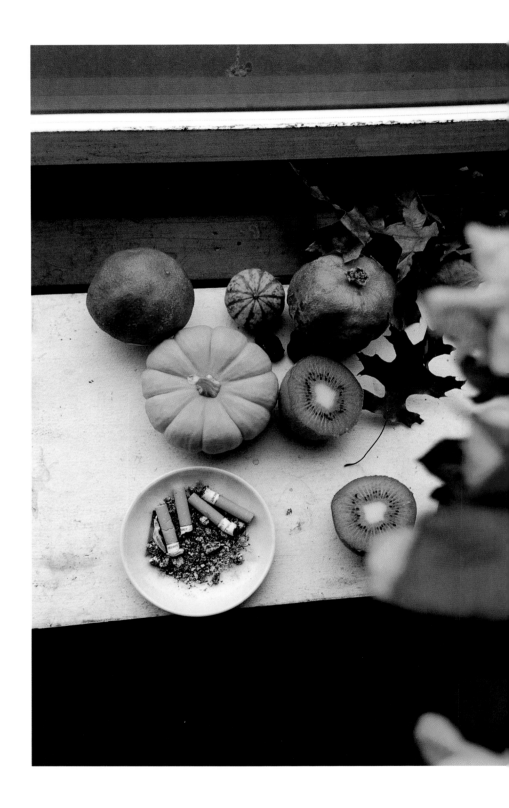

deranged granny, 1995 last still life, 1995

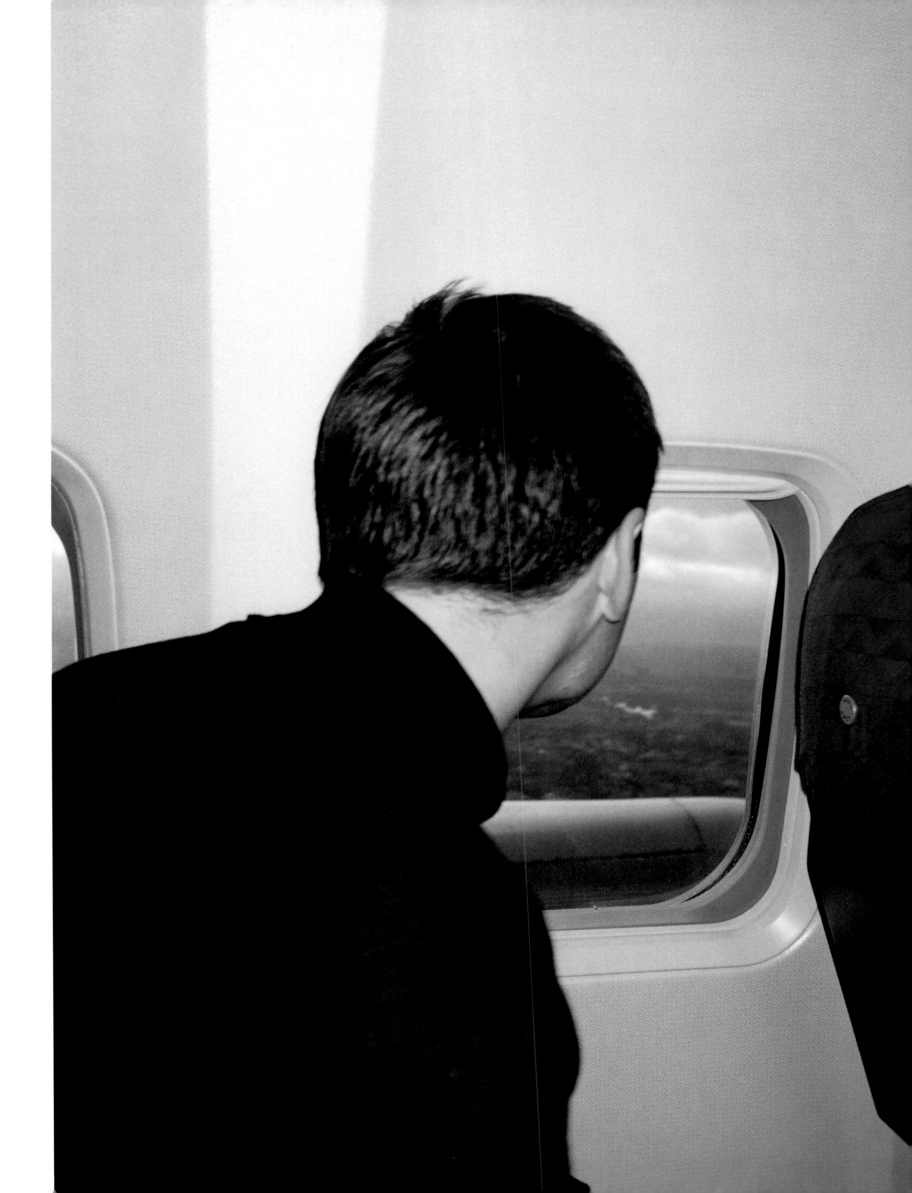

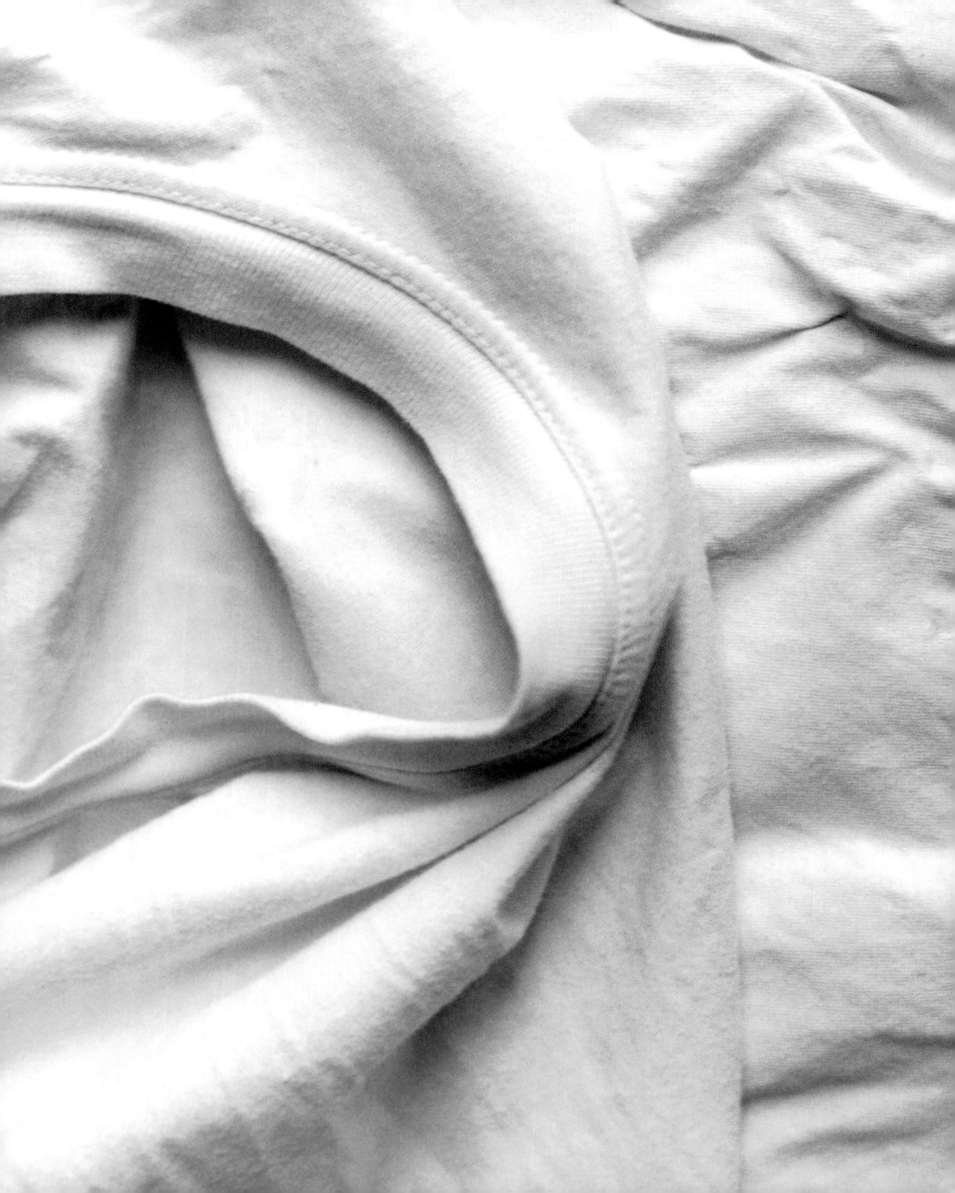

Sportflecken, 1996

Highway Bridges, 1996

Habakkuk & Cherubim, 1996 Space Between Two Buildings, 1996

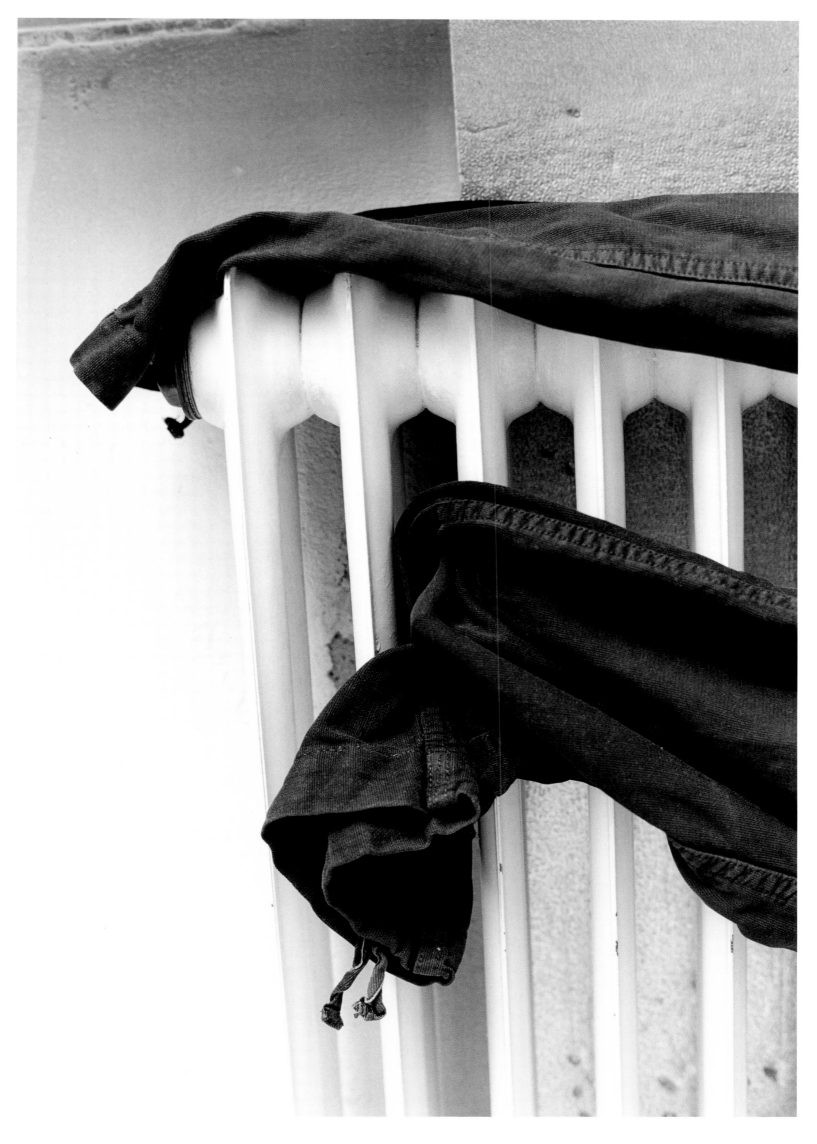

Faltenwurf (oliv), 1996

Arkadia I, 1996

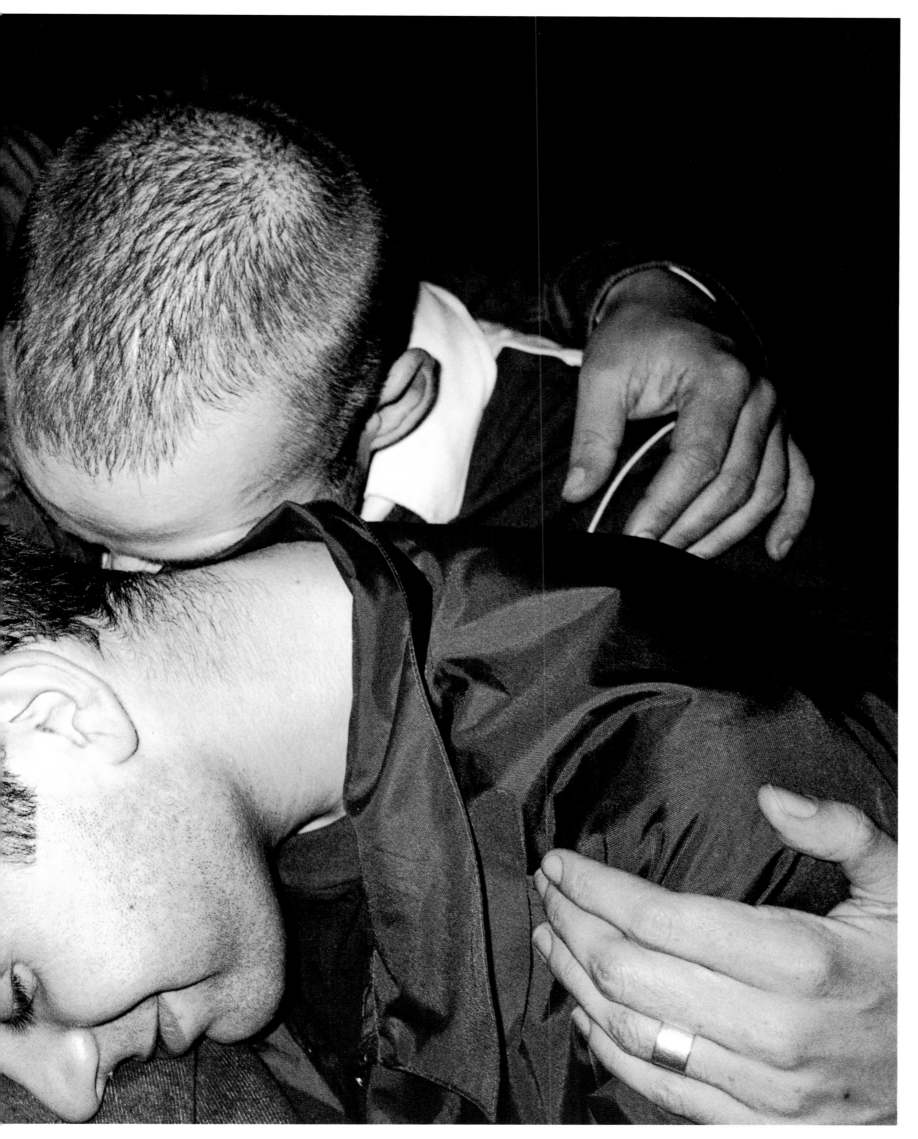

The Point II, 1996 →

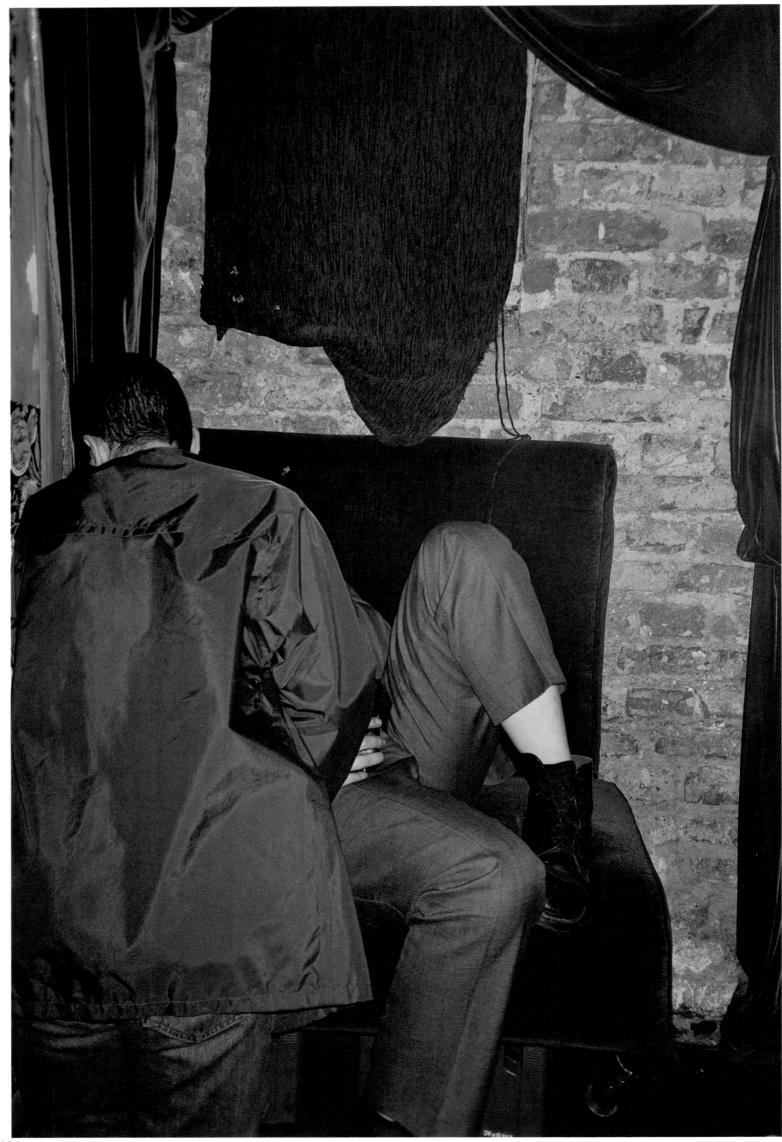

Arkadia III, 1996

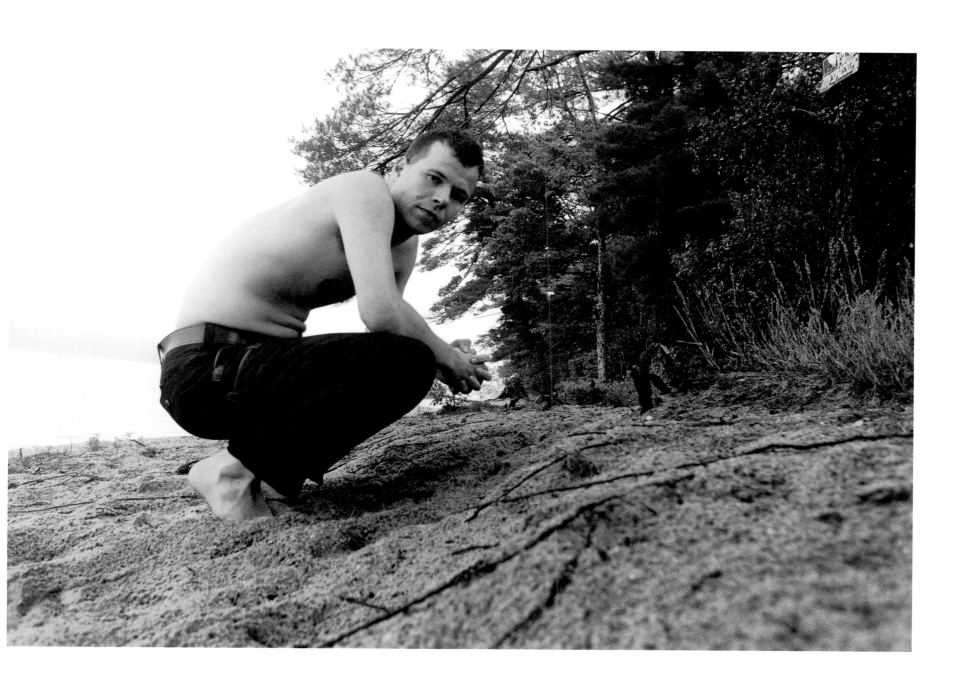

he Point III, 1996

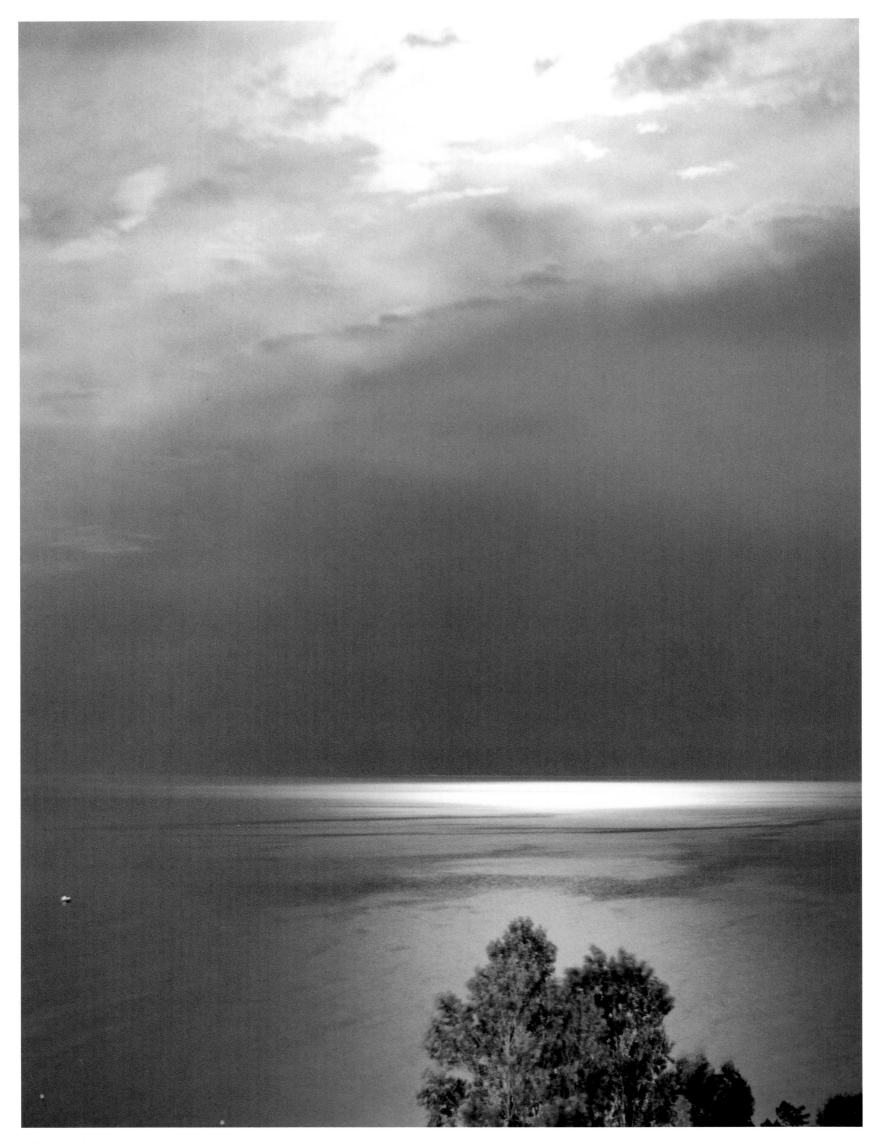

Port La Galère, 1996

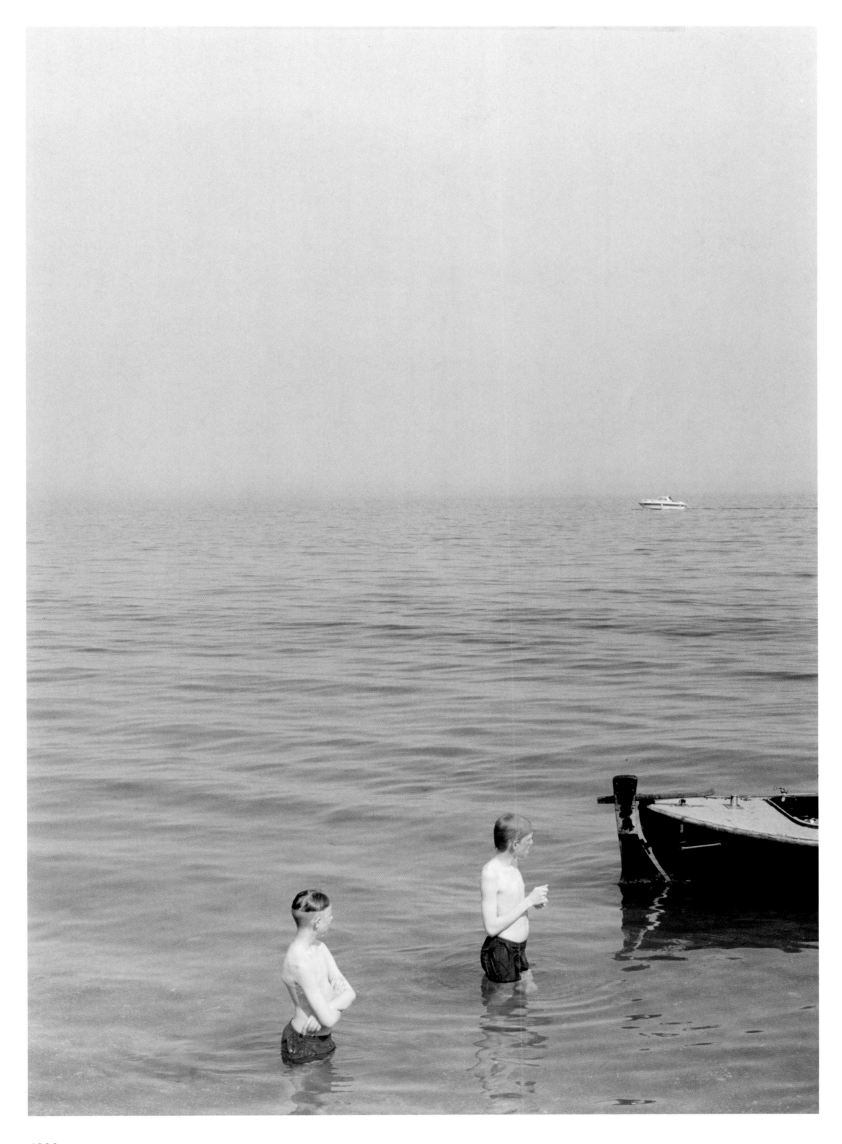

Louisiana, 1996

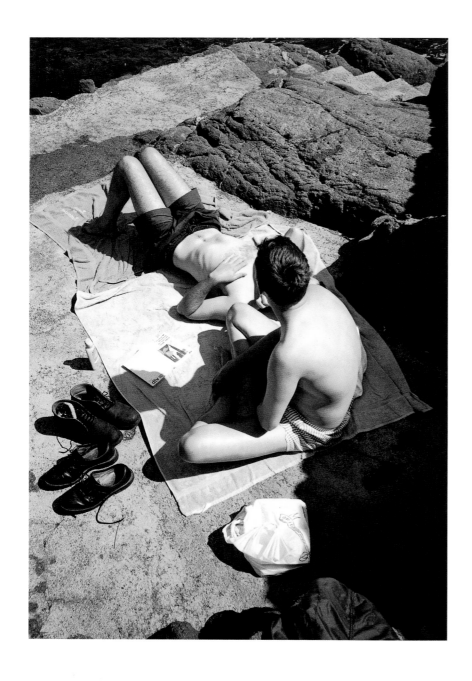

Christopher & Daniel, 1996 Pride, 1996

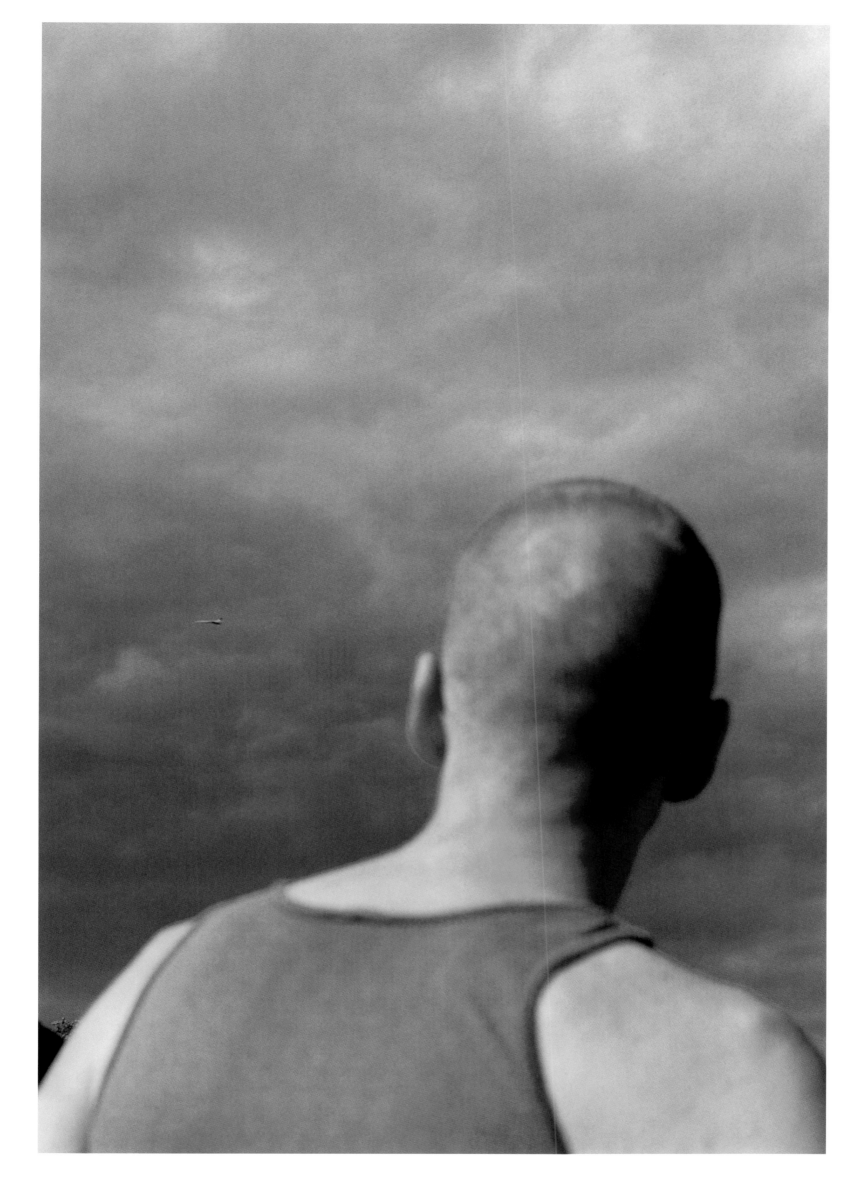

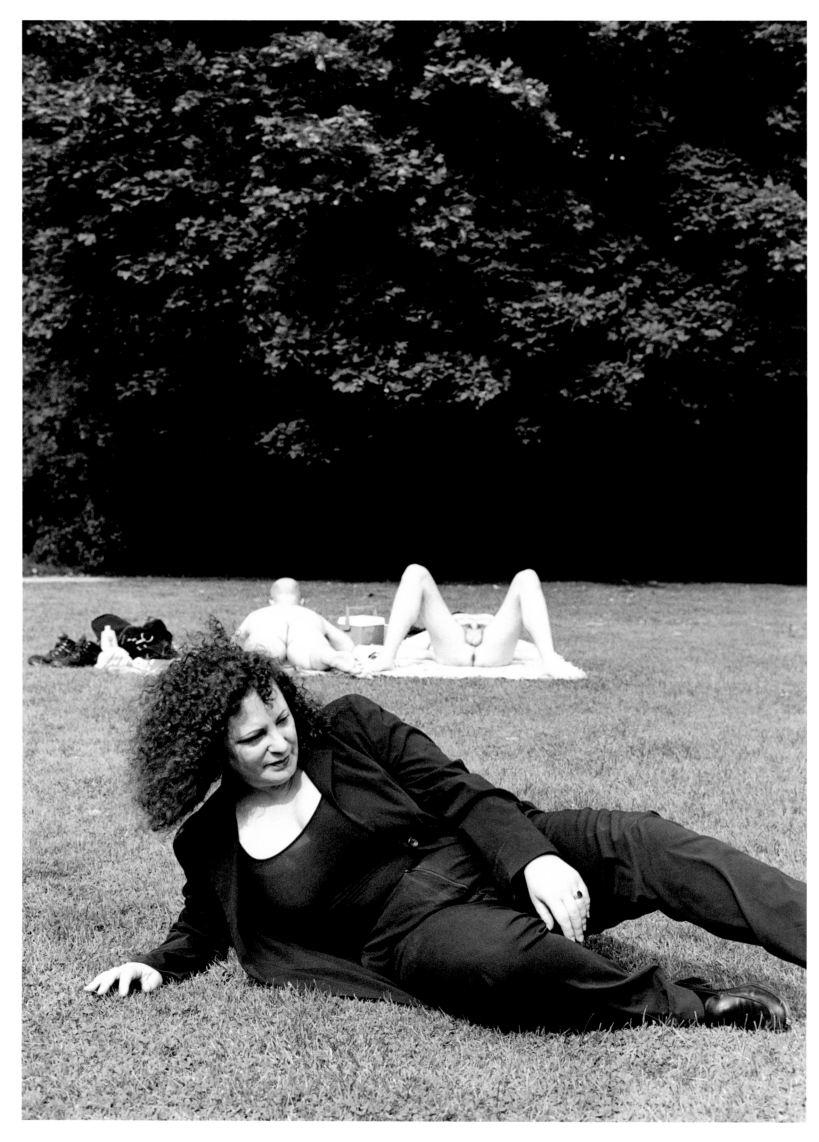

Nan reclining, 1996

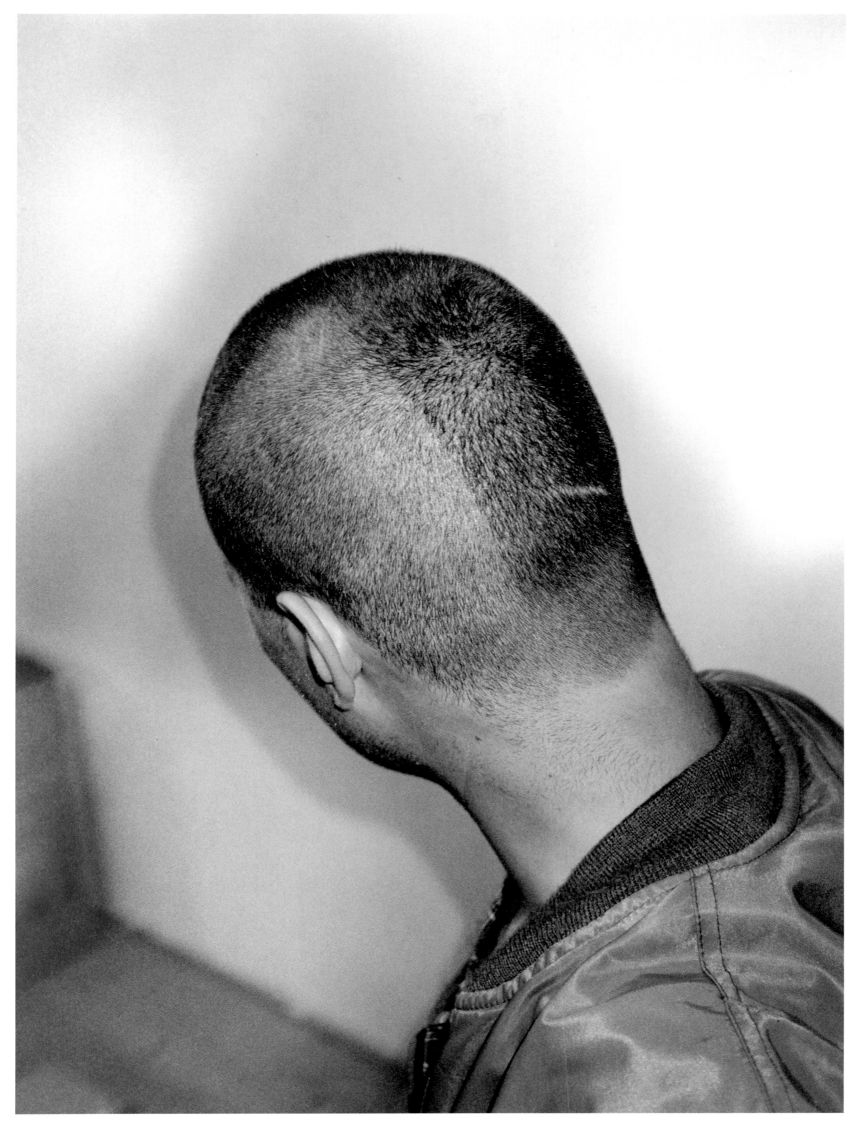

After Warriors, 1996

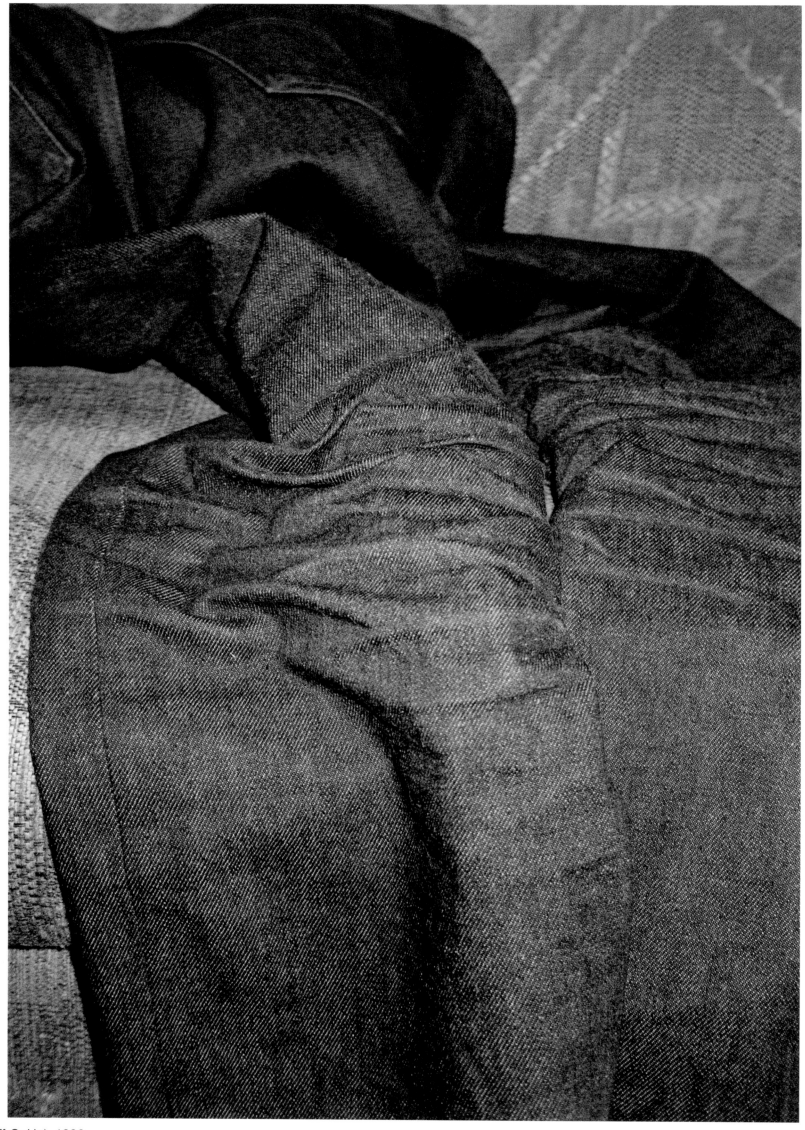

Faltenwurf (off-SoHo), 1996

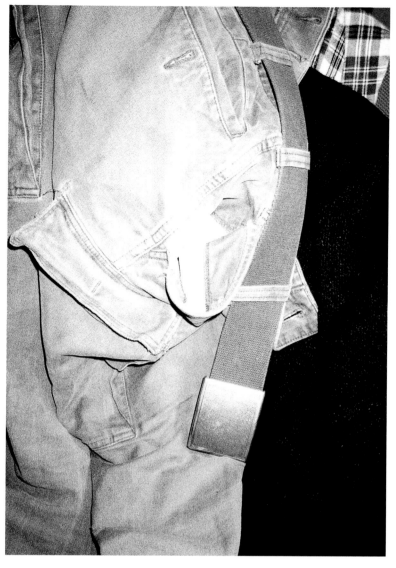
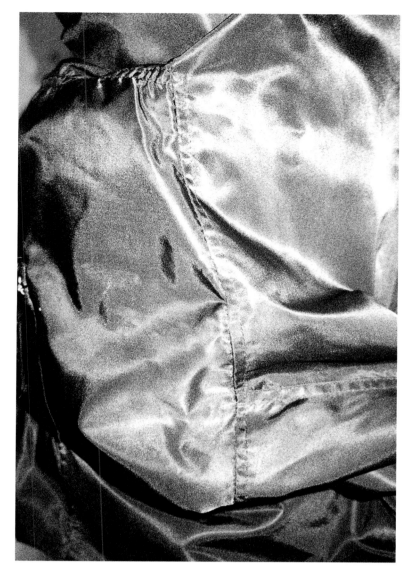
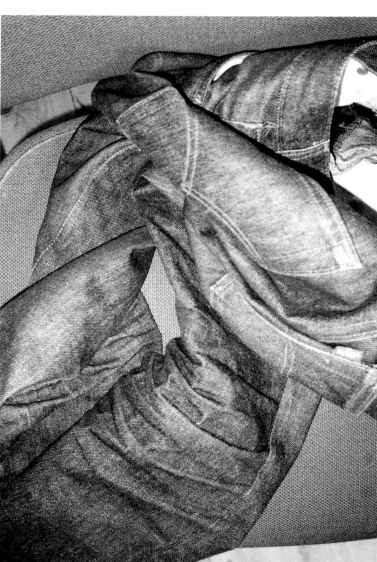

altenwurf New Inn Yard I-III, 1996 Ciel Rouge, 1996

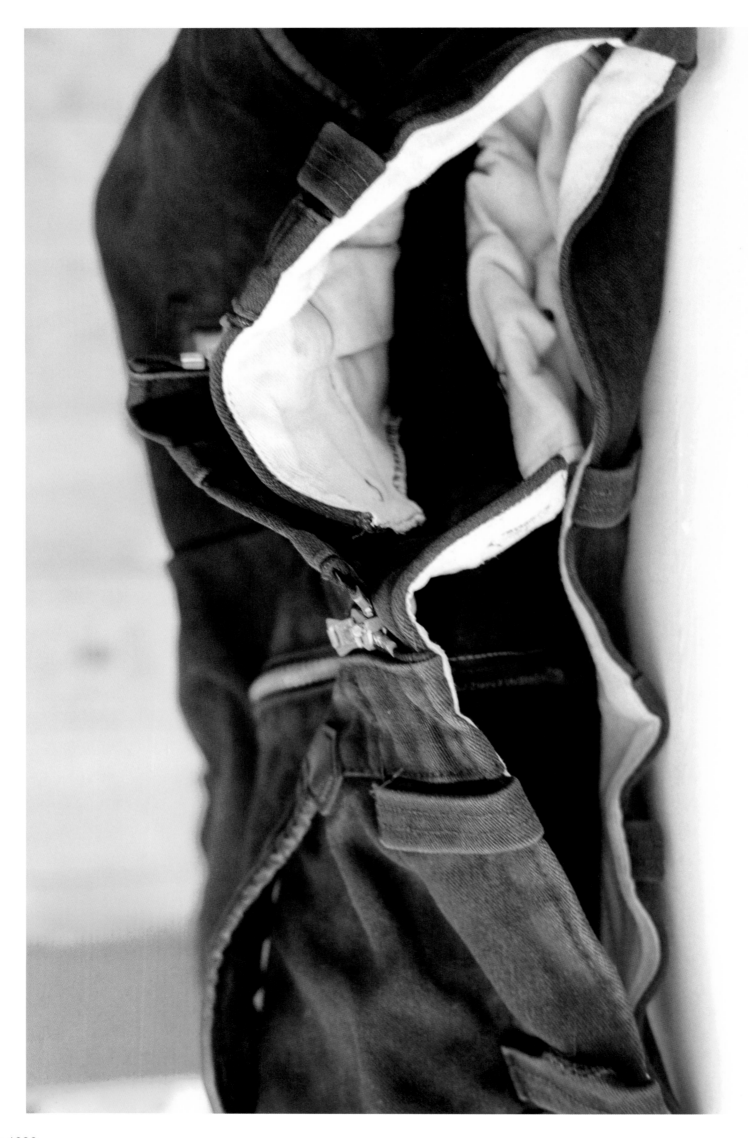

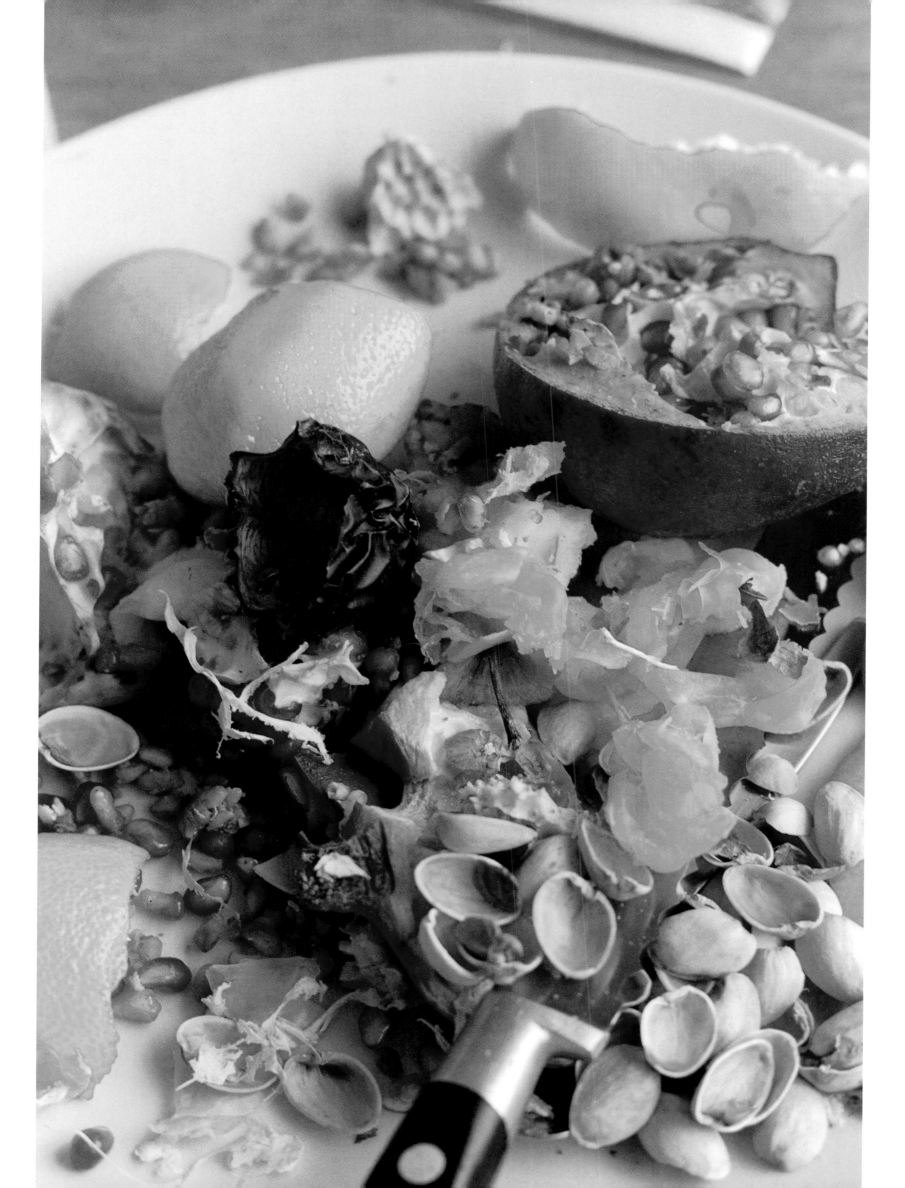

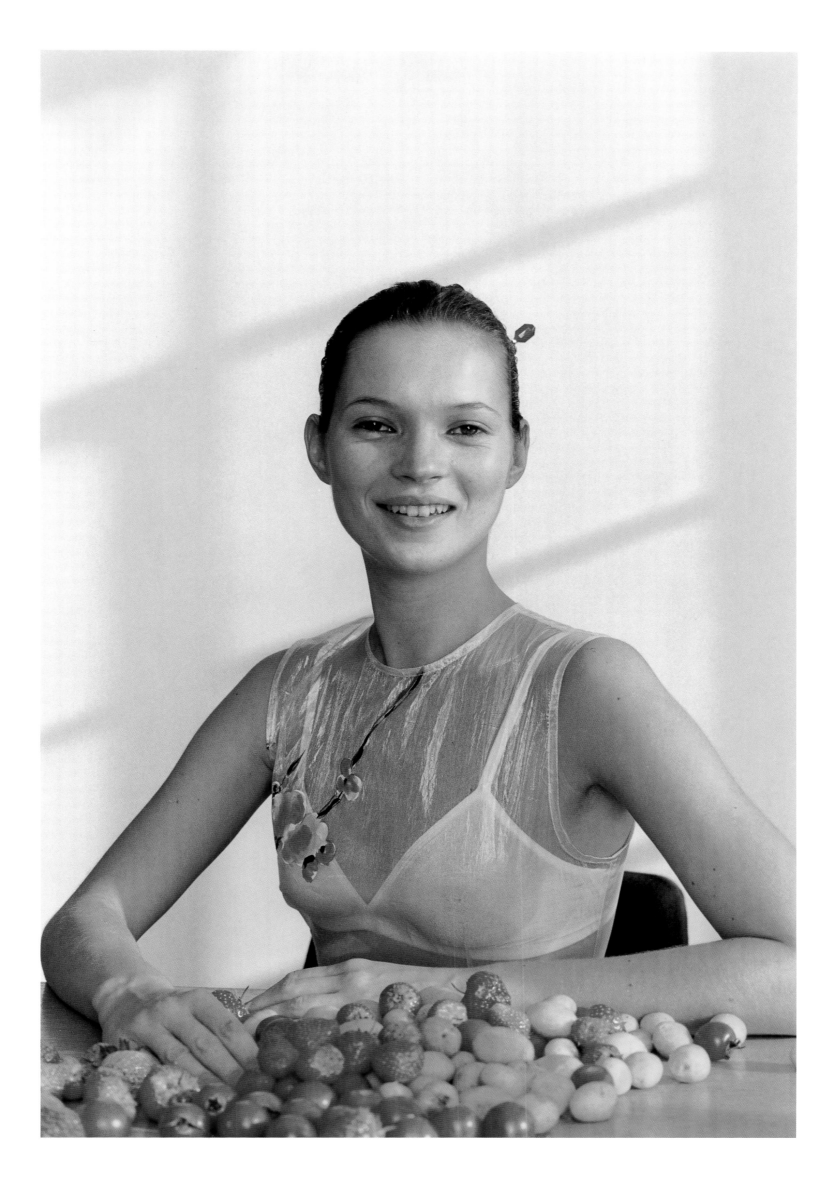

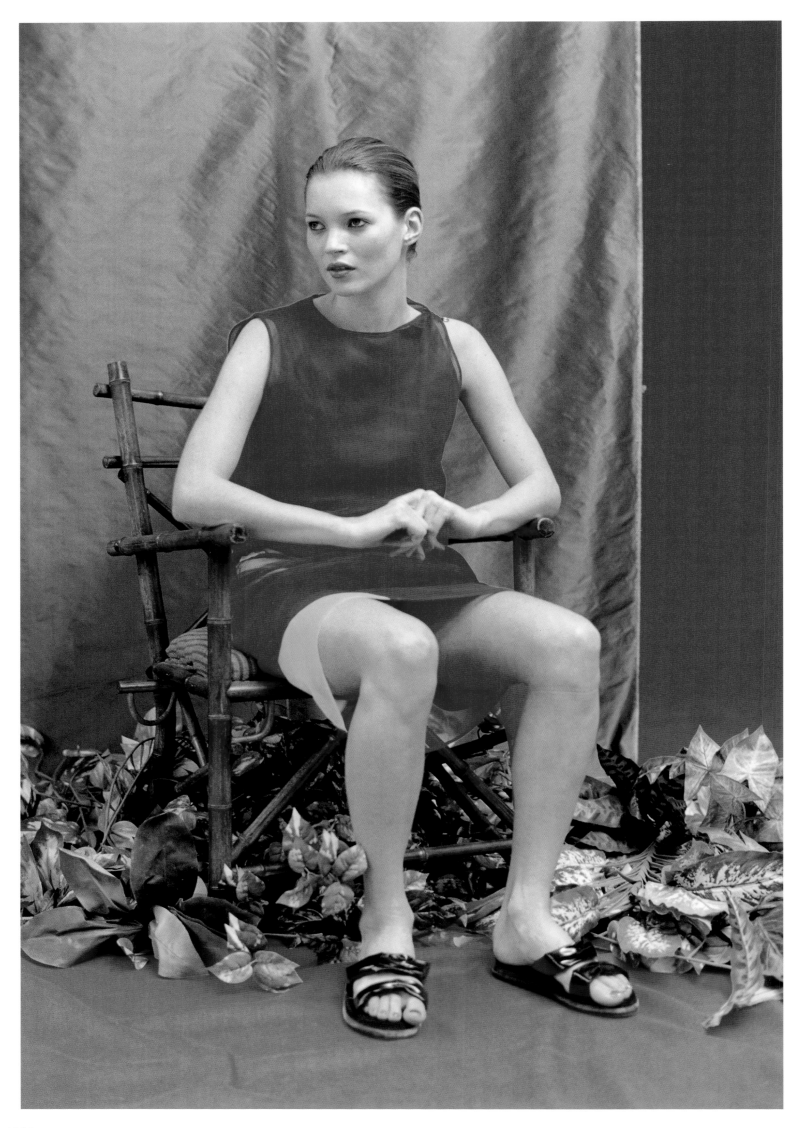

Kate sitting, 1996

Kate with tree, 1996

The London Apprentice, 1996 →

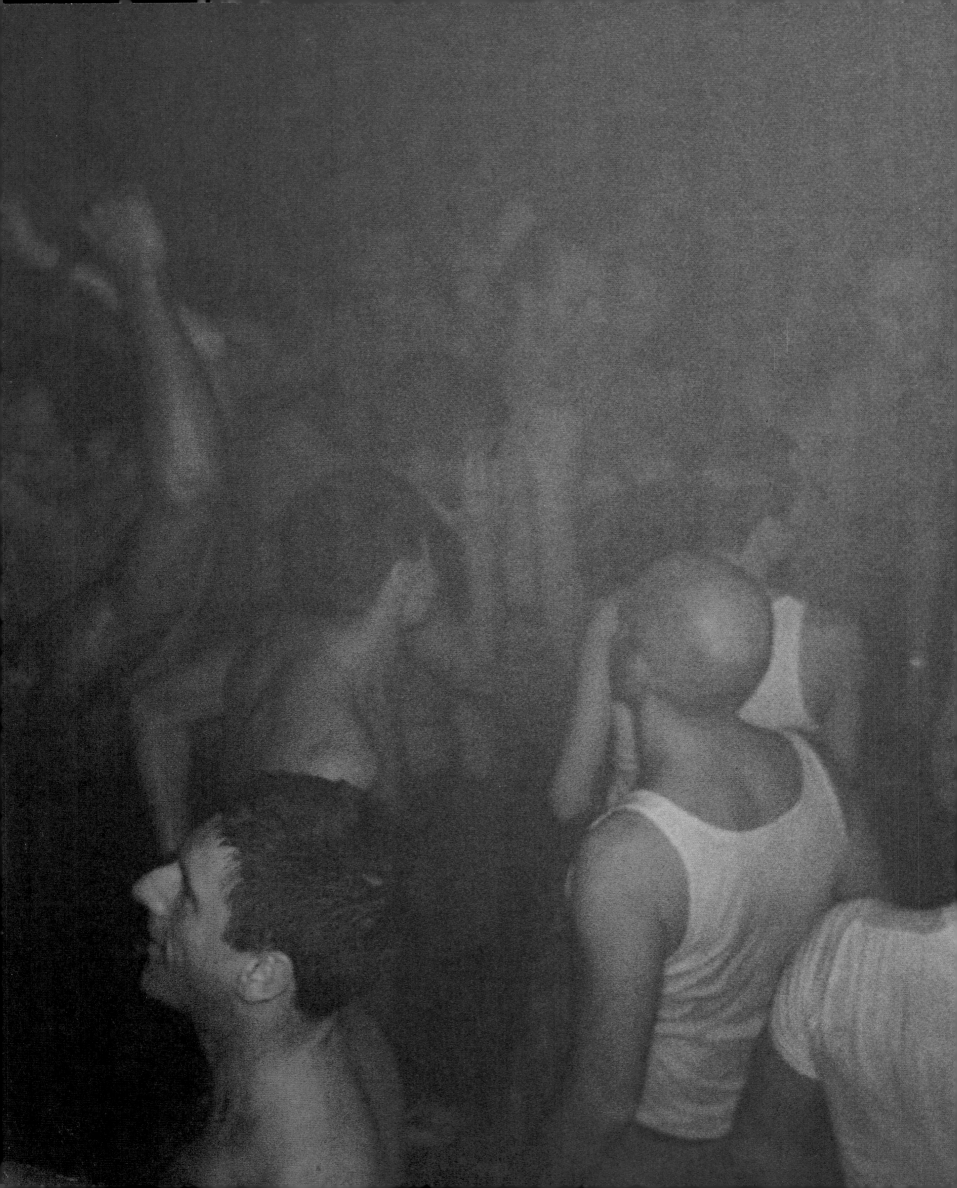

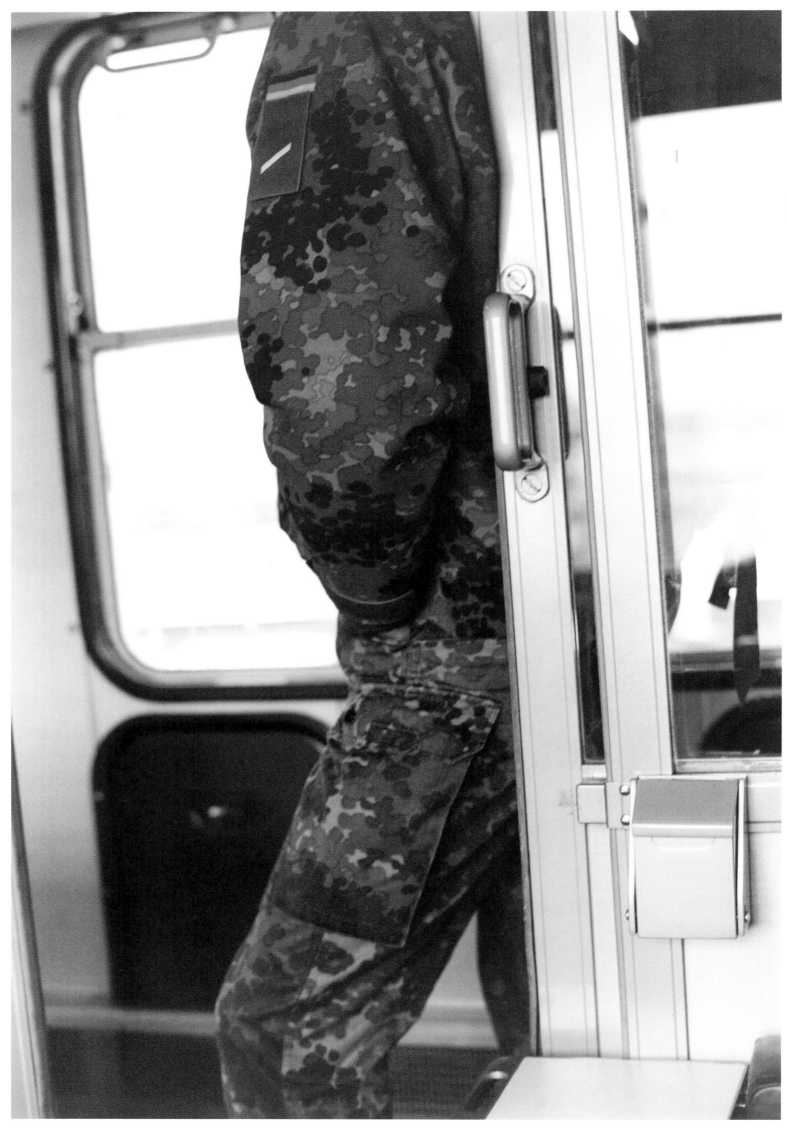

← Bahndamm, 1996 Soldat I, 1996

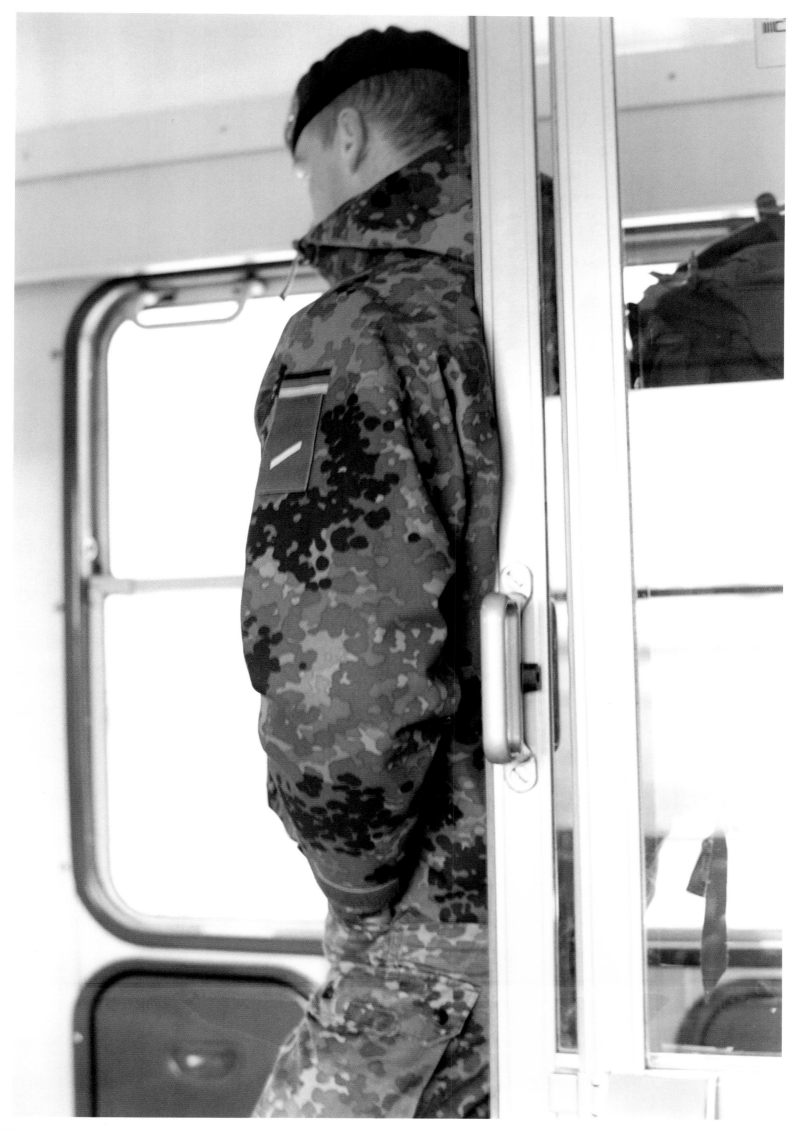

Soldat II, 1996

Matsudabär, 1997

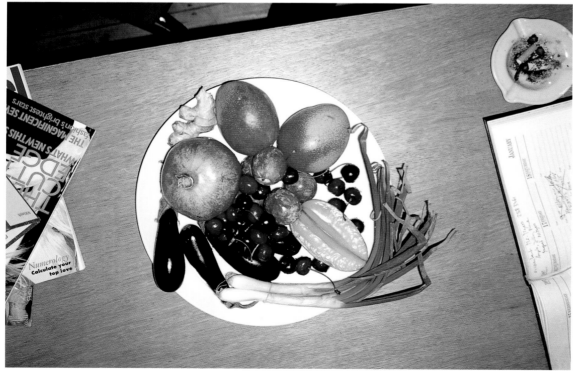

Yokohama Installation, 1997

Jochen's Plate, 1997

Minato-Mirai-21, 1997

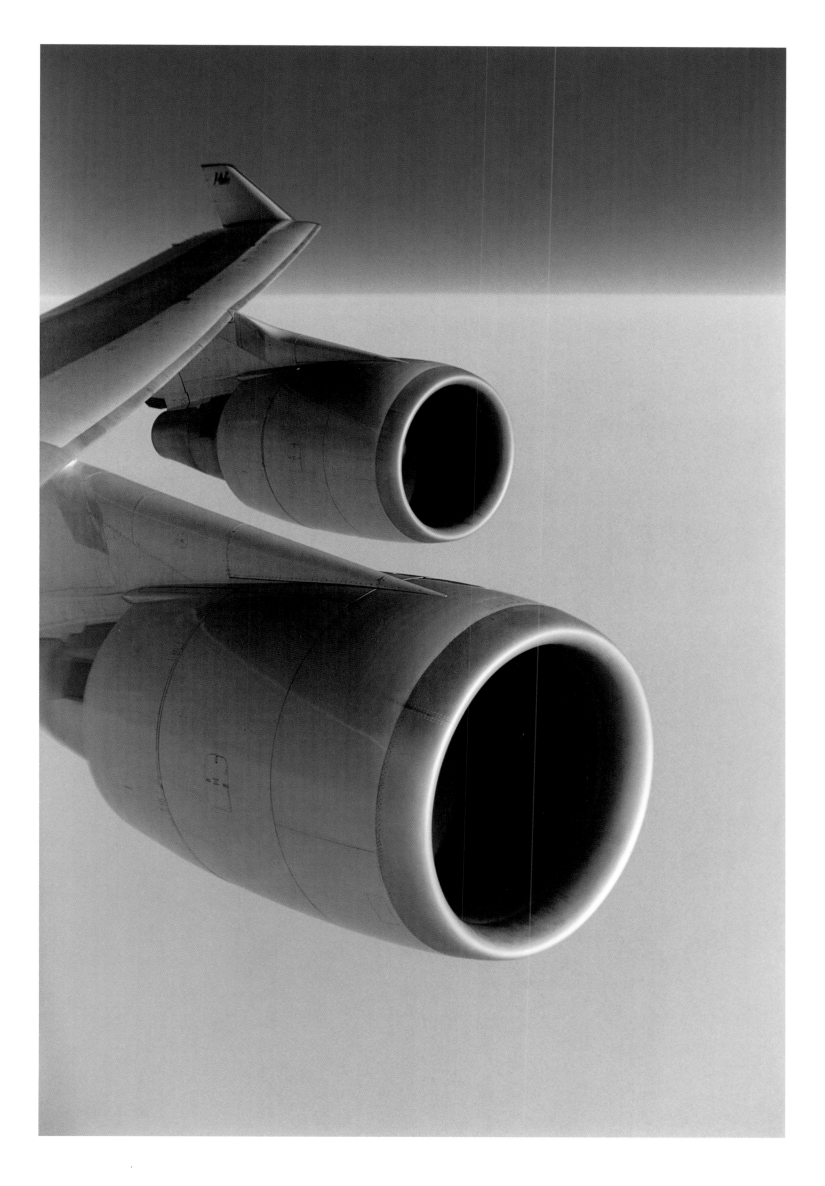

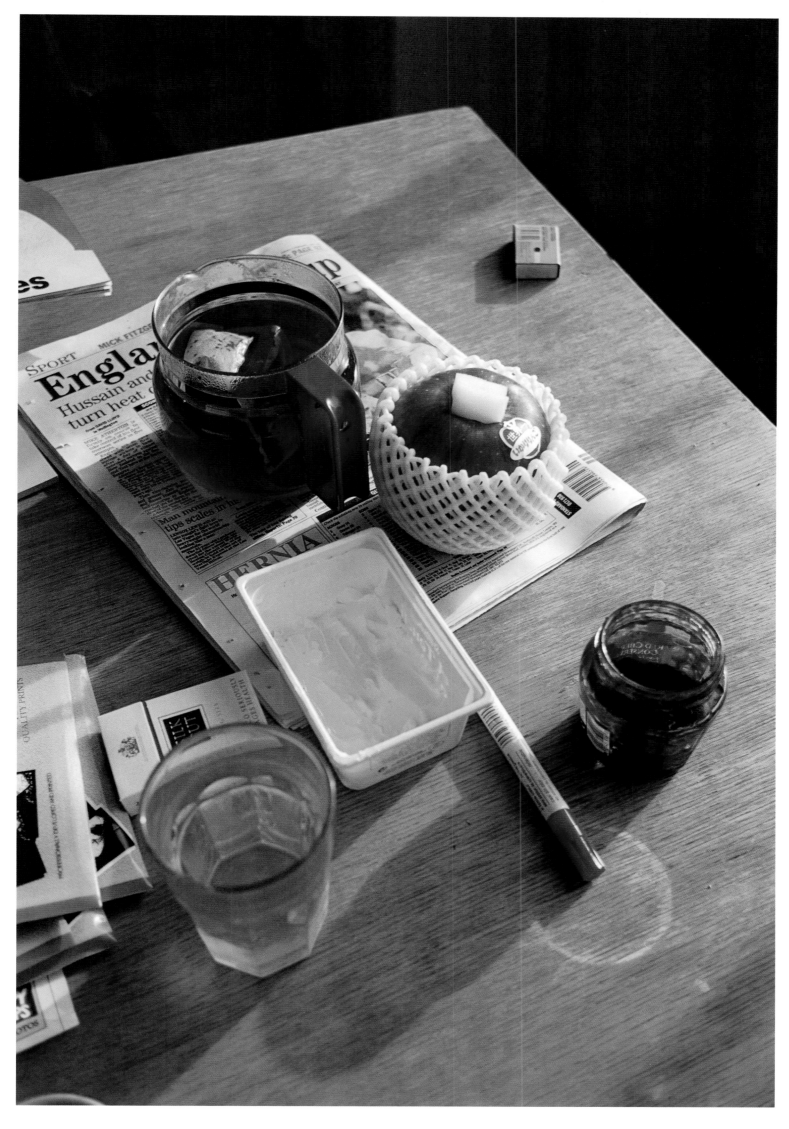

Michael, New Inn Yard, 1997 On The Verge of Visibility, 1997

Strommast I, 1997

trommast II, 1997

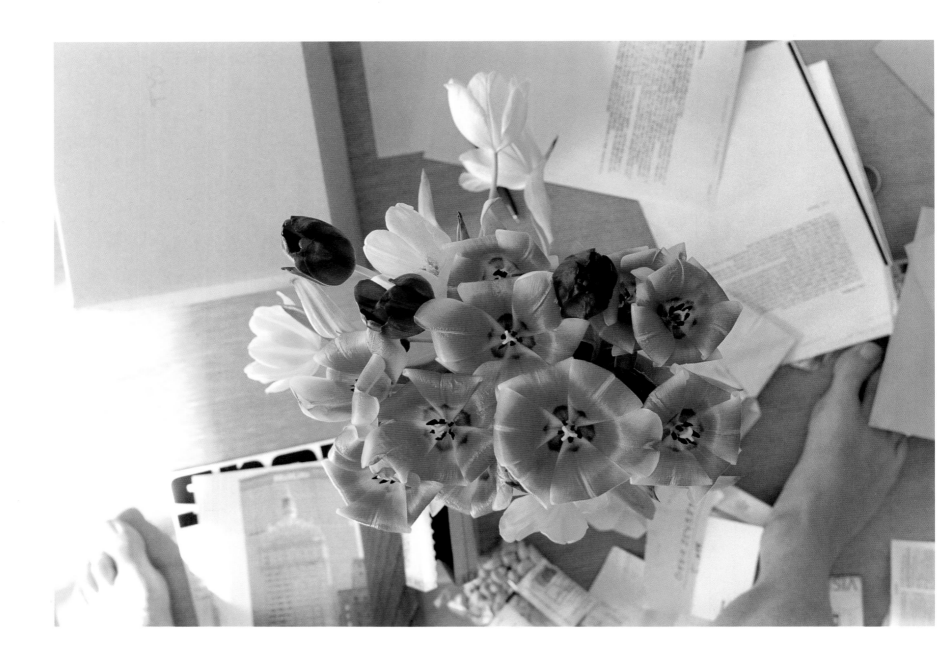

Naoya Tulips, 1997

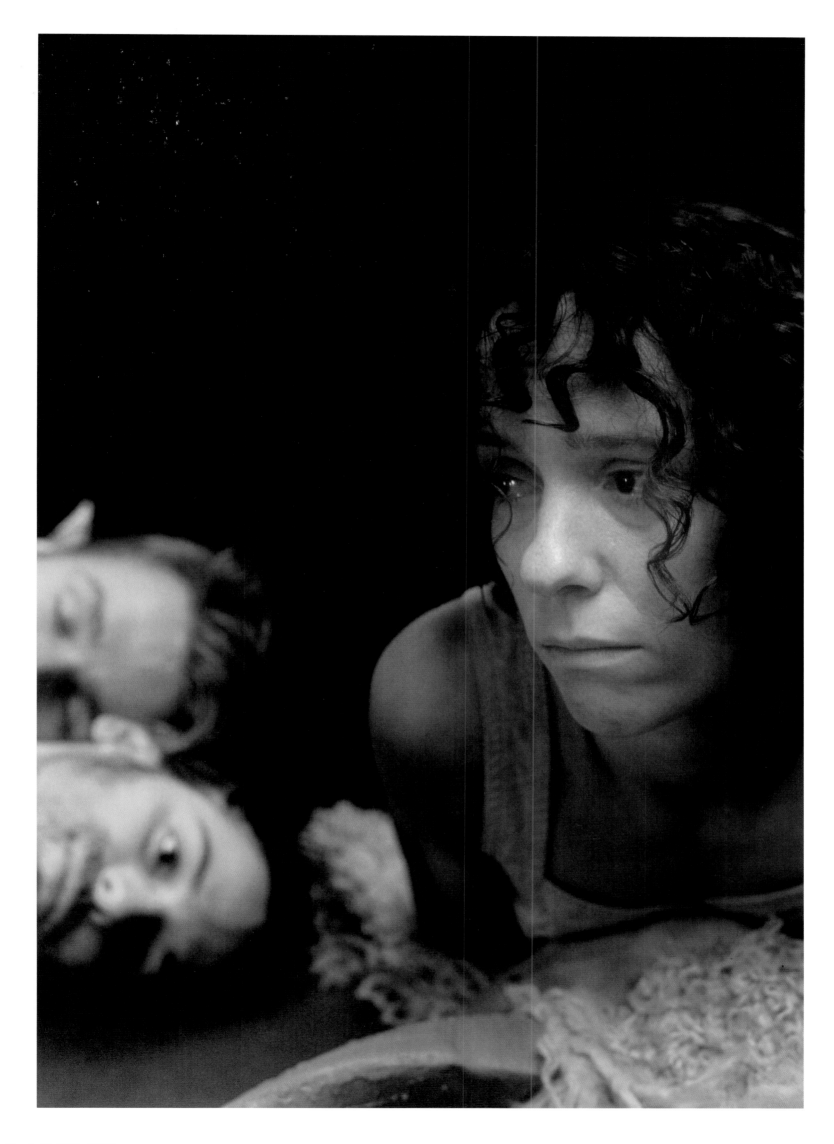

Wie Es Euch Gefällt, 1997

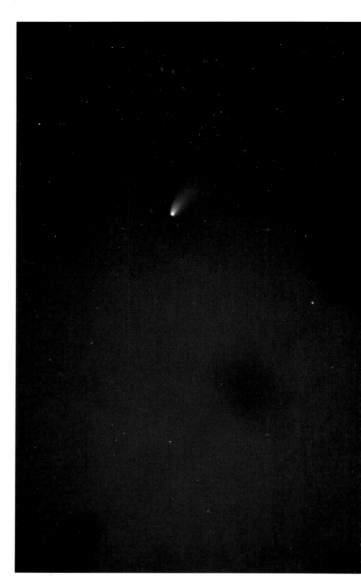

Hale-Bopp, 1997

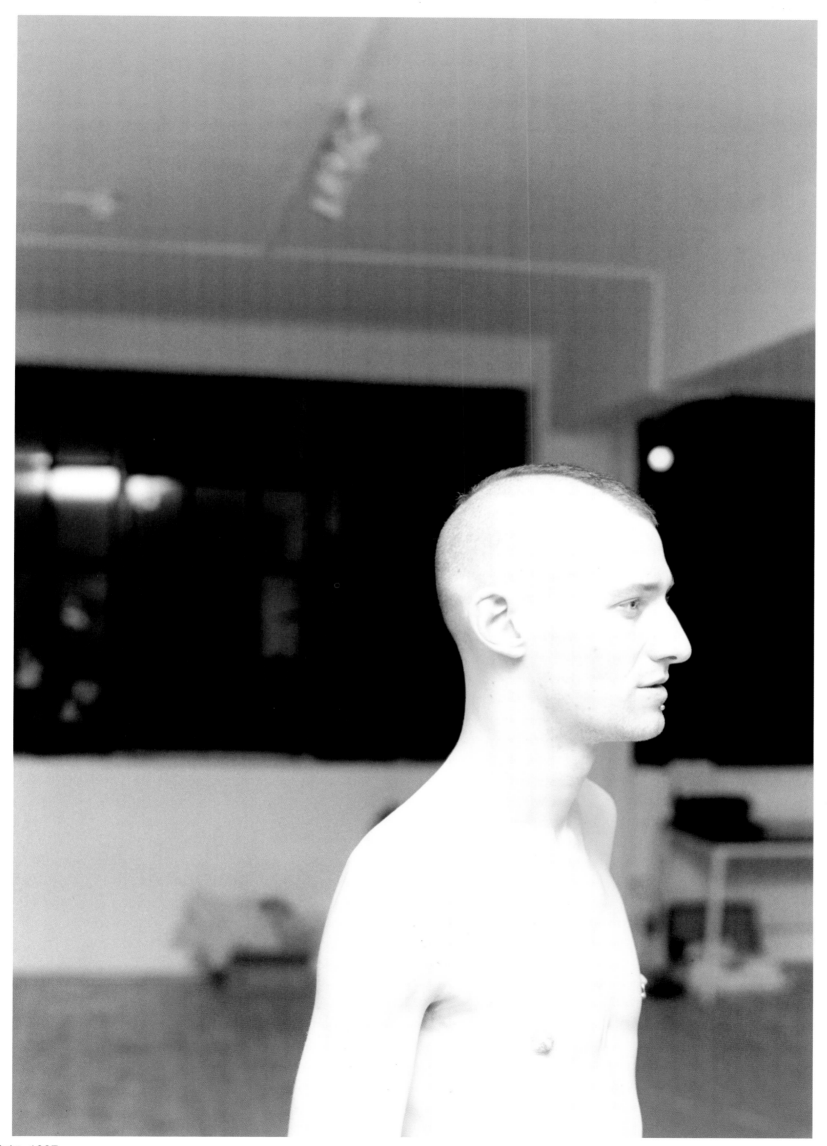

Philip Light, 1997

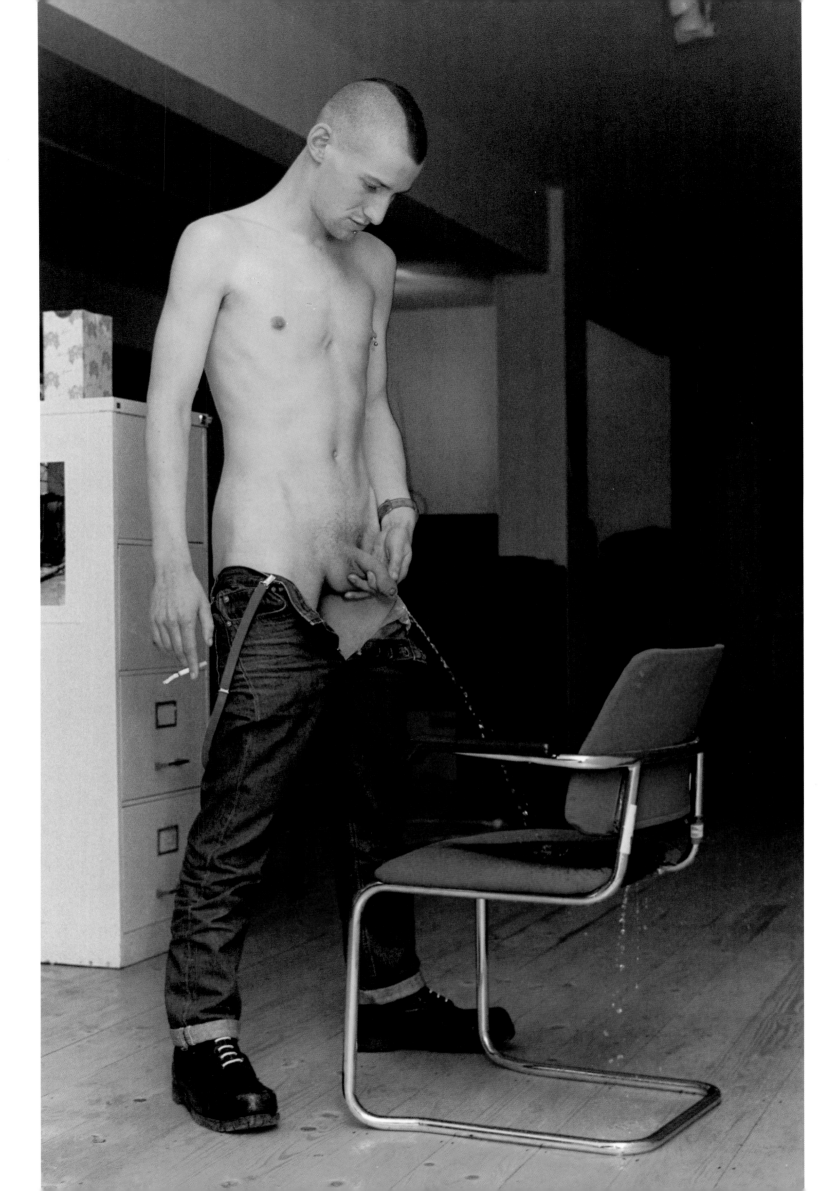

man pissing on chair, 1997

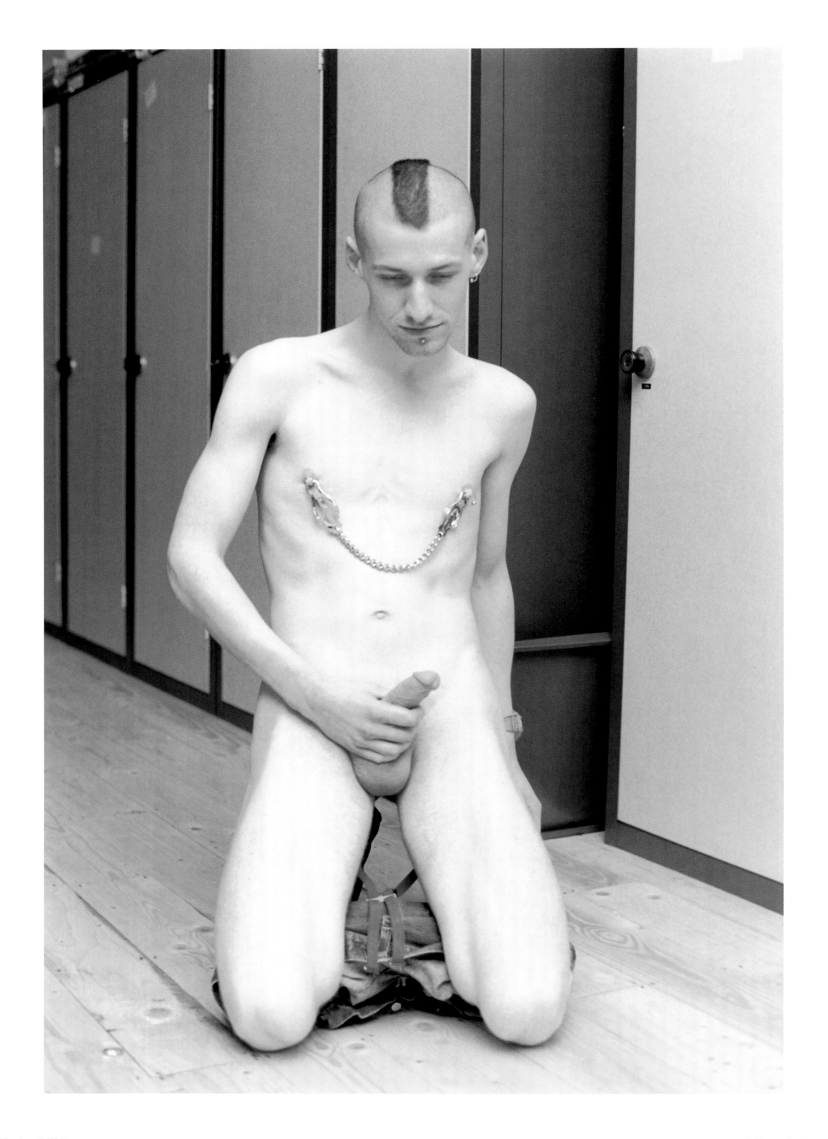

Kneeling Nude, 1997

Gilbert & George, 1997

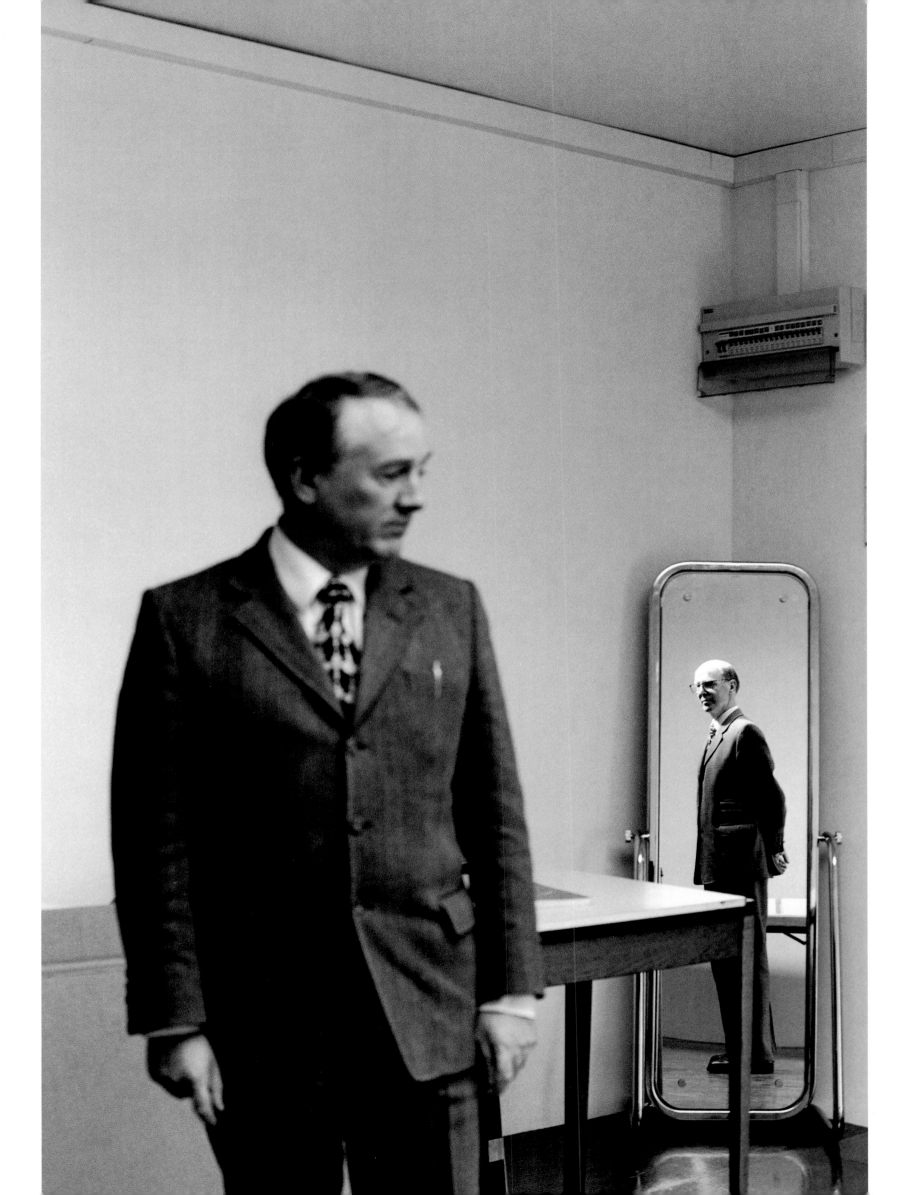

Concorde L 440 - 2 A, 1997

Concorde L 440 - 6A, 1997

Concorde L 432 - 6, 1997

Concorde L 432 - 7, 1997

Concorde L 441 - 1 A, 1997

Concorde L 444 - 9, 1997

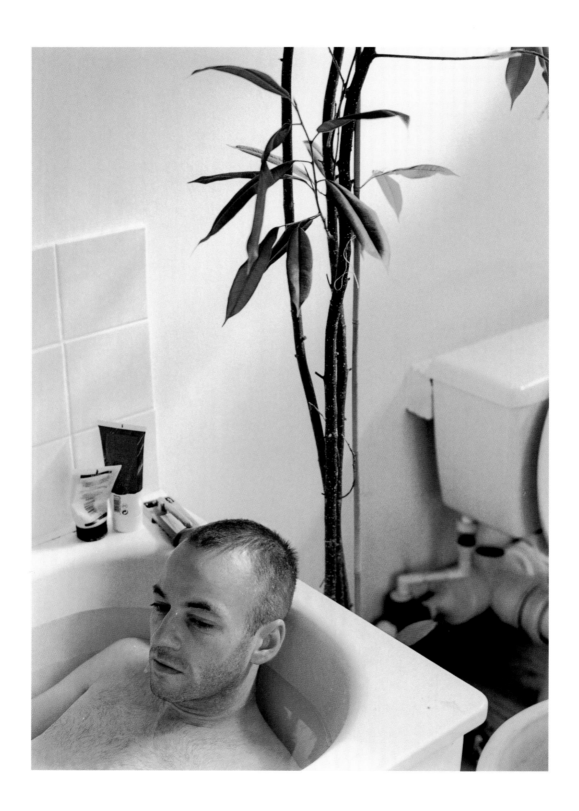

Jochen taking a bath, 1997

New Inn Broadway, 1997

Nest, 1997 Rainer at Spitalfields Community Farm, 1997

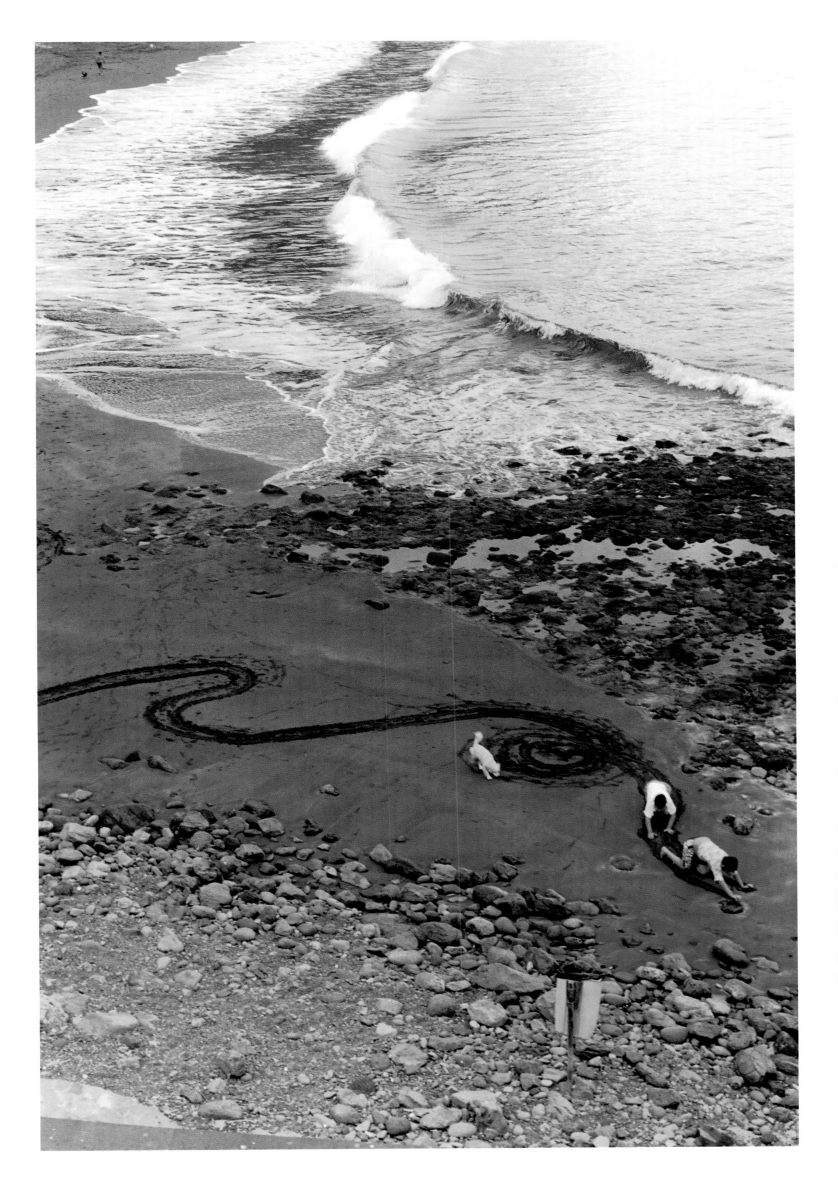

La Gomera, 1997

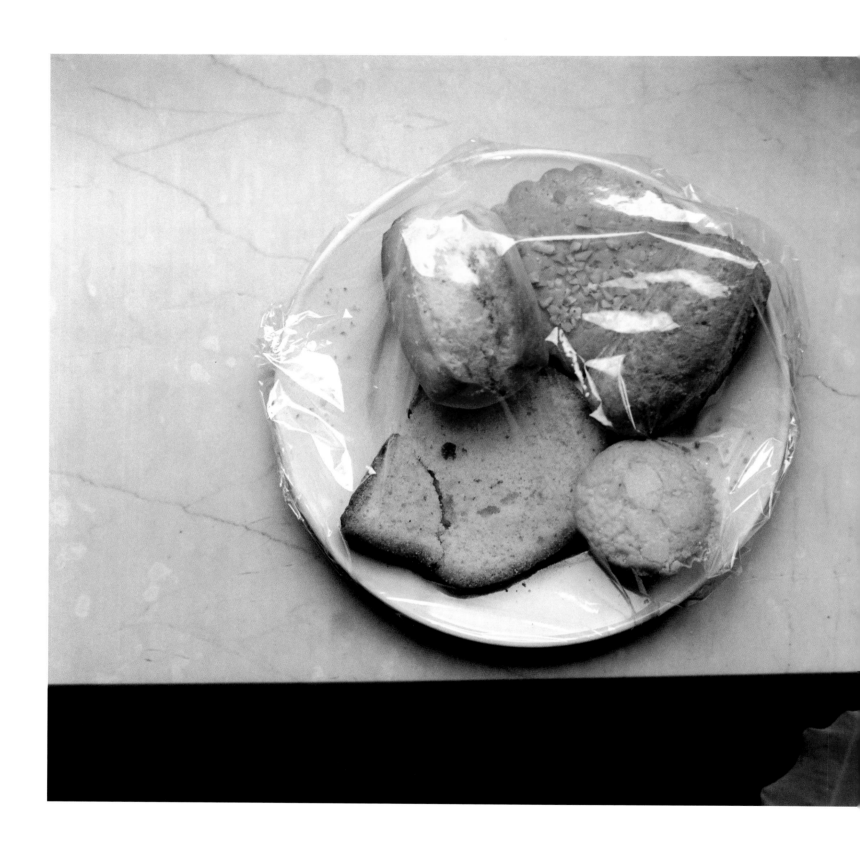

o.T., München, 1997

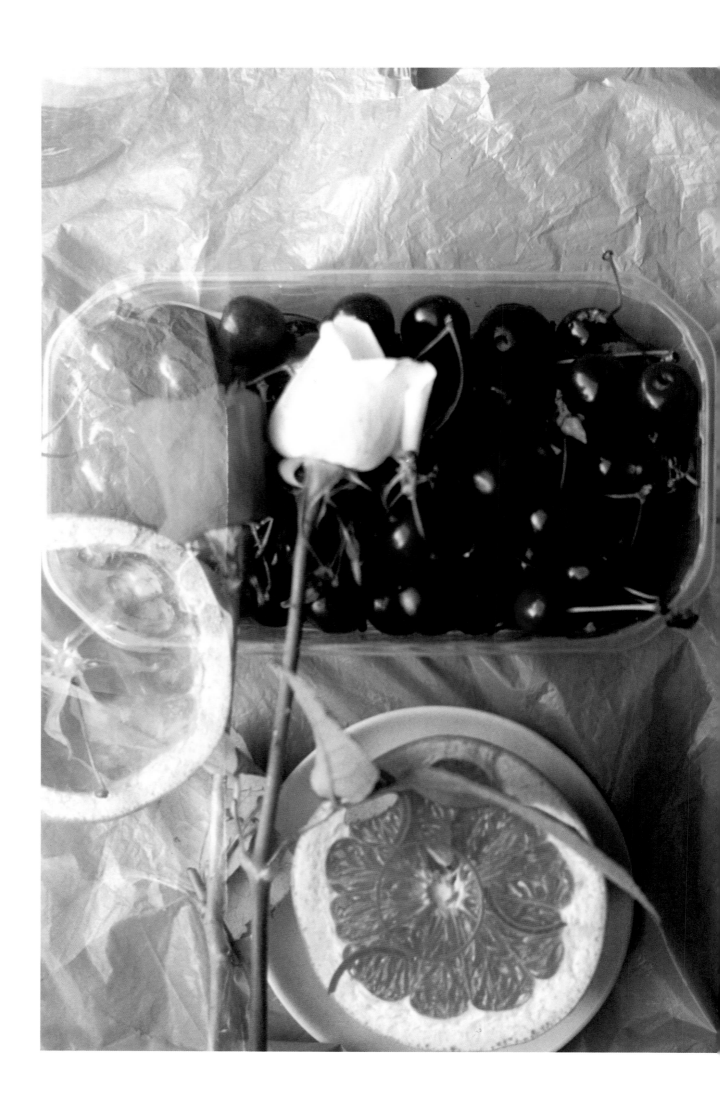

Stilleben Marktstrasse, 1997

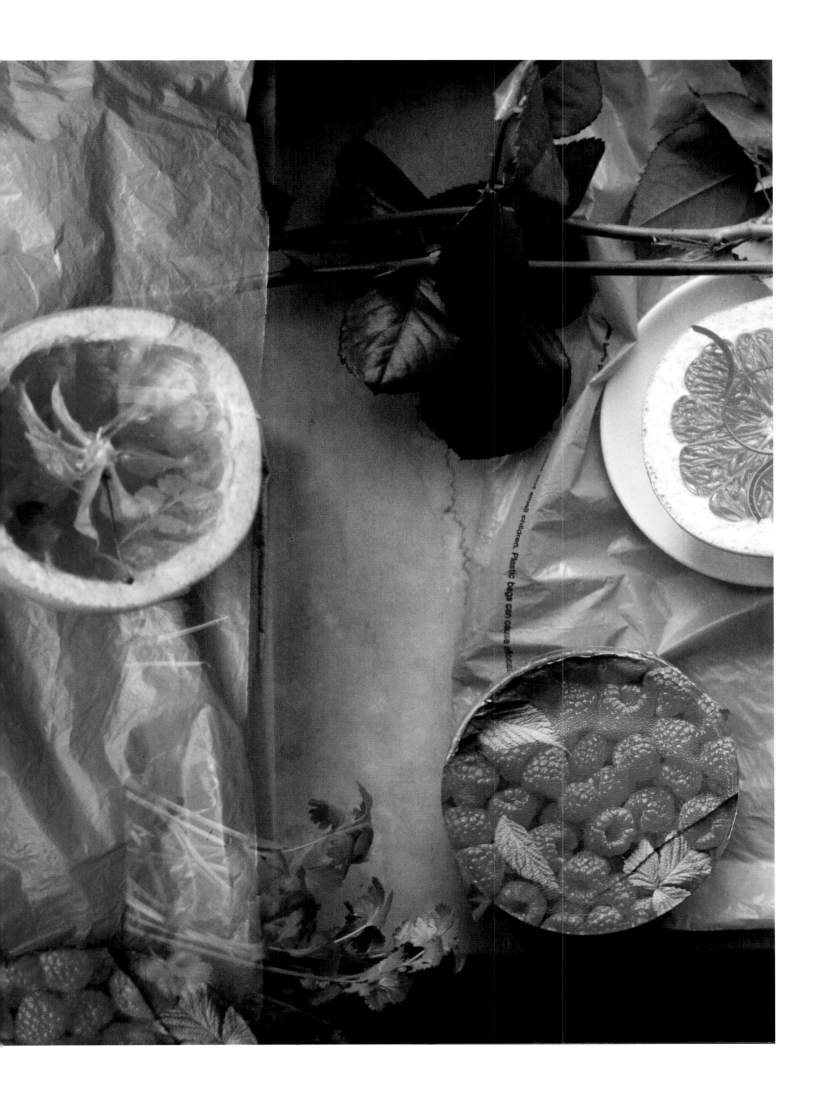

Für Immer Burgen, 1997 →

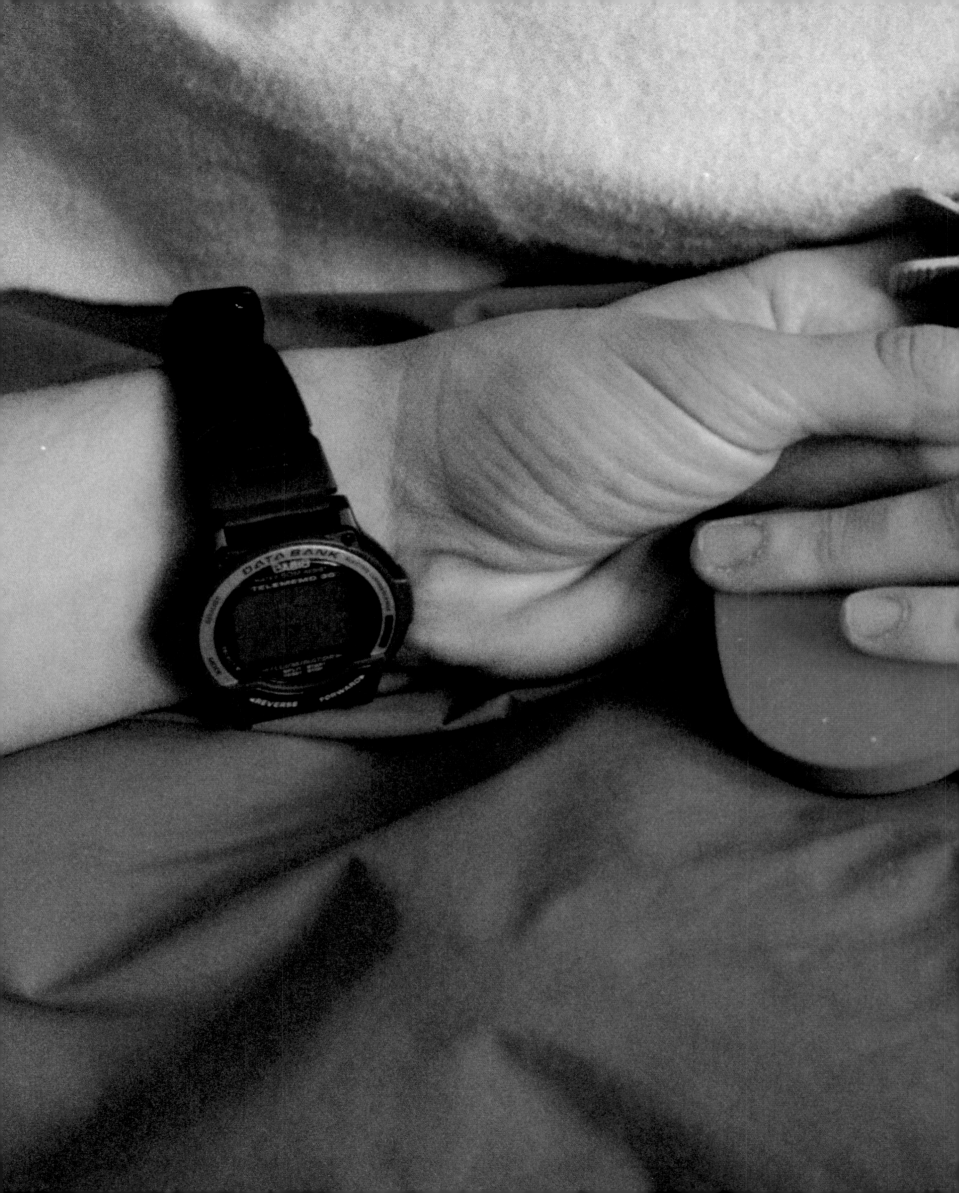

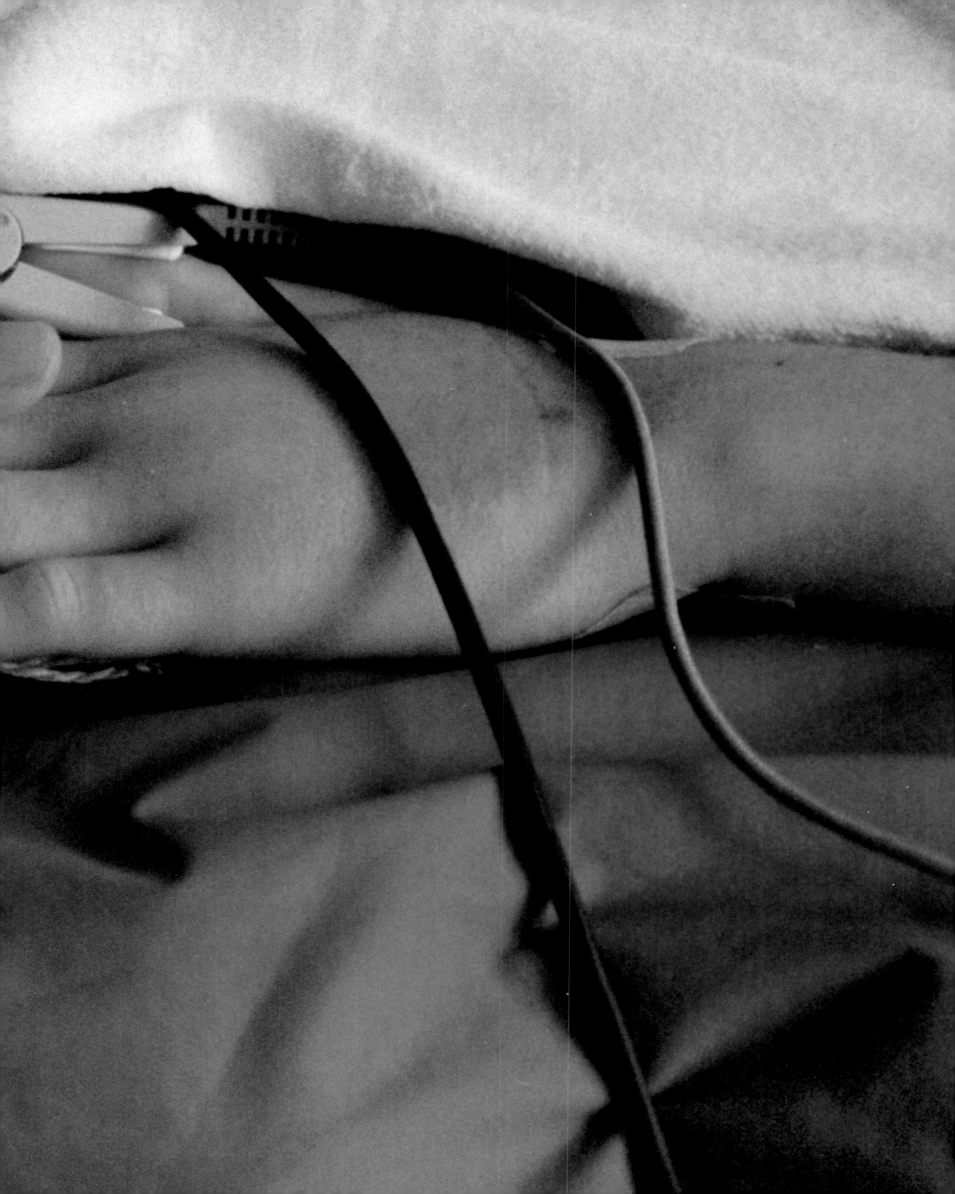

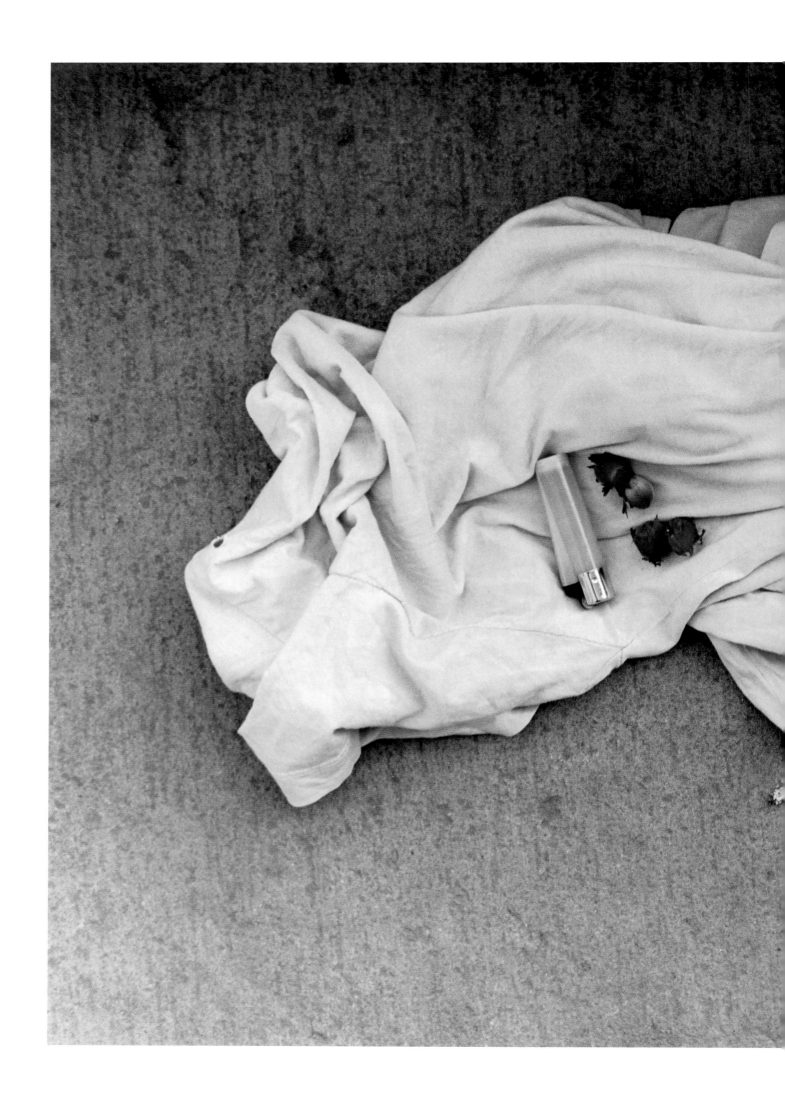

Stilleben Nüsschen II, 1997

o.M., 1997

Radioteleskop Effelsberg I - VI, 199

Alex, 1997

Vito & Paolina, 1997

Baum, 1997

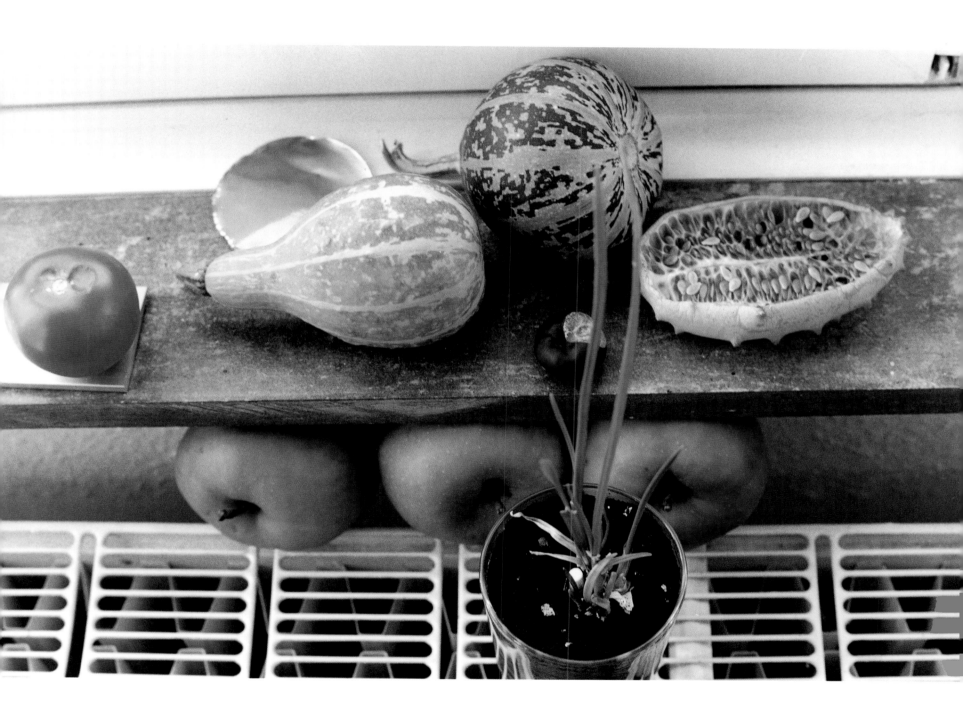

K5, 1997

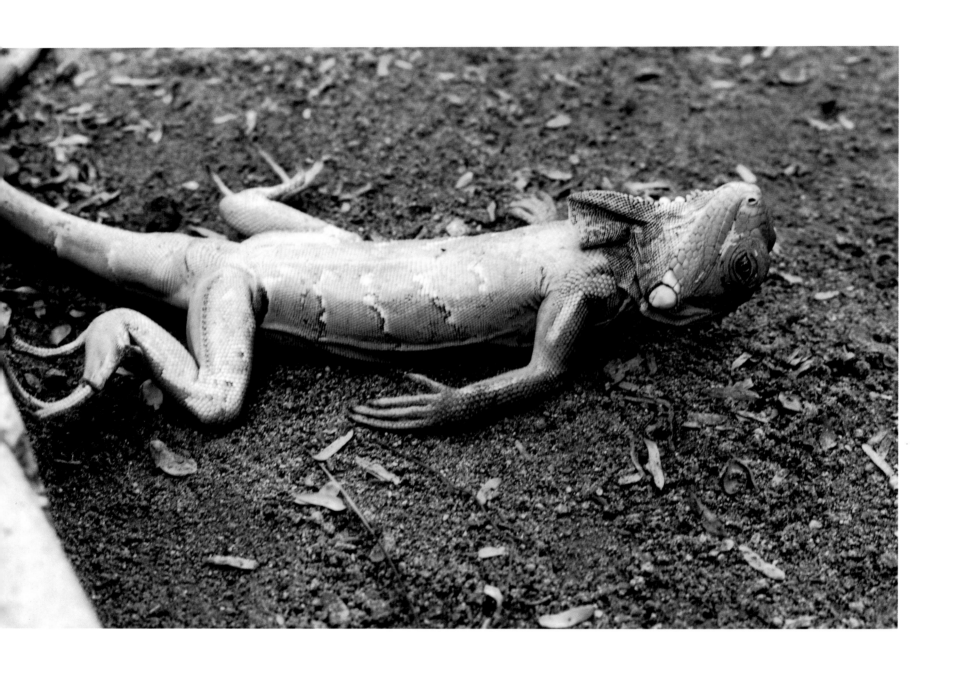

Wurm, 1998

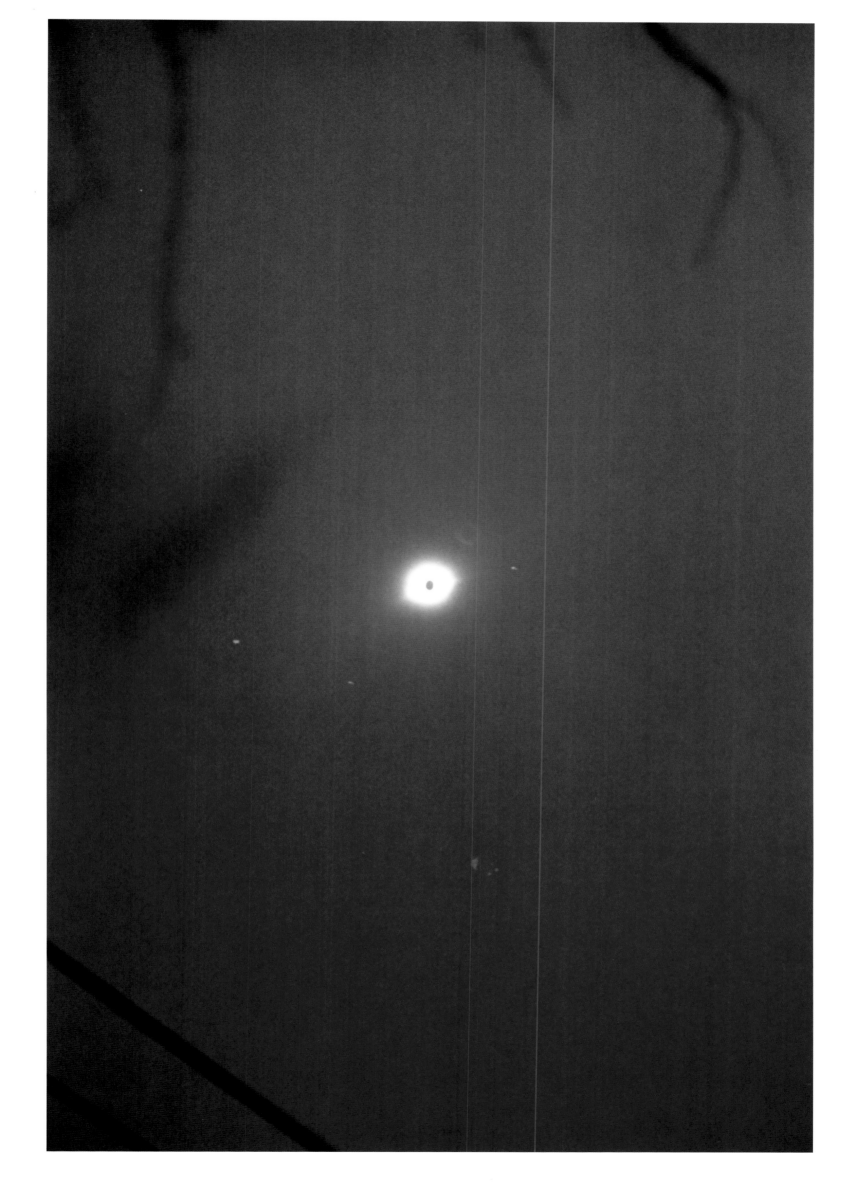

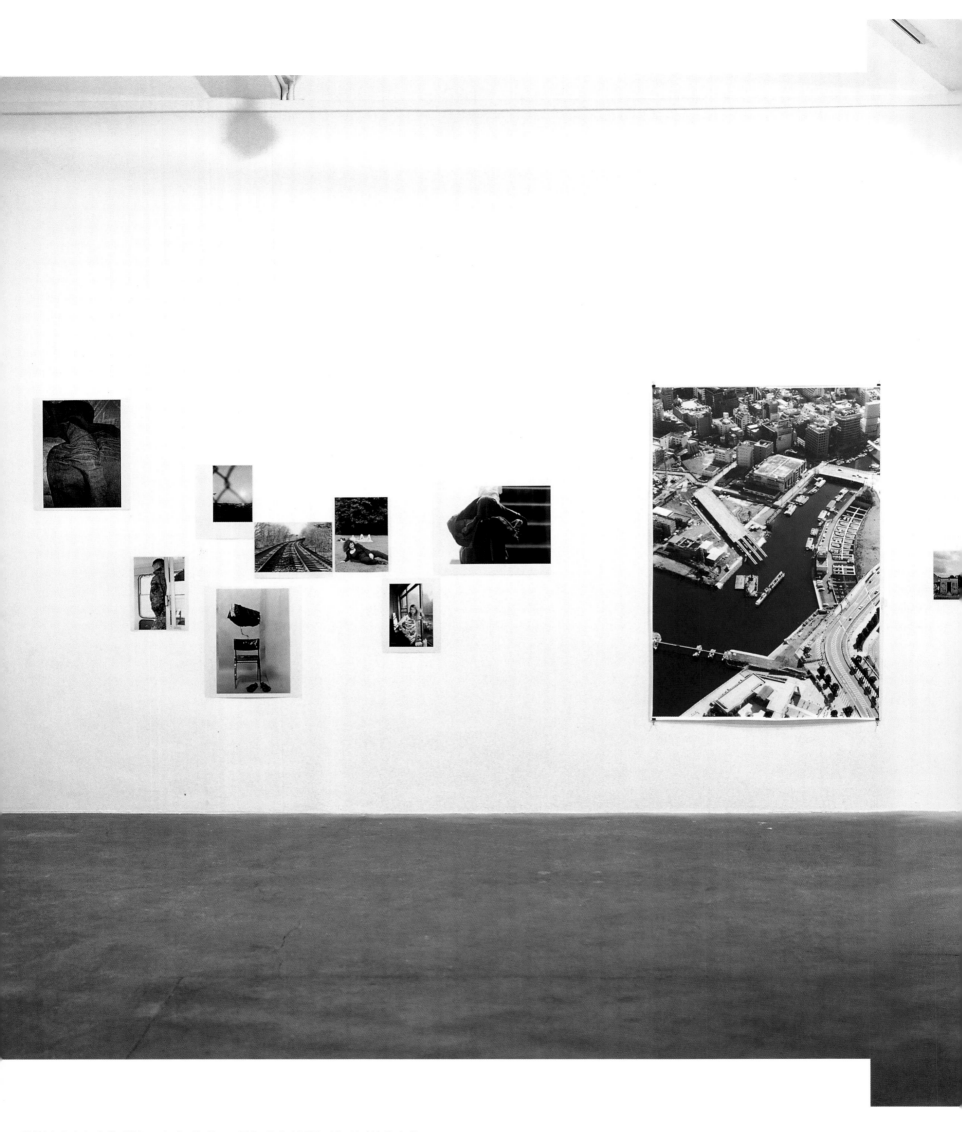

"I Didn't Inhale", Chisenhale Gallery, 7.6.-3.8.1997 North Wall, left

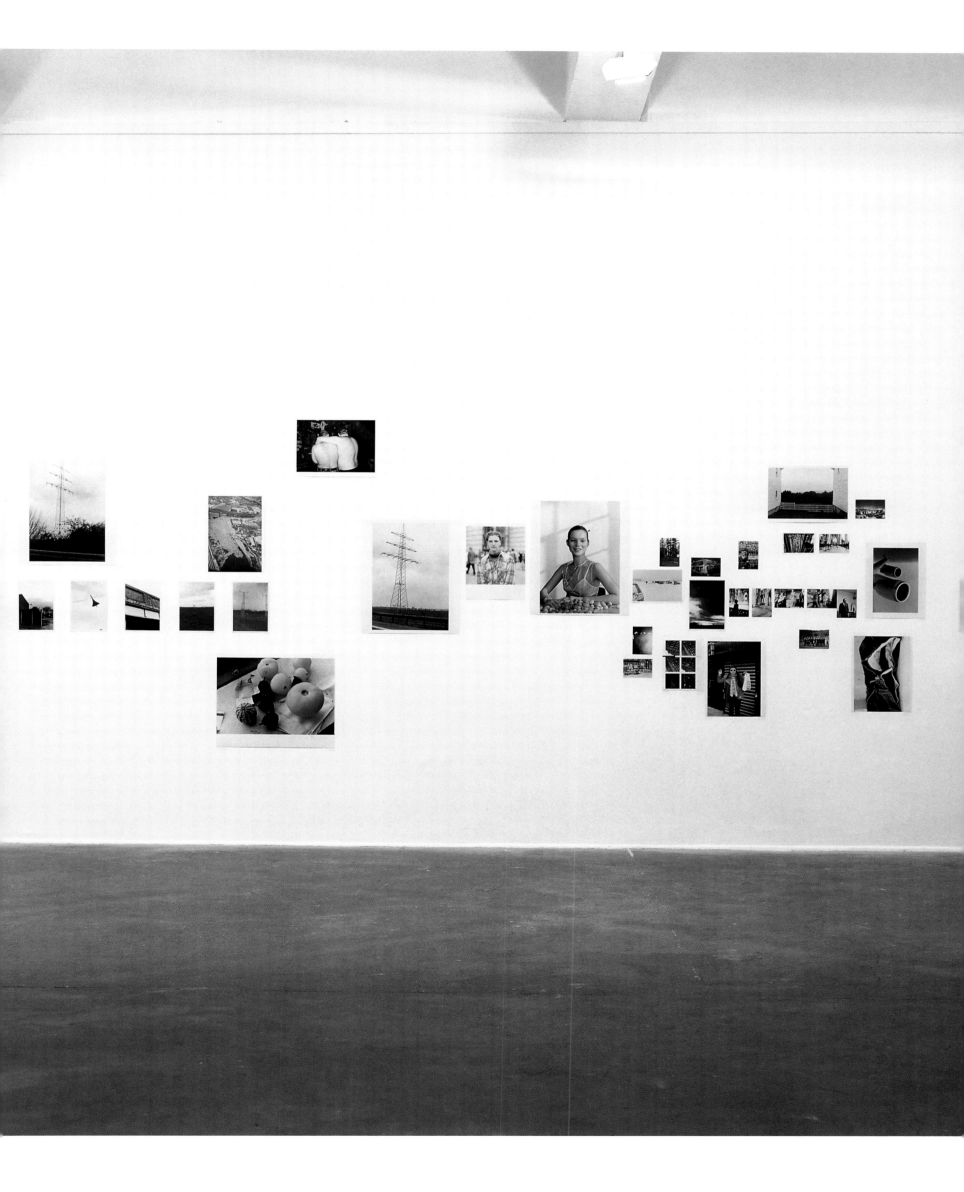

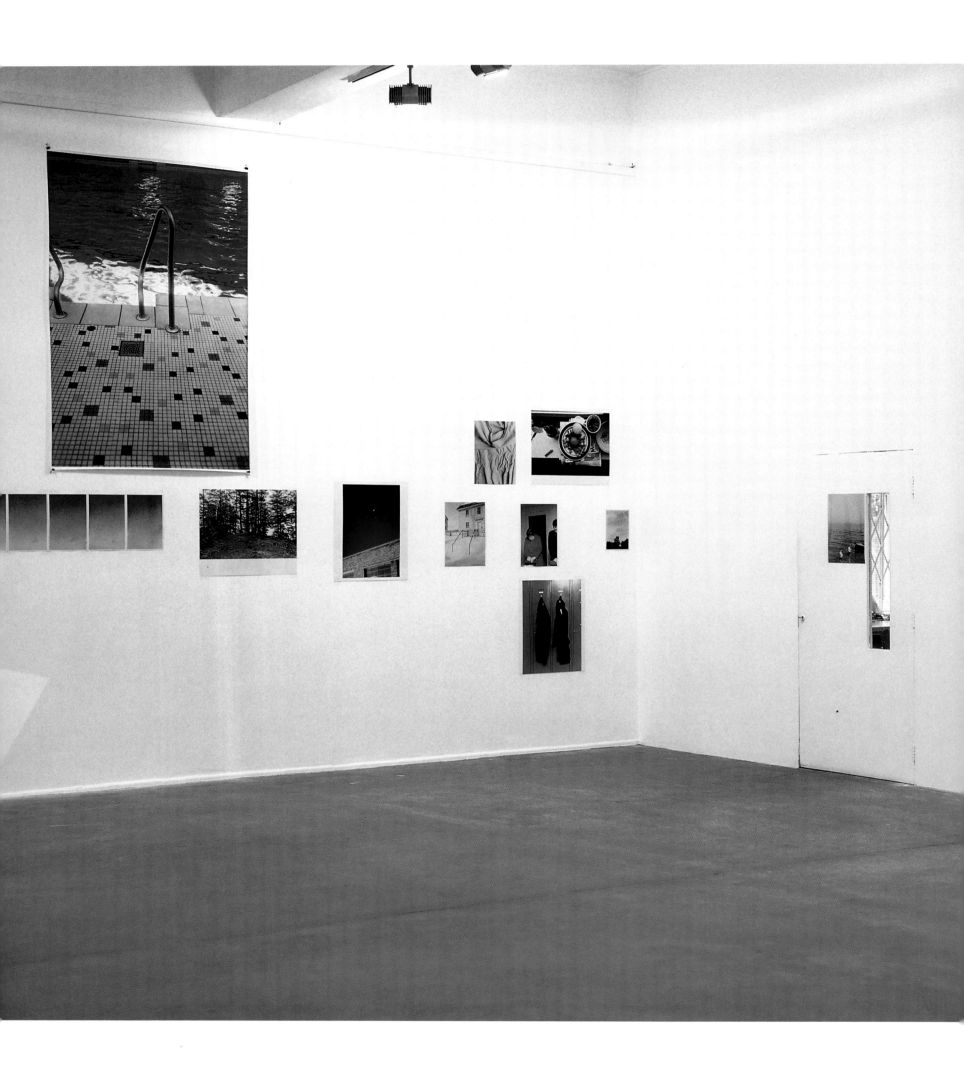

North Wall, right

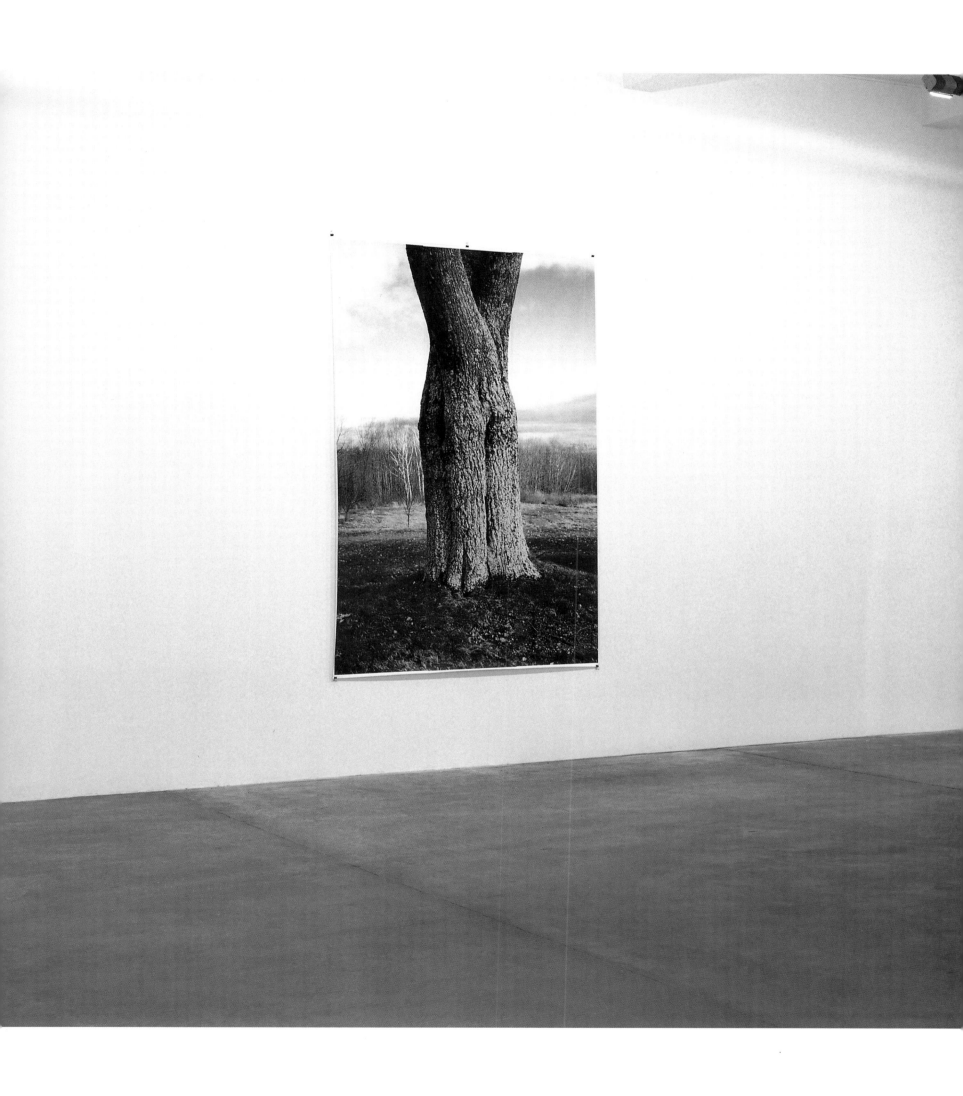

East Wall

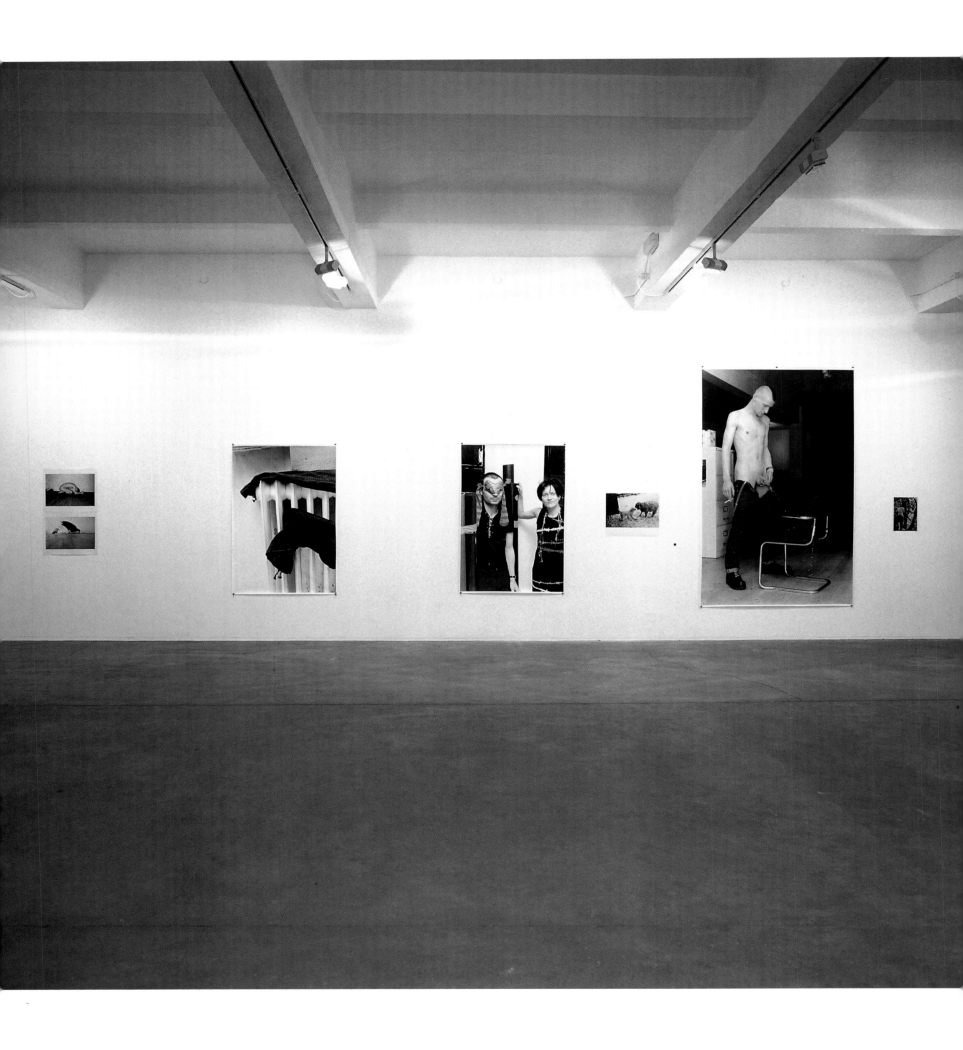

South Wall, left

South Wall, right

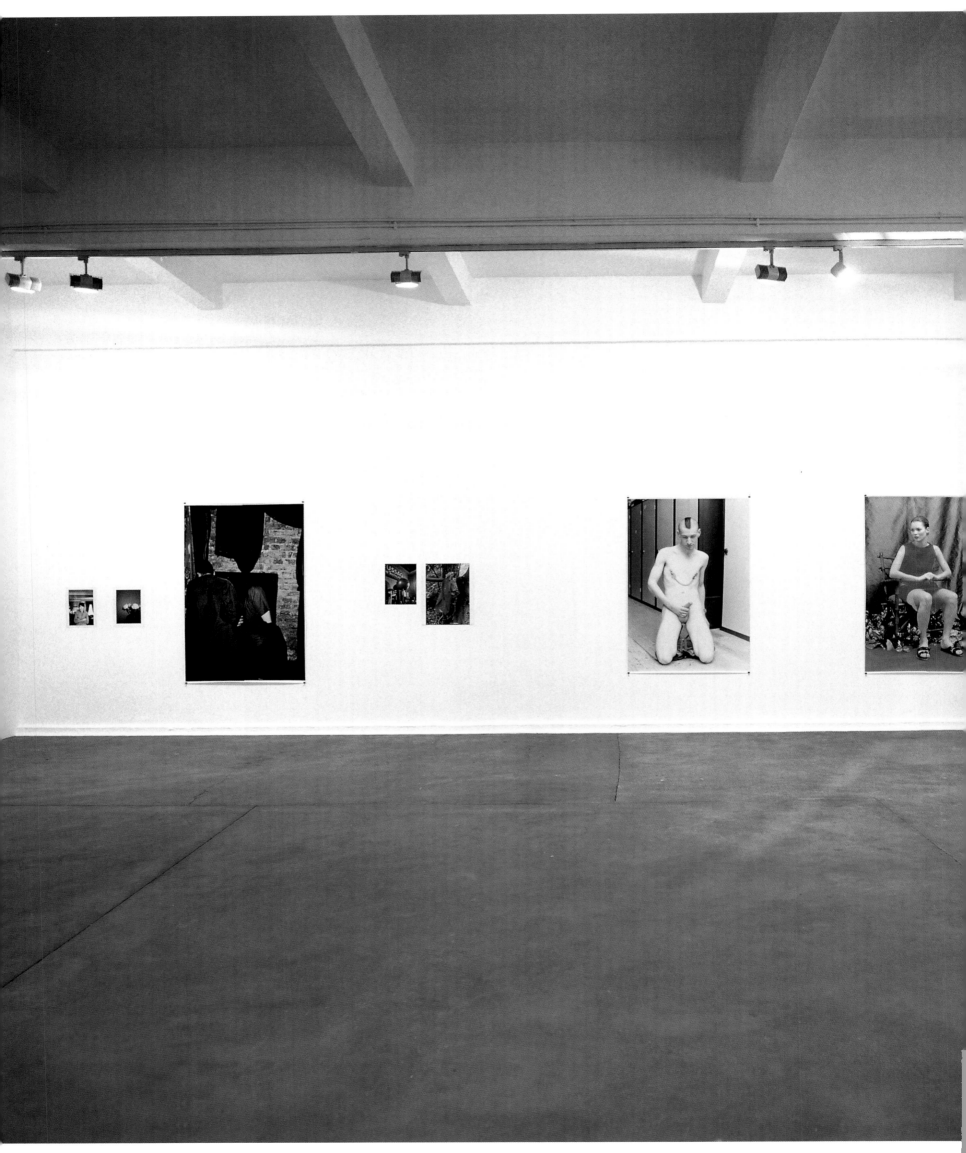

West Wall

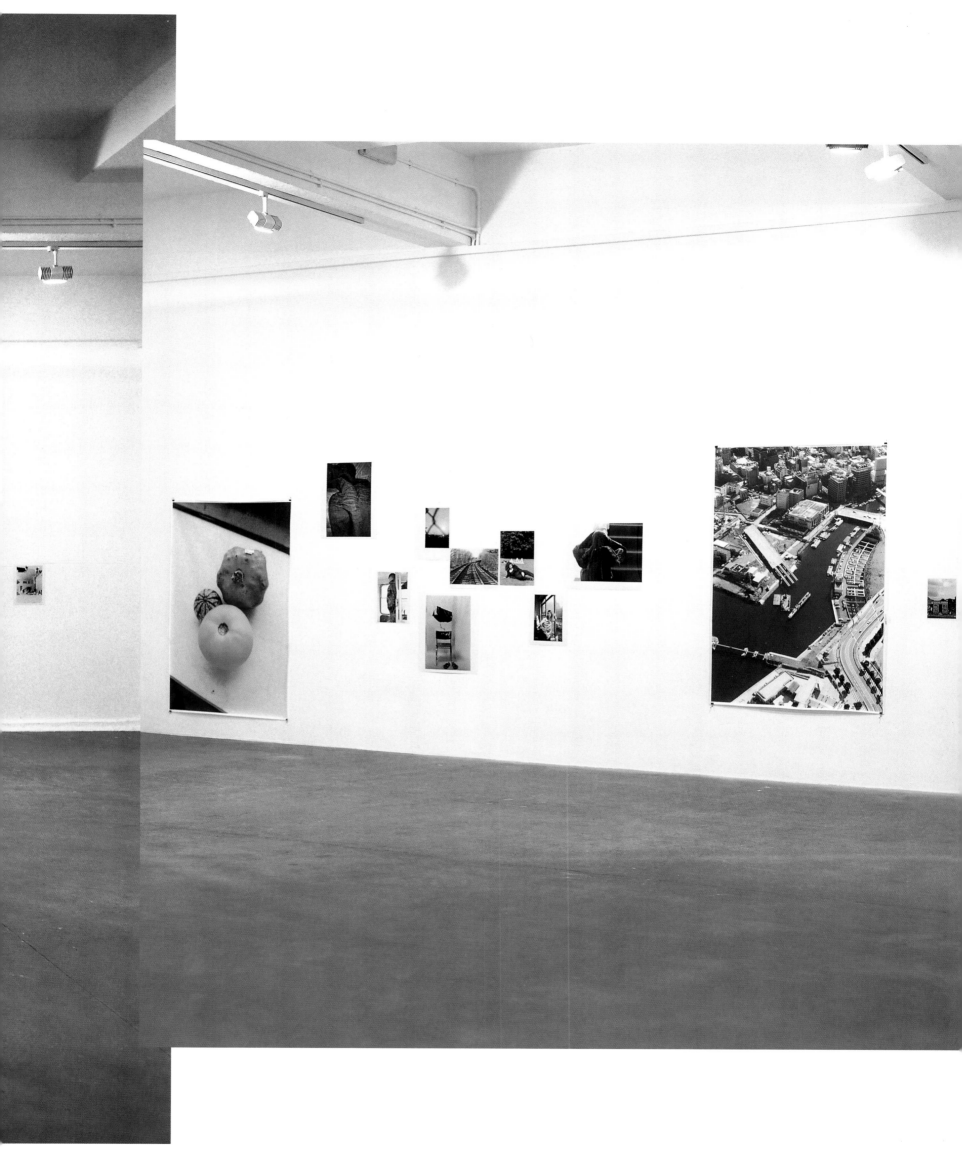

"I Didn't Inhale", Chisenhale Gallery, 7.6.-3.8.1997 North Wall left

Wolfgang Tillmans

Biography

1968 Born in Remscheid
1987-90 Lived and worked in Hamburg
1990-92 Studied at Bournemouth & Poole College of Art & Design, England
1992-94 Lived and worked in London
1994-95 Lived and worked in New York
1995 ars viva Prize from the Kulturkreis der Deutschen Wirtschaft
1995 Böttcherstraße Prize, Bremen
1995-96 Worked for three months in Berlin
1996-97 Lived and worked in London
Since 1997 Co-publisher of the magazine *Spex*
1997-98 Worked for six months in Cologne
1998 Guest-professorship at the Hochschule für Bildende Künste (School of Fine Arts) in Hamburg
Since 1998 Lives and works in London

Biographie

1968 in Remscheid geboren
1987-90 lebt und arbeitet in Hamburg
1990-92 Studium am Bournemouth & Poole College of Art & Design, England
1992-94 lebt und arbeitet in London
1994-95 lebt und arbeitet in New York
1995 Kunstpreis ars viva des Kulturkreises der Deutschen Wirtschaft im BDI
1995 Kunstpreis der Böttcherstraße in Bremen
1995-96 dreimonatiger Aufenthalt in Berlin
1996-97 lebt und arbeitet in London
Seit 1997 Mitherausgeber der Zeitschrift *Spex*
1997-98 sechsmonatiger Aufenthalt in Köln
1998 Gastprofessur Fachbereich Freie Kunst, Hochschule für Bildende Künste, Hamburg
Seit 1998 lebt und arbeitet in London

Biographie

1968 naît à Remscheid
1987-90 vit et travaille à Hambourg
1990-92 étudie au Bournemouth & Poole College of Art & Design, Angleterre
1992-94 vit et travaille à Londres
1994-95 vit et travaille à New York
1995 Prix artistique ars viva de l'association culturelle de l'économie allemande du BDI
1995 Prix artistique de la Böttcherstraße à Brême
1995-96 séjour de trois mois à Berlin
1996-97 vit et travaille à Londres
depuis 1997 coéditeur de la revue *Spex*
1997-98 séjour de six mois à Cologne
1998 professeur invité section Art libre, université des Beaux-Arts, Hambourg
depuis 1998 vit et travaille à Londres

Solo Exhibitions
Einzelausstellungen
Expositions individuelles

1998
Andrea Rosen Gallery, New York
Fruiciones, Museo Nacional Reina Sofia, Espacio Uno, Madrid
Cafe Gnosa, Hamburg

1997
hale-Bopp, Art Cologne, Galerie Daniel Buchholz, Cologne
I Didn't Inhale, Chisenhale Gallery, London
Galleria S.a.l.e.s., Rome

1996
Andrea Rosen Gallery, New York
Wer Liebe wagt lebt morgen, Kunstmuseum Wolfsburg (catalogue)
Galleri Nicolai Wallner, Copenhagen
ars futura Galerie, Zurich
Faltenwürfe, Galerie Daniel Buchholz, Cologne
Kunstverein Elsterpark, Leipzig

1995
Interim Art, London
Regen Projects, Los Angeles
Portikus, Frankfurt (catalogue)
Stills Gallery, Edinburgh
Kunsthalle Zürich, Zurich (catalogue)
neugerriemschneider, Berlin

1994
Daniel Buchholz, Cologne
Andrea Rosen Gallery, New York
Fehlmann AG Schoftland, Switzerland
Galerie Thaddaeus Ropac, Paris

1993
Interim Art, London
ars futura Galerie, Zurich
L.A. Galerie, Frankfurt
Daniel Buchholz – Buchholz & Buchholz, Cologne

1992
Diptychen, 1990–1992, PPS Galerie F.C. Gundlach, Hamburg

1991
Grauwert Galerie, Hamburg

1989
Cafe Gnosa, Hamburg

1988
Approaches, Fabrik – Foto – Forum, Hamburg, and Stadtbücherei Remscheid
Blutsturz, Front, Hamburg
Approaches, Cafe Gnosa, Hamburg

Group Exhibitions
Gruppenausstellungen
Expositions de groupe

1998
Berlin/Berlin, Berlin Biennale
La Sphère de l'Intime, Le Printemps de Cahors Festival, Saint-Cloud
The DG Bank Collection, Hara Museum of Contemporary Art, Tokyo (catalogue)
Stretch, Tensta Konsthall, Stockholm (catalogue)
The Quiet in the Land: Everyday Life, Contemporary Art and the Shakers. The Institute of Contemporary Art, Boston, MA (pamphlet)
New York Color School, Valerie's, New York
From the Corner of the Eye, Stedelijk Museum, Amsterdam (catalogue)
Galerie Daniel Buchholz, Cologne
Portrait – human figure, Galerie Peter Kilchmann, Zurich
Fast Forward Image, Kunstverein in Hamburg (catalogue)
The Sound of One Hand: The Collection of Collier Schorr, Apex Art C.P., New York
Still Life: 1900–1998, Marlborough Graphics, Marlborough Gallery, Inc., New York
Fashion at the Beach, Bass Museum of Art, Miami Beach; Contemporary Art Center of Virginia, Virginia Beach, VA; Orange County Museum of Art, Newport Beach, CA (catalogue)
Kunsthalle Bremen
Galerie Ghislaine Hussenot, Paris
Edifying Sappho and Socrates, Sydney Gay & Lesbian Mardi Gras, Sydney
Sunday by Matthew Higgs, Cabinet Gallery, London
Collection, un autre regard, Capc, Musée d'Art Contemporain, Bordeaux
Look at me, Kunsthal Rotterdam/The British Council Touring Exhibition

1997
Veronica's Revenge, Sammlung Lambert, Geneva; Centre d'Art Contemporain, Geneva; Deichtorhallen, Hamburg (catalogue)
We gotta get out of this place, Cubitt, London
Framed Area, Amsterdam (catalogue)
Little Boxes, Cambridge Darkroom Gallery, Cambridge
Habitat Limited Edition Prints, Habitat, London
Film Still/Still Life, Le Case d'Arte, Milan
"Kunst … Arbeit", Südwest LB Forum, Stuttgart (catalogue)
Positionen künstlerischer Photographie in Deutschland von 1945–1995, Berlinische Galerie im Martin-Gropius-Bau, Berlin (catalogue)
The 90s: A Family of Man?, Casino Luxembourg – Forum d'Art Contemporain, Luxembourg (catalogue)
The Quiet in the Land: Everyday Life, Contemporary Art and the Shakers, Institute of Contemporary Art, Maine College of Art, Portland, ME (pamphlet)
Projects, Irish Museum of Modern Art, Dublin (catalogue)
Sous le manteau, Galerie Thaddaeus Ropac, Paris (catalogue)
Absolute Landscape – Between Illusion and Reality, Yokohama Museum of Art, Yokohama (catalogue)
Zeitgeist Becomes Form – German Fashion Photography 1945–1995, Pat Hearn Gallery, New York and Morris Healy Gallery, New York
Die Kunsthalle Bremen zu Gast in Bonn, Kunst- und Ausstellungshalle der Bundesrepublik Deutschland, Bonn (catalogue)

1996
New Photography #12, The Museum of Modern Art, New York
a/drift: Scenes from the Penetrable Culture, Bard College Center for Curatorial Studies, Annandale-on-Hudson, NY
Blind Spot: Photography: The First Four Years, Paolo Baldacci Gallery, New York
I Feel Explosion, flat above Manchester Arndale Centre, Manchester
Shift, Haus der Kulturen der Welt, Berlin, organisiert von: Neue Gesellschaft für Bildende Kunst (catalogue)
Intermission, Basilico Fine Arts, New York
Visitors' Voices: Recomposing the Collection, Walker Art Center, Minneapolis, MN
Pictures of Modern Life, Galerie Rodolphe Janssen, Brussels; Ecole Regionale des Beaux-Arts de Tours, Tours
The Quiet in the Land: Everyday Life, Contemporary Art and the Shakers, Sabathday Lake, ME
Dites-le avec des fleurs, Galerie Chantal Crousel, Paris
Das deutsche Auge – Fotojournalismus in Deutschland, Deichtorhallen, Hamburg (catalogue)
Festival International de la Photo de Mode, Biarritz
Prospect '96 – Fotografie in der Gegenwartskunst, Frankfurter Kunstverein and Schirn Kunsthalle Frankfurt (catalogue)
wunderbar, Kunstraum Wien, Vienna; Kunstverein in Hamburg
Urgence, Capc Musée d'Art Contemporain Entrepôt, Bordeaux (catalogue)
Traffic, Capc Musée d'Art Contemporain Entrepôt, Bordeaux
By night, La Fondation Cartier pour l'art contemporain, Paris (catalogue)
Nudo y Crudo: sensitive body, visible body, Claudia Gian Ferrari Arte Contemporanea, Milan (catalogue)

Everything That's Interesting is New: The Dakis Joannou Collection, Athens; School of Fine Art, Athens; Museum of Modern Art, Copenhagen (catalogue)
Composing a Collection: Recent Gifts and Acquisitions, Walker Art Center, Minneapolis, MN
Le Plaisir et les Ombres, Fondation pour l'Architecture, Brussels

1995
Galerie Analix-B. & L. Polla, Geneva
Bildermode – Modebilder: Deutsche Modephotographien von 1945–1995, Institut für Auslandsbeziehungen, Stuttgart, Berlin (catalogue)
Kunstpreis der Böttcherstraße in Bremen, Kunsthalle Bremen (catalogue)
ars viva 95/96 Photographie, Anhaltische Gemäldegalerie Dessau; Frankfurter Kunstverein, Frankfurt; Kunsthalle Nürnberg, Nuremberg (catalogue)
Benefit Exhibition for D.E.A.F., Inc., Nicole Klagsbrun Gallery, New York
The Enthusiast, Gavin Brown's Enterprise, New York
Photographies, Galerie Rodolphe Janssen, Brussels
Mondo Nova, Le Case d'Arte, Milan
Human Nature, The New Museum of Contemporary Art, New York
Every time I see you, Galleri Nicolai Wallner, Malmö; galleri index, Stockholm
Take me (I'm yours), Serpentine Gallery, London; Kunsthalle Nürnberg, Nuremberg
Guaranteed Personalities, Lydmar Hotel, Stockholm
White Columns, Auction Benefit, New York

1994
Streetstyle, Victoria & Albert Museum, London
100 Umkleidekabinen, Bad zur Sonne, Graz (catalogue)
The Winter of Love, P.S. 1 Museum, Long Island City, NY
Soggetto Soggetto, Castello di Rivoli, Turin (catalogue)
Rien à signaler, Galerie Analix, Geneva (catalogue)
Mechanical Reproduction, AP, Amsterdam (catalogue)
Ars Lux, 100 artist billboard light boxes across Italy
Les Dimanches de l'Amour, Ecole des Beaux-Arts de Rennes, Rennes
Sonne München, Daniel Buchholz, Cologne
Dinos and Jake Chapman, Georgina Starr, Wolfgang Tillmans, Andrea Rosen Gallery, New York
Expose Yourself, The Tannery, London
L'Hiver de l'Amour, Musée d'Art Moderne de la Ville de Paris, Paris (catalogue)
Homegrown, Lotus Club, Cologne
Photo '94, The Photographer's Gallery on Art '94, London

1993
Christmashop, Air de Paris, Paris
Belcher, Höller, General Idea, Tillmans, Odenbach, Daniel Buchholz, Cologne
Phenylovethylamour, Unfair 1993 Cologne, Stand Daniel Buchholz and Tresorraum
November Television, Videoprojekt Remscheid, Esther Schipper, Cologne
Fuck the System, Villa Rossi, Lucca
Atelier, photoproject in collaboration with Isa Genzken, Daniel Buchholz, Cologne, and Wilma Tolksdorf, Hamburg
June, Galerie Thaddaeus Roppac, Paris

1992
tomorrow people, i – D now, Imagination Gallery, London
We haven't stopped dancing yet, acht Photographen von i – D magazine, London; PPS Galerie F.C. Gundlach, Hamburg
i – D now, Pitti Imagine, Palazzo Corsini, Florence

1991
Icons of a mutinous age, three photographers, Bournemouth & Poole College of Art & Design, Bournemouth

1989
Die Hamburg Schachtel, Museum für Kunst und Gewerbe, Hamburg (catalogue)

Monographs
Monographien
Monographies

Burg, Benedikt Taschen Verlag, Cologne, 1998
Concorde, Verlag der Buchhandlung Walther König, Cologne, 1997
Wer Liebe wagt lebt morgen and *For when I'm weak I'm strong*, publ. by Kunstmuseum Wolfsburg and Cantz, Ostfildern, 1996
Wolfgang Tillmans, publ. by Portikus Frankfurt, Frankfurt./Main, and spex magazine, Cologne 1995
Wolfgang Tillmans, publ. by Kunsthalle Zürich, Zurich, 1995
Wolfgang Tillmans, ed. by Burkhard Riemschneider, Benedikt Taschen Verlag, Cologne, 1995

Work in Magazines
Arbeiten in Zeitschriften
Travaux pour des journaux

1998

Big, no. 19, New York Times Soldiers Project
Gay Games Amsterdam, poster
index, 6/98, cover & pp. 10–17, Bianca Jagger
jetzt, no. 19, pp. 6–7, Pulp
Paradex, no. 1, insert
Purple Fashion, no. 5, Martin Margiela/Alex Bircken
Faridi
Ray Gun, no. 55, cover & 7 pages, Pulp
RE –, no. 2, pp. 32–33, Pascale Gatzen Project
Spex, 4/98, pp. 18–21, Pulp
Spex, 2/98, p. 65, Jutta Koether & Christoph Gurk
Studio Voice, vol. 265, Jan. 1998, cover photo
Visionaire, no. 24, Light
Vogue Italia, Feb. 1998, pp. 328–329, artist's pages

1997

Honcho New York, Dec. 1997, pp. 3 & 24–31, Porn
jetzt, no. 38, p. 18, Aphex Twin
i – D, no. 163, pp. 58–65, Matthew Collin & John Godfrey
index, Sept./Oct. 1997, pp. 44–52, Gilbert & George
index, 1/97, cover, pp. 6 & 17, John Waters
Interview, April 1997, p. 9, ad for Matsuda (also in Matsuda catalogue)
Interview, Jan. 1997, p. 44, John Lynch
Landscapes Tokyo, no. 1, pp. 2–13, Mouse Walk with Me
Portfolio
Out, no. 40, p. 48, Neil Bartlett
Skool of Edge, vol. 2, pp. 52–55, Portfolio
Spex, no. 9, cover & pp. 24–27, Goldie
Spex, no. 7, p. 9, Kraftwerk
Spex, no. 6, cover & pp. 34–39, Wu Tang Clan; pp. 26–29, Rob Playford
Spex, no. 4, cover & pp. 24–27, Supergrass
Süddeutsche Zeitung Magazin, no. 26, pp. 32–41, Concorde Portfolio
Visionaire, no. 22, Kate Moss
Vogue US, Nov. 1997, pp. 356–361, Fashion Naomi Campbell
Vogue US, March 1997, p. 70, Kate Moss
Vogue US, Feb. 1997, pp. 246–251, Fashion Kate Moss
Zeit Magazin, no. 6, cover & pp. 11–19, text on Nan Goldin

1996

Blvd. Amsterdam, 6/96, pp. 39 & 46, Manifesta 1 Portfolio Project
Château Marmont Hollywood Handbook, inner cover, pp. 2, 48 & 149
Fotofolio New York, series of postcards
Habitat Broadsheet (autumn 1996), fold-out poster
i – D, no. 158, p. 98
i – D, no. 156, pp. 52–57, Love Parade '96
i – D, no. 151, pp. 36–40, The KLF
index, 11/96, cover & pp. 6–10, Parker Posey
index, 8/96, cover & pp. 6–9, Larry Brown
index, 6/96, cover & pp. 6–10, Mira Nair
index, 4/96, cover & pp. 6–7, Udo Kier
index New York, 2/96, cover & pp. 6–9, Allison Folland
Interview, June 1996, pp. 78–83, Twister Fashion
jetzt, no. 52, p. 18, Nan Goldin
Out New York, no. 2, pp. 90–93, Gay and Lesbian Parents
Permanent Food, p. 105
Purple Fashion, no. 2, Faridi Fashion
Purple Prose (winter 1996), pp. 84–91, Chateau Portfolio
Spex, no. 11, pp. 4–5, Gallon Drunk; p. 12, J. Saul Kane
Spex, no. 10, pp. 20–21, Suede (photo and interview)
Spex, no. 9, pp. 48–56, Youth and Violence Project
Spex, no. 5, pp. 66–69, Bruce LaBruce, Tony Ward, Rick Castro
Spin, Nov. 1996, p. 82, Nan Goldin
Süddeutsche Zeitung Magazin, no. 38, cover & pp. 18–22, Robbie Williams
Süddeutsche Zeitung Magazin, no. 16, cover & pp. 42–49, Fashion Model Gillian Wearing
Switch Tokyo, no. 6, pp. 156–157, Visual Diary #10
Switch, no. 5, pp. 124–125, Visual Diary #9
Switch, no. 4, pp. 122–123, Visual Diary #8
Switch, no. 3, p. 13 & 26–39, Fashion Model Gillian Wearing; pp. 136–137, Visual Diary #7
Switch, no. 2, pp. 138–139, Visual Diary #6
Switch, no. 1, pp. 154–155, Visual Diary #5
Zine Tokyo, no. 2, pp. 34–40, Portfolio

1995

Aktuell Berlin, no. 13, pp. 10–35, Project
Brutus Tokyo, no. 1, pp. 28–37, Paula, John & Paul Nudes
i – D, no. 147, p. 38, Chris Ofili; p. 39, Georgina Starr;
p. 42, Tracey Emin; p. 43, Gillian Wearing
i – D, no. 146, pp. 32–38, Harmony Korine
i – D, no. 145, p. 11, Blur
i – D, no. 144, pp. 16–19, Fashion Tristan Webber, Alex Bircken Faridi, Alexis Panayiotou, Lutz Huelle; pp. 94–97, Gay Pride London + New York, Isa Genzken, Jochen Klein, Inga Humpe
i – D, no. 141, p. 7, Sam Sever
i – D, no. 139, pp. 22–27, Carl Craig
i – D, no. 138, p. 13, Simon Reynolds & Joy Press
Interview, Oct. 1995, p. 98, Mizrahi Skirt
Interview, Sept. 1995, pp. 132–135, Andrew Sullivan
Interview, July 1995, pp. 64–71, Mistress Formika, Liv Tyler, Margaret Wertheim, Dan Matthews, Ed Burns, Morwenna Banks, Grandmaster Flash, Michael Bergin, Gaetano Pesce, Jill Sobule, Mariko Mori
Interview, April 1995, pp. 84–91, Deana, Sister Bliss, Smokin' Jo, Queen Maxine & Vikki Red, Mrs. Wood, Anita Sarko, Princess Julia, Belinda Becker, Rachel Auburn
jetzt, no. 45, pp. 12–13, Chloe Sevigny
jetzt, no. 44, cover, pp. 3 & 8–14, Bronx Skaters Reportage
jetzt, no. 23, p. 14, Aphex Twin
Max (G), 6/95, p. 170, Fake New York Diary
Permanent Food, no. 1, News, Cigs, Mags & Teens talk of danger
Purple Fashion, no. 1, Bernadette Corporation, Gillian Haratani, Elizabeth Peyton
Purple Prose, #9, pp. 22–29, how much Portfolio
Spex, no. 12/95, pp. 28–31, Boss Hog
Spex, no. 9/95, cover, pp. 28–34, Blur & 32-page insert (*Portikus* catalogue)
Spex, no. 2/95, pp. 24–26, Richie Hawtin/Plastikman
stern, no. 26, pp. 56–66, Evangelischer Kirchentag Porträts
Switch, no. 10, pp. 154–155, Visual Diary #4
Switch, no. 9, pp. 148–149, Visual Diary #3
Switch, no. 8, pp. 146–147, Visual Diary #2
Tempo, no. 9, pp. 62–69, Take That Fans

1994

ADAC Special, no. 22, pp. 84–89, Oktoberfest
i – D, no. 134, pp. 32–36, Richie Hawtin
i – D, no. 133, p. 10, Ray Brady
i – D, no. 132, p. 40, Kai Althoff & Justus Koencke; p. 83, X-Project/Rebel MC
i – D, no. 131, pp. 74–75, Madrid i – D Night
i – D, no. 130, p. 9, Criminal Justice Bill Demo & pp. 24–28, Erasure, Gus van Sant
i – D, no. 129, pp. 52–53, Music Technology
i – D, no. 128, pp. 42–46, A Guy Called Gerald, Deep Blue, LTJ Bukem, Ray Keith, DJ Hype, Kenny Ken, Jumping Jack Frost, Goldie
i – D, no. 126, pp. 38–43, Victor & Rolf, Pascale Gatzen, Marcel Verheijen, Saskia van Drimmelen, Lucas Ossendrijver
i – D, no. 125, pp. 3 & 20, Portishead; p. 19, Ewan McGregor; p. 25, Kaliphz
Interview, March 1994, Richard Pandiscio's "Ones to Watch"
Lutteurs, Swiss Work Wear catalogues
Purple Prose (winter 1994), pp. 74–75
Switch Tokyo, no. 7, pp. 130–136, Portfolio
Tempo, 8/94, cover & pp. 20–25, Gay Lifestyles
Tempo, 5/94, pp. 92–94, Fashion Gillian Haratani, Christopher Moore, Thuy Phem, Tom Borghese & Ramon
Vibe New York, April 1994, pp. 84–87, Fashion Gillian Haratani, Christopher Moore, Thuy Phem

1993

i – D, no. 120, pp. 67–68, i – D Night Rimini, Ten City, Graeme Park, Tony Humphries, Simon DK; pp. 70–73, Fashion Sportswear
i – D, no. 119, pp. 3 & 28–31, Moby
i – D, no. 118, pp. 14–17, Faslane Peace Camp; pp. 22–25, Fashion Camouflage; pp. 66–67, Street Portraits (Lothar Hempel, Alan Belcher & Others)
i – D, no. 117, p. 3, Ambient & pp. 14–15, Fashion (Brown)
i – D, no. 115, pp. 12–14, Ears; pp. 43–43, Suede; pp. 58–59, Roland 303; pp. 70–71, Dries van Noten Devotees
i – D, no. 114, pp. 8–10, Vic Reeves & Bob Mortimer; pp. 68–70, Fashion (Sweaters)
i – D, no. 113, pp. 4–8, Survival Stories
Ray Gun Los Angeles, no. 11/93, p. 5 & 75–80, Fashion Lars, Alex & Alex, Lutz & Others
Spex, no. 9/93, pp. 34–35, Shara Nelson
Tempo, 7/93, pp. 118–125, Club Portofolio
Time Out, no. 1174, cover Berlin Portraits
Time Out Amsterdam, no. 5, pp. 49–55, Amsterdam
Time Out Amsterdam, no. 3, p. 7, Street Fashion; p. 8, Tattoo Museum, Squats; pp. 12–13, Amsterdam; pp. 23–24, Clubs; p. 34, Gay Nightlife; pp. 43–44, Restaurants
Time Out Student Guide, p. 43, Street Portraits

1992

i – D, no. 111, pp. 4–10, Ragga, Jamaica, Shabba Ranks, Lady Patra
i – D, no. 110, p. 45, General Levy; pp. 56–58, Chemistry Club; pp. 80–87, Fashion Like Brother Like Sister Alex & Lutz
i – D, no. 108, pp. 60–61, Sega; p. 75, Dexter Wong; p. 80, Chris O'Reilly; p. 82, Colin Harvey; pp. 86–90, Gay Pride London; pp. 64–69, Love Parade, Berlin
i – D, no. 107, pp. 18–21, Public Enemy
i – D, no. 106, p. 42, Levi's
i – D, no. 105, pp. 10–13 & 18–22, Athens Reportage, Juan Atkins, Darren Emmerson
i – D, no. 104, pp. 81–82, Glam Club
i – D, no. 102, p. 4, Fashion; p. 12, Florence + Video Stills; pp. 36–40, Cyberpunk Technology; pp. 21, 46 & 57, Straight-up Portraits
i – D, no. 100, p. 50, Aids Page (photos & text)
i – D, Japan, 12/92, pp. 86–89, Gay Pride London
i – D, Japan, no. 4, p. 43, Aids Page
i – D now, Suppl. Nov. 1992, p. 5, Suede; p. 7, St. Etienne; p. 8, Velda Lauder; p. 9, Tomoko Yoneda & Jon Barnbrook; p. 13, Alan Maughan; p. 20, Lawler Duffy; p. 22, Al Berlin;

p. 23, Non-Aligned; p. 24, Eugene Souleimen; p. 25, Spiral Tribe
Spex, 12/92, cover & pp. 36–37, Mike D
Spex, 10/92, pp. 36–38, Ten City
Spex, 9/92, cover & p. 22, Stereo MCs
Spex, 5/92, pp. 3 & 46–48, Beastie Boys
Spex, 4/92, cover, Henry Rollins; pp. 3 & 6–7, Soul II Soul; pp. 38–41, Adrian Sherwood
Spex, 3/92, cover & pp. 26–28, My Bloody Valentine; pp. 6–7, Joey Negro
Spex, cover, Ragga Twins
Tempo, Momus
Zeit Magazin, no. 38, pp. 14–20, Street Portraits Portfolio

1991

i – D, no. 99, pp. 18–23, Techno Reportage Gent & Frankfurt
Prinz Hamburg, 10/91, pp. 76–79, Fashion (Couples)
Spex, 8/91, cover, pp. 3 & 26–27, Primal Scream; pp. 18–20, Rebel MC
Spex, 7/91, pp. 26–28, Stephen Duffy
Spex, 5/91, pp. 38–40, Electronic

1990

Prinz Hamburg, 10/90, pp. 74–78, First Fashion Story
Prinz Hamburg, 6/90, cover; p. 24, Adamski; pp. 42–46, Nightlife; p. 112, Friedrich Kurz
Prinz Hamburg, 3/90, pp. 10–11, Peep-Show; p. 24, The Weather Girls; pp. 30–34, Nightlife; p. 38, Yoko Tawada; pp. 44–48, Sport Idols + Willi Schulz; p. 103, Ulrich Wildgruber
Spex, Soul II Soul
The Face, no. 24, Aug. 1990, p. 70, Euroclubbing
The Face, no. 17, Jan. 1990, p. 109, Berlin (text and photos)

1989

Hamburger Rundschau, no. 49, p. 15, artist's page
i – D, no. 69, p. 8, Opera House; pp. 12–14, Hamburg i – D Night
Prinz Hamburg, 9/89, p. 14, Lutz Huelle; p. 16, Gaststätte Sparr; pp. 24–25, Boy George, Christoph Schäfer & Cathy Skene; pp. 30–34, Hamburg Nightlife
Tango Hamburg, 3/89, pp. 146–147, Nightlife
Tempo, 9/89, pp. 50–56, Martin Kippenberger, Hendrik Martz, Trude Unruh, Gerhard Schröder, Marius Müller-Westernhagen, Alfred Mechtersheimer, Uta Ranke-Heinemann, Willy Millowitsch, Natja Brunkhorst, Rainer Fettig, Dr. Jürgen Schreiber,

Bibliography
Bibliographie

1998

Blase, Christoph: "Vorwärts – und nicht vergessen", *Frankfurter Allgemeine Zeitung* (April 7, 1998)
Budney, Jen: "Come On Baby", *Parkett*, no. 53 (autumn 1998)
Casadio, Mario: "D – dedicata", *Vogue* Italia, no. 570 (Feb. 1998), pp. 324–331
Celis, Bárbara: "Emergentes en Arco 68", *El País de las Tentaciones* (Feb. 6, 1998), p. 16 f.
Deitcher, David: "Lost and Found", in: *Burg*, Benedikt Taschen Verlag, Cologne, 1998
Knopke, Burkhard: "Identität und Sinnlichkeit", *hinnerk* (2/98), pp. 6–9
Matsui, Midori: "Memory Machine", *Parkett*, no. 53 (autumn 1998)
Nesbitt, Judith: *Parkett*, no. 53 (autumn 1998)
Piccoli, Cloe: "Le ultime donne", *D*, no. 94 (March/April 1998), pp. 63–72
Price, Dick: "We gotta get out of this place", *i – D*, no. 172 (Jan./Feb. 1998), p. 39
Sager, Peter: "Sammeln ist ein Trip", *Zeit Magazin*, no. 22, pp. 12–18
Schiff, Hajo: "Wenn Van Gogh gezappt hätte", *die tageszeitung* Hamburg (Feb. 28, 1998)
Seyfarth, Ludwig: "Sensationell oder banal", *Hamburger Rundschau*, no. 11 (March 12, 1998)
____: "Zurück in die Zukunft", *Szene Hamburg* (3/98)
Stange, Raimar: "Das Comeback der 80er Jahre", *neue bildende kunst* (2/98), p. 81 f.
Sutton, Tara: "Think Before You Shoot ... Talking to Wolfgang Tillmans", *Big*, no. 19 (May 1998)
Sweet, Matthew: "Porn again", *Frank* (April 1998), pp. 154–155
Wakefield, Neville: *Parkett*, no. 53 (autumn 1998)
Ziegler, Ulf Erdmann: *Parkett*, no. 53 (autumn 1998)
Entwurf – Religionspädagogische Mitteilungen (3/97), back cover
form, no. 161 (1/1998)
Hanatsubaki, no. 574 (April 1998), p. 35
Hanatsubaki, no. 572 (Feb. 1998), pp. 13 & 15
Hanatsubaki, no. 571 (Jan. 1998), p. 5
Segno, no. 160 (Jan./Feb. 1998), p. 6
The Male Nude, ed. by Burkhard Riemschneider, Benedikt Taschen Verlag, Cologne, 1998
"Veronica's Schweißtuch und andere Abbilder", *Hamburger Abendblatt* (Feb. 27, 1998)
"Wolfgang Tillmans", *Photonews*, no. 4 (April 1998)

1997

Allen, Vicky: "Cry Wolfgang", *Arena* (July/Aug. 1997)
Aronowitz, Richard: "Invasion of the sewer rats", *The Highbury and Islington Express* (June 20, 1997), p. 6
Bach, Caroline: "Photographie et mode", *Art Press* (Oct. 1997), pp. 153–156
Beem, Edgar Allen: "The artist as spiritual tourist", *MAINE Times* (Sept. 4, 1997), p. 20
Bernard, Kate: "Wolfgang Tillmans", *Hot Tickets* (June 5, 1997), p. 45
Boodro, Michael: "fashion for art's sake", *Vogue* (Feb. 1997), pp. 118 & 122
Boogard van den, Oscar: "Ik leef nu", *Metropolis M.* (Aug./Sept. 1997), cover & pp. 34–37
Bonami, Francesco (ed.): *Echoes: Contemporary Art at the Age of Endies Conclusions*, publ. by The Monacelli Press, Inc., New York, 1997
Brittan, David: "The Crowd", *Creative Camera*, p. 35
Brubach, Holly: "Beyond Shocking", *New York Times Magazine* (May 1997)
Bryant, Eric: "The 10 Best Magazines of 1996", *Library Journal* (May 1, 1997), pp. 42–43
Campany, David: "Little Boxes", *Creative Camera*, no. 349 (Dec. 1997/Jan. 1998), p. 42
Cirant, Catherine: "Absolute Landscape", *Absolute Landscape* (Yokohama Museum of Art), p. 143
Clancy, Luke: "Art with a sense of humour", *The Irish Times* (Aug. 18, 1997)
Coomer, Martin: "We Gotta Get Out of This Place", *Time Out*, no. 1426/7 (Dec. 1997), p. 69
____: "Wolfgang Tillmans", *Time Out* (July 23–30, 1997), p. 51
Demir, Anaïd: "L'art fait le lit de la mode", *Technikart* (March 1997)
Dominicis de, Daniela: "Wolfgang Tillmans, S.A.L.E.S.", *Flash Art*
Domröse, Ulrich & Inga Knölke: *Positionen künstlerischer Photographie in Deutschland seit 1945*, catalogue, Dumont Buchverlag, Sept. 1997, pp. 38–39 & 138–139
Draxler, Helmut: "Requiem für einen: Jochen Klein", *Texte zur Kunst*, no. 28, pp. 179–180
Dziewor, Yilmaz: "Tobias Rehberger", *Artforum* (Jan. 1997), pp. 74–75
Faller, Heike: "Aus dem Keller zu den Sternen", *stern* (Jan. 1997), p. 82
Gächter, Sven: "Fotopoet der Straße", *profil*, no. 50 (Dec. 6, 1997), pp. 26–27 (Foto-Sonderheft)
Gaskin, Vivienne: "Wolfgang Tillmans", *everything magazine* (July 1997), pp. 5–7.
Germer, Stefan: "Fluch des Modischen – Versprechungen der Kunst", *Texte zur Kunst* (March 1997), pp. 52–60
Giampa, Pino: "Wolfgang Tillmans – Sociale, Sessuale e Spirituale", *Romarte* (March/April 1997)
Gleadell, Colin: "Is This Tomorrow", *Art Monthly* (Oct. 1997), pp. 52–53
Goto, Shigeo: "Paradise #2: Virtual Insanity", *Dune*, no. 12 (spring 1997), pp. 56–57
Greene, David: "Group Exhibition: New Photography 12", *Creative Camera* (Feb./March 1997), p. 46
Halley, Peter & Bob Nickas: "Wolfgang Tillmans", *Index* (3/97), pp. 39–45
Halpert, Peter Hay: "Buy, Hold, Sell", *American Art* (March/April 1997), p. 49
Heiferman, Marvin: "New Photography 12", *Artforum* (Jan. 1997), p. 79
Heiser, Jörg: "Heroin Chic", *Die Beute*, no. 15/16 (winter 1997), pp. 127–136
Hermes, Manfred: "Kunst", *Spex* (Jan. 1997), pp. 32–33
Hüllenkremer, Marie: "Art Cologne 1997", *Kölner Stadt-Anzeiger*, no. 261 (Nov. 10, 1997), p. 6
Kaufhold, Enno: "Positionen künstlerischer Photographie in Deutschland seit 1945", *Photonews* (Nov. 1997)
Koether, Jutta: "Kunst", *Spex* (Jan. 1997), p. 48
Kurtz, Thomas: "Kunst zeigt bedrohte Menschenwürde", *Pforzheimer Zeitung* (Feb. 3, 1997)
Larson, Kay: "A Month in Shaker Country", *New York Times* (Aug. 10, 1997), p. H33
Martin, Richard: "Zeitgeist Becomes Form", *Artforum* (March 1997), p. 87
Marcoci, Roxana, Diana Murphy & Eve Sinaiko (eds.): *New art*, publ. by Harry N. Abrams, Inc., 1997, pp. 141–142
McQuaid, Kate: "Maine's Quiet in the Land' Plumbs Art of Shaker Life", *The Boston Globe* (Aug. 15, 1997)
Meyer, Claus Heinrich: "Schweres Blut", *Süddeutsche Zeitung* (Dec. 5, 1997)
Millard, Rosie: "The art gang", *The Independent Magazine* (Aug. 30, 1997), pp. 8–12
Moro, Silvia Gaspardo: "How to Marry a Million Tree", *L'uomo Vogue*, no. 285 (Nov. 1997), pp. 60–77
Morrissey, Simon: "Interrogating Beauty", *Contemporary Visual Art* (Oct. 1997), pp. 26–33
Murphy, Fiona: "A shopping sensation", *The Guardian* (Weekend) (Sept. 1997), pp. 56–59
O'Flahert, Mark C.: "Crazy, Sexy, Cool", *boyz* (June 14, 1997)
Parkes, James Cary: "The cult of Wolfgang Tillmans", *Gay Times* (July 1997), pp. 15–16
Ragozzina, Marta: "Wolfgang Tillmans", *Artel*
Remy, Patrick: "Esthétique du sursis", *Art Press* (Oct. 1997), pp. 157–159
Rian, Jeffrey: "the generatin Game", *ECHOES*, p. 68
Saltz, Jerry: "Camera Lucida: MoMA takes a clear-eyed look at some new photography", *Time Out* New York (Jan. 16–23, 1997), p. 35

Sato, Eko: "Hiromix Interview", *Self Service*, no. 6 (fall/winter 1997), p. 93

Schmitz, Rudolf: "Das Schweißtuch der Veronika", *Frankfurter Allgemeine Zeitung* (April 21, 1997), p. 45

___: "Die Raumfusion der gegenwärtigen Fotografie", *Portikus 1987–1997*, pp. 70–73 & 252–253

Schwarz, H.H.: "Ute ganz cool auf der Art", *Express* Cologne (Nov. 12, 1997), p. 21

Searle, Adrian: "Is this the cutting edge?", *The Guardian* (July 22, 1997), p. 10

Shand Kydd, Johnnie: *Spitfire – photos from the London artworld 96/97*, Violette pub., 1997, pp. 199–201

Slyce, John: "Wolfgang Tillmans", *What's on* London (July 16, 1997), p. 22

Smith, Caroline: "Wolfgang Tillmans" (Interview), *ProfiFoto* no. 3 (May/June 1997), pp. 45–52

Smith, Roberta: "German Fashion Art as Serious Art", *The New York Times* (Feb. 7, 1997), p. C26

Stöhr, Dr. Jürgen: "Die Arbeit in der Blick-Schneiderei", *Kult* (June/July 1997), pp. 6–9

Tiedemann, Holger: "Adam am Zermatt", *Deutsches Sonntagsblatt*, p. 29

Tietenberg, Annette: "Ballade von der medialen Abhängigkeit", *Frankfurter Allgemeine Zeitung* (Feb. 1997), p. 35

Vollmer, Wolfgang: "Eintracht?", *Camera Austria International*, no. 59/60, p. 154

Weidner, Corinna: "Deutschland, deine Fotos", *Prinz* Berlin (Sept. 1997)

Wendenburg, Christina: "Bildsprache", *Berliner Morgenpost* (Nov. 21, 1997)

Wyatt, Kieran: "A – Z of obsessions", *i – D* (Aug. 1997), p. 56

Ziegler, Ulf Erdmann: *Contemporary German Photography*, ed. by Markus Rasp, Benedikt Taschen Verlag, Cologne, 1997

___: "Gewinnerspieler und Verliererspieler", *die tageszeitung* (Dec. 30, 1997), p. 12

Actuel Paris, no. 3, p. 205

Hanatsubaki, no. 570 (Dec. 1997), p. 6

Inter Medium Textbook (Japan)

Items, no. 6 (Oct. 1997), p. 18 f.

Kultur des Friedens, Wissenschaftliche Buchgesellschaft, pp. 110, 186–190 & 233–234

Studio Voice, vol. 257 (May 1997), pp. 26–27

Tasei Quarterly, no. 101, inner cover

The Sculptors' Society Newsletter (Sept./Oct. 1997)

Via Bus Stop Paper (March 24, 1997)

Vogue US (Nov. 1997), p. 94

"Art Cologne", *Focus*, no. 46 (Nov. 10, 1997), p. 204

"Art or Commerce?", *Vogue* US (Feb. 1997), p. 60 & 122

"Auf Spuren des Begriffs Menschenwürde", *Pforzheimer Kurier* (Feb. 3, 1997), p. 9

"Breathe in, breathe out", *D > Tour* (July 1997), pp. 20–21

"Buy! Hold! Sell!", *American Photo* (March/April 1997), pp. 40–66

"Chisenhale", *Hot Tickets* (July 3, 1997), p. 43

"Contributors – Wolfgang Tillmans", *Vogue US* (Nov. 1997), p. 94

"Covers", *Hanatsubaki* (April 22, 1997)

"Der alltägliche Blick", *Facette* (Sept. 1997), p. 3

"Eye catching", *The eye* (June 7, 1997)

"I Didn't Inhale", *Habitat Art Broadsheet* (summer 1997)

"Interview – Wolfgang Tillmans/Photographer", *Hanatsubaki* (Aug. 1997), pp. 27–28

"In to – out of", *Le Millénium*, no. 20

"Kate Moss serviert uns was Süßes", *Express* Cologne (Nov. 12, 1997), p. 21

"Le immagini di una vita in fotografia", *Quiroma* (April 18, 1997)

"Offbeat agenda", *Spex* (June 1997), p. 63

"Paris", *Le Journal des Arts* (April 18, 1997)

"Polaroid versus Fashion sous le manteau", *Têtu* (March 1997)

"Tailpiece", *Creative Camera* (Feb./March 1997), p. 50

"Un maggio di fotografia", *Time Out* Rome

"Vogue Contributors", *Vogue* US (Feb. 1997), p. 60

"Wer Liebe wagt, lebt morgen", *Prinz* (Feb. 1997)

"Wolfgang Tillmans", *Evening Standard* (July 29, 1997)

"Wolfgang Tillmans", *Evening Standard* (June 11, 1997)

"Wolfgang Tillmans", *La Repubblica Roma* (April 1997)

"Wolfgang Tillmans", *New Art*, pp. 141–142

"Wolfgang Tillmans", *Studio Voice*, vol. 2, pp. 52–55

"Wolfgang Tillmans", *The Big Issue* (June 2, 1997), p. 11

"Wolfgang Tillmans", *The Big Issue* (June 2, 1997)

"Wolfgang Tillmans alla galleria S.A.L.E.S.", *L'Opinione* (April 25, 1997)

1996

Affentranger-Kirchrath, Angelika: "Wolfgang Tillmans", *Artis* (Aug./Sept. 1996)

Aletti, Vince: "Wolfgang Tillmans", *Village Voice* (Sept. 24, 1996), p. 10

___: "Snap Shot", *Village Voice* (Sept. 17, 1996)

Arend, Ingo: "Partisanen im Dickicht der Städte", *Freitag* (March 15, 1996), p. 10

Beard, Steve: "Deutschland, deine Photographen", *Neue Zürcher Zeitung* (July 31, 1996), p. 46

___: "Partisanen im Dickicht der Städte", *Freitag* (March 15, 1996), p. 10

Beil, Ralf: "Deutschland, deine Photographen", *Neue Zürcher Zeitung* (July 31, 1996), p. 46

Bianchi, Paolo: "Subversion der Selbstbestimmung", *Kunstforum* (May – Sept. 1996), pp. 56–64

Brockmann, Roland: "Deutsches Auge", *Wochenpost* (May 31, 1996), p. 39

Bröder, F.J.: "Fotografie beherrscht die Szene", *Nordbayerischer Kurier* (March 13, 1996)

___: "Verfremdender Blick hinter die Wirklichkeit", *Main Echo* (March 1996)

___: "Kunst und Fotografie – zwei Ausstellungen in Nürnberg", *Donaukurier* (Feb. 29, 1996)

Collin, Matthew: "A Weakness for Photography", *Wired UK* (Nov. 1996), p. 89

Dziewor, Yilmaz: "Fair Wars", *Artforum* (Nov. 1996), p. 32

Enslein, Giseld: "Peking-Ente mit Pelzkragen", *Abend Zeitung* (Feb. 14, 1996), p. 13

Ericsson, Lars O.: "Ein Photograph für die neunziger Jahre", *Dagens Nyheter* (July 15, 1996)

Farrelly, Liz: "So you want to be a rock'n roll star ...", *The Face*, p. 167

Fechner-Smarsly, Thomas: "Die gegenwärtige Unschärfe des Seins", *Frankfurter Rundschau* (Nov. 1996)

Fenn, Walter: "Varianten der Fotografie", *Bayerische Staatszeitung* (March 1, 1996)

___: "Die Natur schlägt ...", *Nürnberger Nachrichten* (Feb. 14, 1996), p. 22

Flood, Richard: "Real Life Rock: Richard Flood's Top Ten", *Artforum* (Feb. 1996), p. 24

Föll, Heike: "Wolfgang Tillmans", *neue bildende kunst*, no. 2 (April/May 1996), p. 39, Künstlerseiten von Wolfgang Tillmans, cover & pp. 40–46

Frehrking, Markus & Matthias Lange: "Die Klasse", in: *Ikonen – selbstgemacht*, Edition Museum für Gestaltung Zürich, 1996, p. 181

Fujimori, Manami: *B.T. Magazine* (June 1996), pp. 94–95

Funke, Claudia: "Nouvelle Vogue", *Stadtrevue* (June 1996)

Gade, Rune: "Fataellinger tilen accelereret Kultur", *Margenavisen Jylands-Posten* (June 19, 1996)

Göttner, Christian & Alexander Haase: "Wolfgang Tillmans – Fotografie als Selbsterfahrung", *Subway* (11/96), pp. 8–11

Guerrin, Michel: "La photo de mode bousculée par la génération réaliste", *Le Monde* (May 4, 1996)

Heé, Bacher, Schatz & Kathrin Frauenfelder: "Vom Traum zur Wirklichkeit" (& in conversation), *Paar Mal Paar*, catalogue, Aug. 1996, pp. 99–107

Henle, Susanne: "Faltenwurf zerknitterten Stücks", *Frankfurter Allgemeine Zeitung* (May 25, 1996), p. 49

Hossner, Ulrich: "Ozelotmantel, Pelzmütze und Taftkorsage", *Die Welt* (July 15, 1996), p. 6

Hucht, Margarete: "Im Baum wohnt ein Lackmantel", *Kölnische Rundschau* (May 4, 1996)

Hueck-Ehmer, Britta: "Art Frankfurt: Moderne und zeitgenössische Kunst gut sortiert", *Welt am Sonntag* (March 10, 1996), p. 70

Hüllenkrämer, Marie: "Erstaunlicher Kraftakt der Galerienszene", *Kölner Stadt-Anzeiger* (April 1996)

Inone-Kräzler, Maria: "Spuren beseitigt", *Nürnberger Zeitung* (Feb. 2, 1996)

Jasper, Martin: "Verbogenes Blech, verrutschte Socke", *Feuilleton* (Sept. 7, 1996)

Karcher, Eva: "Das Leben ist ein Tanz auf dem Hausflur", *Art* (June 1996), cover & pp. 78–79

Karroum, Abdellah & Hilton Als: *Urgence*, catalogue, Jan. – March 1996

Karweik, Hans-Adelbert: "Nichts Künstlicheres als Normalität", *Stadt-Wolfsburg* (Sept. 6, 1996), p. 27

Kreis, Elfi: "Kunstauktion zugunsten von Kulturbrauerei und Bethanien", *Die Tageszeitung* (June 17, 1996), p. 11

Königer, Maribel: "Nachts ist es kälter", *Süddeutsche Zeitung* (May 3, 1996), p. 14

Kuni, Verena: "Wille und Vorstellung", *Pakt* (Feb. 8, 1996)

Lütgens, Annelie: "Kein Stoff für Voyeure", catalogue, Kunstmuseum Wolfsburg, 1996, pp. 6–8

Lyttelton, Celia: "Wolfgang Tillmans", *The Now Art Book*, pp. 150–152

Maurer, Simon: "Fragile Schönheit", *Züritip* (June 6, 1996), p. 60

Meyer, Stefan: "Rasender Stillstand", *Der Tagesspiegel* (Kultur) (July 13, 1996), p. 19

Molesworth, Helen: "Picture Books", catalogue, Kunstmuseum Wolfsburg, 1996, pp. 11–12

Nickerson, C. & N. Wakefield (eds.): *Fashion (photography of the nineties)*, Scalo pub., 1996

Pesch, Martin: "Obst und Gemüse", *Wochenpost* (Sept. 19, 1996), p. 36

___: "Wolfgang Tillmans – Authentisch ist immer eine Frage des Standpunkts", *Kunstforum International*, vol. no. 133 (Feb. – April 1996), pp. 256–269

Rachline, Sonia: "Du goût et des couleurs", *Vogue* France (March 1996)

Roth, Wilhelm: "Vom langsamen Verschwinden des Lebens", *Frankfurter Rundschau* (Jan. 2, 1996)

Rottmann, Kerstin: "Sperrmüll – Charme", *Die Welt* (Nov. 12, 1996)

Sans, Jerome: "Tillmans' Portfolio", *East/West Avenue Magazine International*, no. 5 (July/Aug. 1996), pp. 46–53

Sasaki, Naoya: "from editors", *Switch* (April 1996), pp. 13 & 25

Schmitz, Rudolf: "Bauchredner der Fotografie", *Frankfurter Allgemeine Zeitung* (June 17, 1996), p. 91

Schorr, Collier: "Things Gone and Things Still Here", catalogue, Kunstmuseum Wolfsburg, 1996, pp. 13–14

Schwendener, Martha: "Wolfgang Tillmans", *Time Out* New York (Oct. 17–24, 1996), p. 60

Seerberger, Stefan: "Konzeptlos und exhibitionistisch", *Art* (Aug. 1996), p. 6

Seyfarth, Ludwig: "Zeitgeist – Photographie", *Süddeutsche Zeitung* (June 6, 1996), p. 60

Smith, Roberta: "Photography Review: Around the World, Life and Artifice", *The New York Times* (Nov. 8, 1996), p. C28

___: "art after a fashion", *Vogue* (Jan. 1996), pp. 164–165 & 184

Spindler, Amy: "90's attitude, Visual and Raw", *New York Times* (Nov. 26, 1996), p. B6

Squires, Carol: "Best & Worst 1996", *Artforum* (Dec. 1996), p. 94

Starl, Timm: "Mutmaßungen über das Deutsche Auge", *Frankfurter Allgemeine Zeitung* (July 18, 1996), p. 35

Trescher, Stephan: "wunderbar: Eine Ausstellung im Kunstverein Hamburg", *neue bildende kunst* (Aug./Sept. 1996), p. 91

Volkart, Yvonne: "wunderbar at Kunstverein Hamburg at the Kunstraum, Vienna", *Flash Art* (Oct. 1996), p. 73

___: "Die Welt subjektivieren", *Springer* (June/July 1996), p. 28

___: "Privacy Order: Die Welt subjektivieren", *Die Beute* (March 1996), p. 49

Wagner, Frank: *family, nation, tribe, community SHIFT*, catalogue, Sept. 1996, pp. 11 & 14

Wagner, Thomas: "Berührungen mit dem Rauschmittel Fotografie", *Frankfurter Allgemeine Zeitung* (July 4, 1996), p. 33

Wahlbrink, Jörg: "Fotografisches Sammlerium", *Am Erker* (summer 1996)

Wamberg, Jacob: "ø jebliksbilleder fra 90erne", *Politiken* (June 16, 1996), p. 12

Wulffen, Thomas: "40 Jahre Kunstpreis der Böttcherstraße in Bremen", *Kunstforum* (May 1996), p. 487

Ziegler, Ulf Erdmann: "Wünschelrute im Themenpark", *Die Zeit* (Sept. 27, 1996), p. 62

Art (Nov. 1996), p. 4

Buch 24 X 30, catalogue, Reprozwölf pub., Vienna, 1996

CAMPO, catalogue, pp. 48 & 56

f – fotografisk tidskrift, pp. 12–13

Junge Welt (March 23/24, 1996), pp. 1–5

Private View – Contemporary Art in the Bowes Museum, catalogue, Henry Moore Institute pub., May – July 1996

Prospect 96, catalogue, March – May 1996, pp. 321 & 412

Royal Dutch Post – day planner (Jan. 1996)

Surface (Contemporary Photographic Practice), Browning, Mack, Perkins (eds.), Booth Clibborn pub., 1996

"A little museum that does", *Flash Art* (Oct. 1996), p. 49

"Alphabet der Knitterfalten", *Neue Zürcher Zeitung* (June 2, 1996)

"Ausstellungen", *Spiegel extra* (Sept. 1996), p. 25

"Ausstellungen", *Die Welt* (Feb. 10, 1996), p. 10

"Because Quality Counts" (reproduction of article in *SWITCH*, April 1996), in: *Art Gallery Exhibiting*, Paul Andriesse (ed./pub.), 1996, pp. 172–173

"Bestseller", *foto Magazin* (Jan. 1996)

"Chronist der Jugendkultur der 90er", in: *Kunst geht nicht*, Cantz (pub.), 1996, p. 17

"Contributors", *Interview* (June 1996), p. 14

"Contributors", *Out* (Feb. 1996), p. 10

"Curiosity", *Quelques Hommes*, #8

"Das deutsche Auge – Der deutsche Blick?", *Photonews*, no. 7/8 (July/Aug. 1996), pp. 3–4

"Das Welt-Mediendorf", *Das deutsche Auge* (May – Sept. 1996), pp. 94–95 & 107–108

"Der Typ mit dem irren Klick mag's gern authentisch", *Leipziger Volkszeitung* (May 1996)

"Die Nachrücker", *Capital* (April 1998), pp. 279–282

"edition Wolfgang Tillmans", *Kunstverein Hannover* (April 1996), p. 25

"Einstieg und Ausstieg", cover, *Vorwärts* (Sept. 1996)

"faulheit und arbeit section", *Junge Welt* (March 23–24, 1996), pp. 1–5

"Flash Art News: Art with Shakers", *Flash Art* (summer 1996), p. 74

"Goings on About Town: Wolfgang Tillmans at Andrea Rosen Gallery", *The New Yorker* (Oct. 7, 1996), p. 26

"Jugendkultur", *Kunstzeitung* (Sept. 1996)

"Kitsch und Klischees", *Cosmopolitan* (Sept. 1996), p. 28

"Kunstmode", *Frankfurter Rundschau* (May 2, 1996)

"Livres", *20 Ans* (April 1996)

"Mitarbeiter der Zeit empfehlen Bücher zum Selberlesen und Verschenken", *Die Zeit* (Dec. 1, 1996), p. 16

"Project: Photo-Du-Jour", *Art + Text*, no. 53 (Jan. 1996), pp. 42–47

"Schneller Sex", *Der Spiegel*, p. 74

"Schon verführt", *Der Spiegel*, p. 264

"Sensiblere Zeit", *Der Spiegel*, no. 43, p. 158

"Shooting-Star der Fotografie", *Focus*, p. 220

"So schön bist Du nun auch nicht", *stern*, no. 56 (Dec. 5, 1996), pp. 238–239

"sozio- und popkultur: die fotografien von Wolfgang Tillmans", *Pur* (Feb. 1996), pp. 6–9

"Top-Job: Fashion", *Images*, Photokina '96, p. 8

"Wolfgang Tillmans", *Blind Spot*, Issue 8, pp. 25–28

"Wolfgang Tillmans", *Geo* (Dec. 1996)

"Wolfgang Tillmans", *Spex* (Dec. 1996)

"Wolfgang Tillmans, Edition", *Texte zur Kunst* (May 22, 1996), pp. 168–169

"Wolfgang Tillmans", *Everything that's Interesting is New*, catalogue, Dakis Joannou Collection, Cantz. pub., 1996, p. 262

1995

Althoff, Kai: "Diskussion am Grat", *Texte zur Kunst* (Nov. 1995), p. 172

Appel, Stefanie: "Wahre Coolness", *Prinz* Frankfurt (Sept. 1995), p. 88

Bartas, Magnus: "Wolfgang Tillmans", *Index* (Jan. 1996), pp. 41–43 & 61

Berg, Ronald: "Die Genießer der Indifferenz", *Zitty* (Feb. 1995), pp. 206–207

Bonami, Francesco: "Wolfgang Tillmans", *Flash Art* (March/April 1995), p. 95

Boyer, Charles: "Lifestyle", *Tribus* (March 1995), p. 44

Bürgi, Bernhard: "Jahresbericht", catalogue, Kunsthalle Zürich, March 1995, p. 10

Colin, Beatrice: "Wolfgang Tillmans at Stills Gallery", *The Guardian* (Aug. 23, 1995)

Crüwell, Konstanze: "Hase, Hirsch und Tisch", *Frankfurter Allgemeine Zeitung* (Dec. 6, 1995)

Dorfmüller, Henrike: "Schnappschuß im Kochtopf", *Remscheider Generalanzeiger* (April 7, 1995)

Eger, Christian: "Vergnügter Spion in der aktuellen Jugend-Szene", *Mitteldeutsche Zeitung* (Nov. 20, 1995)

Enslein, Thomas: "Wolfgang Tillmans", *Siegessäule* (Feb. 1995)

Eshun, Kodwo: "Wolfgang Tillmans", *i – D* (March 1995), p. 8

Feaver, William: "That's entertainment", *The Observer Review* (April 2, 1995), p. 13

Fischer, Frauke: "Ein Blick", *Weser-Kurier Bremen* (Nov. 22, 1995)

Fischer, Klaus: "Nerv der Zeit?", *Strandgut* (Oct. 1995), pp. 24–25

___: "Mit Star-Fotograf Tillmans auf Piste", *Frankfurter Neue Presse* (Sept. 4, 1995), p. 9

Flowers, Claire: "Interesting People, Uninteresting Show", *The Scotsman* (Aug. 28, 1995), p. 9

Freedman, Carl: "Take Me (I'm Yours)" at the Serpentine Gallery, London", *Frieze* (summer 1995), pp. 73–74

Fricke, Harald: "Die Noblesse des Lustprinzips", *die tageszeitung Berlin* (Jan. 18, 1995), p. 13

___: "Outdoor-Artisten", *die tageszeitung* (Jan. 17, 1995)

Graves, Peter: "Partners at Heart", *The Times Literary Supplement* (May 19, 1995)

Guha, Tania: "Wolfgang Tillmans, Interim Art", *Time Out*, no. 1319 (Nov. 29, 1995), p. 48

Halentz, Regine: "Die Romantiker", *Wochenpost* (April 20, 1995)

Heller, Markus: "Bilder am den Soundso", *Die Zeit* (Feb. 10, 1995), p. 69

Henke, Barbara: "Ein Lifestyle-Dokumentarist", *Handelsblatt* (Sept. 15/16, 1995)

Henry-Künzel, Ginger: "Fair and the Unfair", *Art News* (Jan. 1995)

Hierholzer, Michael: "Von Menschen und Bäumen", *Frankfurter Allgemeine Sonntagszeitung* (Sept. 3, 1995)

Hillger, Andreas: "Nachrichten aus der Wirklichkeit", *Mitteldeutsche Zeitung* (Sept. 20, 1995)

Horman, Egbert: "Generation X", *Euros* (March/April 1995)

Huebel, Birger: "Dabeisein, Machen, Bewegung …", *Spex* (Feb. 1995), pp. 44–45

Huther, Christian: "Die Welt – so breitschichtig wie irgend möglich", *Badische Neueste Nachrichten* (Dec. 13, 1995)

___: "Möbel geraten ins Trudeln", *Main-Echo* (Dec. 13, 1995)

___: "Jahrhundert der Bilder", *Art Kaleidoscope*, no. 1, (Oct. 1995), pp. 14–21

___: "Mit selbstverliebtem Blick", *Main-Echo* (Sept. 8, 1995)

Janaczak, Christian: "Preisträger musizierten mit den Bayer-Philharmonikern", *Unser Werk* (Nov. 1995)

Kageneck, Christian: "Bilder zwischen Traum und Wirklichkeit", *Südkurier* (April 27, 1995)

Karcher, Eva: "Die neunziger Jahre: Künstler als Forscher", *Art* (July 1995), pp. 50–59

Krahe, Helmut: *Berliner Zeitung* (Jan. 11, 1995), p. 140

Kratzert, Armin: "Er trinkt Pepsi und glaubt an Gott", *Wochenpost* (April 1, 1995)

Kuni, Verena: "Wolfgang Tillmans Portikus Frankfurt", *Springer*, vol. 1, no. 5/6 (Nov. 1995), p. 101

Kwasnitza, Josef: "Fotoband über eine ganze Generation", *Leipziger Rundschau* (June 27, 1995)

Löffler, Sigrid: "Generation X – The kids are all right", *Falter* (March 31, 1995)

Massery, Michel: "Nouvelles tribus culturelles en photo", *Le Nouveau Quotidien* (Sept. 19, 1995)

Matsumoto, Hiroshi: "4B – Expo", asashi press pub., 1996

Molesworth, Helen: "Wolfgang Tillmans at Andrea Rosen Gallery", *Art + Text*, no. 50 (Jan. 1995)

Montgomery, Robert: "Street wise", *The List* (Aug. 1995), p. 75

Niemczyk, Ralf: "Joey Beltram", S*pex* (Oct. 1995), pp. 18–19

Oberholzer, Niklas: "An der Grenze zwischen Intimität und Öffentlichkeit", *Luzerner Zeitung* (April 1, 1995)

___: "Intimität und Öffentlichkeit", *Kunst und Kirche* (April 1995), pp. 238–239

Pesch, Martin: "Wolfgang Tillmans", *Die Woche* (Sept. 1, 1995)

Pesch, M. & M. Weisbeck (eds.): *techno style*, edition olms ag Zürich pub., 1995

Peter, Charlotte: "Wie das Knipsen zur Kunst wurde", *Zuriwoche* (May 4, 1995)

Poschardt, Ulf: "Ach, die Jugend", *Süddeutsche Zeitung Magazin* (March 1995), pp. 22–27

Prokop, Nikolaus: "Tarnen und Täuschen", *Der Standard*, p. 8

Roth, Wilhelm: "Der Grenzgänger", *Frankfurter Rundschau* (Sept. 4, 1995)

Sasaki, Naoya: "Wolfgang Tillmans, Because Quality Counts", *Switch* (Sept. 1995), pp. 131–139

Schaar, Erwin: "Fotos von Menschen", *Medien und Erziehung* (Aug. 1995)

Schmitz, Rudolf: "Rauskriegen was in der Luft liegt", *Frankfurter Allgemeine Zeitung* (Sept. 19, 1995)

Schönherr, Florian & Urs Hattung: "Der Grenzgänger", *Journal Frankfurt* (Aug. 25, 1995)

Schreuf, Kristof: "Blur", *Szene Hamburg*

Schwarzmann, Jörg: "Hellwach aber ratlos?", *Bolero* (April 1995), p. 17

Slonim, Jeffrey: "Sound for … eyes", *Artforum* (Feb. 1995), p. 10

Vogel, Sabine: "Wolfgang Tillmans in der Kunsthalle", *Kunst Bulletin* (May 1995), pp. 47–48

Volkart, Yvonne: "Frisch, frech und alltagsnah", *neue bildende kunst*, no. 3 (June 1995), p. 80

Wakefield, Neville: "In conversation with Wolfgang Tillmans", *Portikus* catalogue

Watney, Simon: *Wolfgang Tillmans*, Benedikt Taschen Verlag, Cologne, 1995

Wolff, Detlef: "Gegenwärtige Rückkehr zu den Gegenständen", *Weser-Kurier* (Oct. 14, 1995)

Wolff, Thomas: "Abziehbilder aus der Ich-Maschine", *die tageszeitung Bremen* (Oct. 25, 1995)

Wulffen, Thomas: *neue bildende kunst*, no. 3 (June 1995), p. 80

Ximenes, Joao: "Moda Verdade", *OGLOBO* (June 24, 1995)

Zwez, Annelies: "Sicht der Generation der 90er Jahre", *Aargauer Tageblatt* (June 19, 1995)

___: "Besuch auf einem kleinen Planeten", *Schaffhauser Nachrichten* (March 30, 1995)

Aktion Sorgenkind, catalogue, Oct. 1995, p. 73

L'immagine Riflessa, catalogue – from collection LAC, Svizzera, 1995

Om, pp. 50–51

Pakt (Jan./Feb. 1995)

Purple Prose (winter 1995)

Wear Me (Fashion & Graphics Interaction), Booth Clibborn pub., 1995, p. 83

"Achtung, Achtung", *Spex* (Sept. 1995), pp. 42–43

"Am Selbstverständnis einer Generation mitarbeiten, Interview mit Wolfgang Tillmans", *Pakt* (May/June 1995), pp. 20–21 & 40

"ars viva", *Spex* (5/95), p. 46

"Art", *Time Out* (March 22, 1995), p. 5

"Ausstellungen", *Nordwest-Zeitung* (Oct. 7, 1995)

"Benedikt Taschen Verlag", *The Bookseller* (Feb. 10, 1995)

"Bestseller List", *foto Magazin* (July 1995)

"Bestseller List", *foto Magazin* (April 1, 1995)

"Bestseller List", *The Art Book* (summer 1995), p. 20

"Blitzlichter einer Generation", *Der Standard* (March 10, 1995), p. 5

"Bücher – Telegramme", *BayernText* (Feb. 26, 1995)

"Die deutsche Wirtschaft prämiert junge Künstler", *Mitteldeutsche Zeitung* (Sept. 28, 1995)

"Die Förderpreise", *Kölner Stadt-Anzeiger* (April 8, 1995)

"Die intimen Fotografien von Wolfgang Tillmans", *Frankfurter Rundschau* (Sept. 2, 1995)

"Die Sehnsucht nach dem Paradies", *Allgemeine Zeitung Mainz* (Dec. 8, 1995)

"Ein ehrlicher Voyeur", *Kieler Nachrichten* (Feb. 23, 1995)

"Fotodokumentation", *Index* (1/95)

"Fotografien von Wolfgang Tillmans", *aktuell – das Magazin der deutschen Aids-Hilfe*, no. 13, cover, pp. 10–34 & 52

"Im Zeichen des Pulp", *Neue Zürcher Zeitung* (April 8/9, 1995)

"Installation und Gesellschaft", *Süddeutsche Zeitung* (Jan. 1995)

"Integrität und Würde einer Generation", *Schwarzwälder Bote* (March 16, 1995)

"In to – out of", *Le Millénium*, no. 13

"Jetzt", *Süddeutsche Zeitung Magazin* (Oct. 30, 1995)

"Kulturtest", *Prinz* (Nov. 1995), p. 87

"Kunstpreis der Böttcherstraße", *Neue OZ Osnabrücker Zeitung*

"Kunstpreis für Wolfgang Tillmans", *Bremer Anzeiger* (Nov. 11, 1995)

"Kunstpreis für Wolfgang Tillmans", *die tageszeitung* (Oct. 31, 1995)

"Künstlerische Reflexion in der modernen Fotografie", *Mitteldeutsche Zeitung* (Sept. 14, 1995)

"Le Grand Passage «expose» une idée d'Analix", *Extension* (Nov. 28, 1995), p. 12

"Les photos de Wolfgang Tillmans", *Double Face/Illico* (May 1995)

"Mode: Fixierter Zeitgeist", *Lüneburger Landeszeitung* (Oct. 18, 1995)

"Namen", *Die Welt* (Nov. 1, 1995), p. 8

"Natur und Künstlichkeit", *Frankfurter Rundschau* (Dec. 6, 1995)

"Preise", *Art* (July 1995), p. 114

"Preise für Fotografen", *Mitteldeutsche Zeitung* (Sept. 18, 1995)

"Preisträger stellen in Dessau aus", *Magdeburger Volksstimme* (Sept. 7, 1995)

"Pur und unverschämt", *Der Spiegel* (Jan. 30, 1995), pp. 106–107

"Sachbücher", *Saarbrücker Zeitung Munich* (Jan. 27, 1995)

"Sein liebstes Kunst-Stück liegt in Formalin", *Art* (Nov. 1995), pp. 46–47

"Snap Unhappy", *boyz* (April 1, 1995), p. 7

"Supermarket und Love Parade", *Veranstaltungen Zürich* (March 24–30, 1995), p. 5

"Take me (I'm yours)", *Time Out* (March 29, 1995), p. 52

"Taschen", *Livres Hebdo* (Jan. 6, 1995)

"Tempodrom", *Tempo* (Feb. 2, 1995), pp. 14–15

"Tillmans, antiglamour et poétique", *Max* (F) (July 1, 1995), p. 16

"40 Jahre Kunstpreis", *Weser Report* (Oct. 15, 1995)

"Vital Use 1994/1995 Wolfgang Tillmans", *Der Standard/Museum in Progress*, Vienna (March 8, 1995), p. 26

"Wer sind diese Leute?", *Prinz Hamburg* (Feb. 1, 1995)

"Wirtschaft fördert Gegenwartskunst", *Mitteldeutsche Zeitung* (Sept. 27, 1995)

"Wolfgang Tillmans", *Bremer* (March 1, 1995)

"Wolfgang Tillmans", *jetzt* (Dec. 18, 1995)

"Wolfgang Tillmans", *Livres Hebdo* (April 28, 1995)

"Wolfgang Tillmans", *Marie Claire* (June 1995)

"Wolfgang Tillmans", *Max* (G) (June 1995), p. 170

"Wolfgang Tillmans", *Profifoto* (July 1, 1995)

"Wolfgang Tillmans", *Photographie* (April 1995)

"Wolfgang Tillmans", *Studio Voice*, pp. 33 & 35

"Wolfgang Tillmans", *Die Welt* (Sept. 13, 1995)

"Wolfgang Tillmans à Zurich", *Tribune de Genève* (April 26, 1995)

"Wolfgang Tillmans: Hunger nach Leben", *Wochenpost* (Feb. 23, 1995)

"Wolfgang Tillmans – neugerriemschneider", *Zapp Magazine* (April 1995)

"Wolfgang Tillmans – Photographies Erotique", *Gay* (May/June 1995)

1994

Adams, Brooks: "Wolfgang Tillmans at Andrea Rosen Gallery", *Art in America* (Dec. 1994), pp. 101–102

Aletti, Vincent: "Season's greetings", *The village voice* (Oct. 24, 1994), p. 73

___: "Voice Choices", *The village voice* (Sept. 20, 1994), p. 72

Als, Hilton: "As is, Wolfgang Tillmans' Livestyle", *Artforum* (May 1994), pp. 68–73

Anderson, Carolyn Gray: "Spotlight: L'Hiver de l'Amour", *Flash Art* (May/June 1994), p. 109

Ardenne, Paul: "Spotlight: L'Hiver de l'Amour", *Art Press*, pp. II–III

Bacon, George: "Around the galleries: New York", *The Art Newspaper*, 38 (May 1994), p. 36

Breerette, Genevieve: "Courants frileux", *Le Monde* (Feb. 20, 1994)

Hainley, Bruce: "Wolfgang Tillmans at Andrea Rosen Gallery", *Artforum* (Dec. 1994), p. 82

Hayashi, Fumihiro: "Wolfgang Tillmans: Super Reality", *Dune* (autumn 1994), pp. 78–81

Kent, Sarah: "Developing Talents", *Time Out*, no. 1221 (Jan. 12, 1994), pp. 16–17

Königer, Maribel: "L'Hiver de l'Amour", *Kunstforum*, 126, (March/June 1994), pp. 344–346

Mosselmann, Arnold & Corinne Groot: "Wolfgang Tillmans at Thaddaeus Ropac, Paris", *Metropolis M.*, no. 3 (June 1994), p. 52

Muir, Gregor: "Wolfgang Tillmans at Interim Art, London", *Frieze*, no. 14 (Jan. 1994), p. 56

Nuridsany, Michel: "Une exposition révolutionnaire", *Le Figaro* (Feb. 15, 1994)

Romano, Gianni: "Wolfgang Tillmans", *Zoom*, no. 130, pp. 24–29

Stahl, Enno: "Wolfgang Tillmans bei Buchholz", *Kölner Stadt-Anzeiger* (Dec. 1, 1994), p. 58

Stein van, Emmanuel: "Im Glanz prächtiger Umsätze", *Kölner Stadt-Anzeiger*, no. 267 (Nov. 18, 1994)

Swingewood, Sally: "The camera never lies down", *Time Out Amsterdam*, no. 1 (June 1994), p. 4

Tessmar, Catherine: "Kunstmarkt", *Frankfurter Allgemeine Zeitung* (Nov. 11, 1994)

Tillmans, Wolfgang: "Techno Soul", catalogue, Musée d'art Moderne, Paris, *L'hiver de l'amour bis* (1994), pp. 8–9

Verzotti, Giorgio: "L'hiver de l'amour at Musée d'art Moderne de la ville de Paris", *Artforum* (Oct. 1994), p. 112

Zahm, Olivier: "Post sexe", *Purple Prose*, no. 5, pp. 32–35

Le Millenium Tokyo, no. 5

"Art 25 '94", *Baseler Magazine* (June 18, 1994), p. 16

"L'hiver de l'amour", catalogue, Musée d'art Moderne, Paris, *L'hiver de l'amour bis* (1994), pp. 38–41

"London arts in New York", *i – D*, no. 128 (May 1994), p. 17

"Wolfgang Tillmans at Andrea Rosen Gallery", *New York Press* (Sept. 14–20, 1994), p. 51

1993

Kent, Sarah: "Urban Warriors", *Time Out*, no. 1210 (Oct. 27, 1993), pp. 4–5

Poschardt, Ulf: "Ein Fleck Freiheit", *Vogue*, no. 8 (Aug. 1993), pp. 110–112

Reich, Elli: "Private Eye", *Prinz Frankfurt* (July 1993), p. 92

Zahm, Olivier: "Tendances", *Purple Prose*, no. 3 (June 1993), pp. 14–15

1992

Brudna, Denis: "I-deas für heute und übermorgen", *Photonews* (June 1992), pp. 8–9

Schulz, Tom: "Reden ist Silber, Schweigen ist Tod", *Szene Hamburg* (May 1995), pp. 23–32

"Parallels", *Creative Camera* (Feb./March 1992), pp. 24–27

1991

Gripp, Anna: "Bournemouth & Poole College of Art & Design", *Photonews* (Oct. 1991), pp. 4–6

1989

Brudna, Denis: "Wolfgang Tillmans", *Photonews* (Dec. 1989)

Gessulat, Stefan: "Ikonen", *Prinz Hamburg* (Aug. 1989)

"i – D Newsflash", *i – D*, no. 66, p. 7

1988

Schiff, Hajo: "Sherlock Holmes am Kopiergerät", *die tageszeitung* (Feb. 12, 1988)

My special thanks to Jochen Klein and to Alex & Alex Bircken Faridi, Lutz Huelle & David Ballu, Daniel Buchholz & Christopher Müller, Andrea Rosen, Maureen Paley, Burkhard Riemschneider, Angelika & Benedikt Taschen, David Deitcher, meine Eltern, Christian Tillmans, Gregorio Magnani, Scott King, Steve Slocombe, John Connelly, Thomas Eggerer, Pia Esch-Renner, Nici von Senger, Bernard Wissing, Judith Nesbitt, Bernd Klein & Mark Loy, Cerith Wynn Eavens & David Bassel, Julie Ault, Jason Eavens, Silke Otto-Knapp, Jane Simpson, Sue Jones, Camilla Nickerson & Neville Wakefield, Walther König, Rosemarie & Rolf Klein, Forkel Family, Ursula Tillmans, Christa Aboitiz, F.C. Gundlach, Louise Neri, Richard Pandiscio, Yvonne Force, Carmen Zita, Doug Ashford, Sarah Safford-Ashford, Mije Hartmann, Cathrin Marquardt, Paula Hayes, Peter Halley, Bob Nickas, Cory Reynolds, Helen van der Meij, Wayne Peterson & Jim, Naoya Sasaki, Isa Genzken, Michelle Reyes, James Lavender, Nina Schmidt, Amrei Janz, Catinka Keul, Horst Neuzner, Bernd Fechner, Volker Gebhardt, Ute Wachendorf, Claudia Frey, Yvonne Havertz, Matthew Collin & Steph, Rafael Doctor Roncero, Holger Tiedemann, Sabine Pflitsch, Michael Stipe, Dr. Hans Jäger, Thom Collins, Christoph Hefti, Mario Kramer, Tom Jones, B6 WG, Shaun Caley, Stuart Regen, Nicolai Wallner, Noberto Ruggeri, Massimo Mininni, Elisabeth Peyton, T.J. Wilcox, Paul Dezardain, Gordon Wallace, Tom Holert, Jutta Koether, Diedrich Diederichsen, Andrea Zittel, Tim Neuger, Renate Goldmann, France Morin, Sisters and Brothers of Shaker Community at Sabbathday Lake, Uwe Koch, Uwe Kraus, Stefan Kalmer, Michael Clark, Brigitte Kölle, Pasquale Leccese, Monika Sprüth, Doug McClemont, Yoshiko Isshiki, Taro Amano, Hideko Numata, Angelika Müller, Kamal Ackarie, Lisa Butler, Tara Sutton, Abdellah Karroum, Tomaso Corvi Mora, Tina Chai, Helmut Draxler, Gillian Wearing, Michael Landy, Tracey Emin, Julie Galant & Martin Bondell, Ben Weaver, Carl Freedman, Dr. Dieter Funke, Stephan Schmidt-Wulffen, Liam Gillick, Phillip Marshall, Lothar Hempel, Isabell Graw, Neil Moodie, Sheryl Conkelton, Cornelia Grassi, Gregor Muir, Werner Büttner, Jimmy Paul, Stefan Rögels, Martin van Nieuwenhuyzen, Leontine Coelewij, Johnnie Shand Kydd, Marina Bassano, Lorcan O'Neill, Astrid Wege, Martin Holtkamp, Kenny Campbell, Anna Friebe & Ullrich Reininghaus, Kasper König, Annelie Lütgens, Uta Grosenick, Collier Schorr, Helen Molesworth, Avril Mair, Oliver Schultz-Berndt, Mendes Bürgi, Hilary Lloyd, Gareth Jones, Tomma Abts, Kate Moss, Scott Andrews, Jimmy Paul, Naomi Campbell, Vickie Bartlett, Boris Rapat, Repro Eichler, Karsten Schwarz, Vladimiro Meneghetti & Sandra Hill, Verena Tintelnot, Valerie & Fred, Ulf Erdmann Ziegler, Jen Budney, Midori Matsui, Dennis Schoenberg.

Drawings on book case by Jochen Klein; "Mayrose", photo by Paula Hayes; "Nest", photo by Jochen Klein; "Küchenschelle", photo by Bernd Klein
Design and typography: Wolfgang Tillmans
Cover typography: Scott King
German translation: Christoph Hollender, Düsseldorf
French translation: Séverine Vitali, Munich

Printed in Germany
ISBN 3-8228-7881-2